HISTORIC PHOTOS OF
ALEXANDRIA

TEXT AND CAPTIONS BY
JULIE BALLIN PATTON AND RITA WILLIAMS HOLTZ

TURNER
PUBLISHING COMPANY

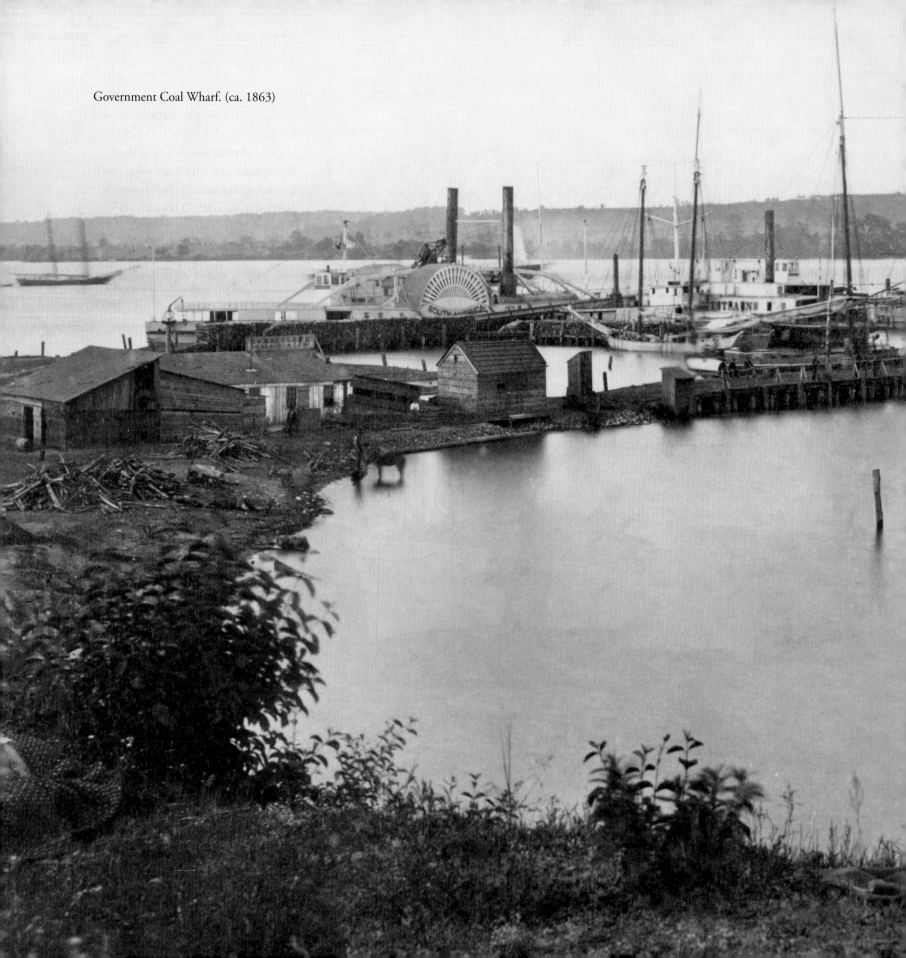

Government Coal Wharf. (ca. 1863)

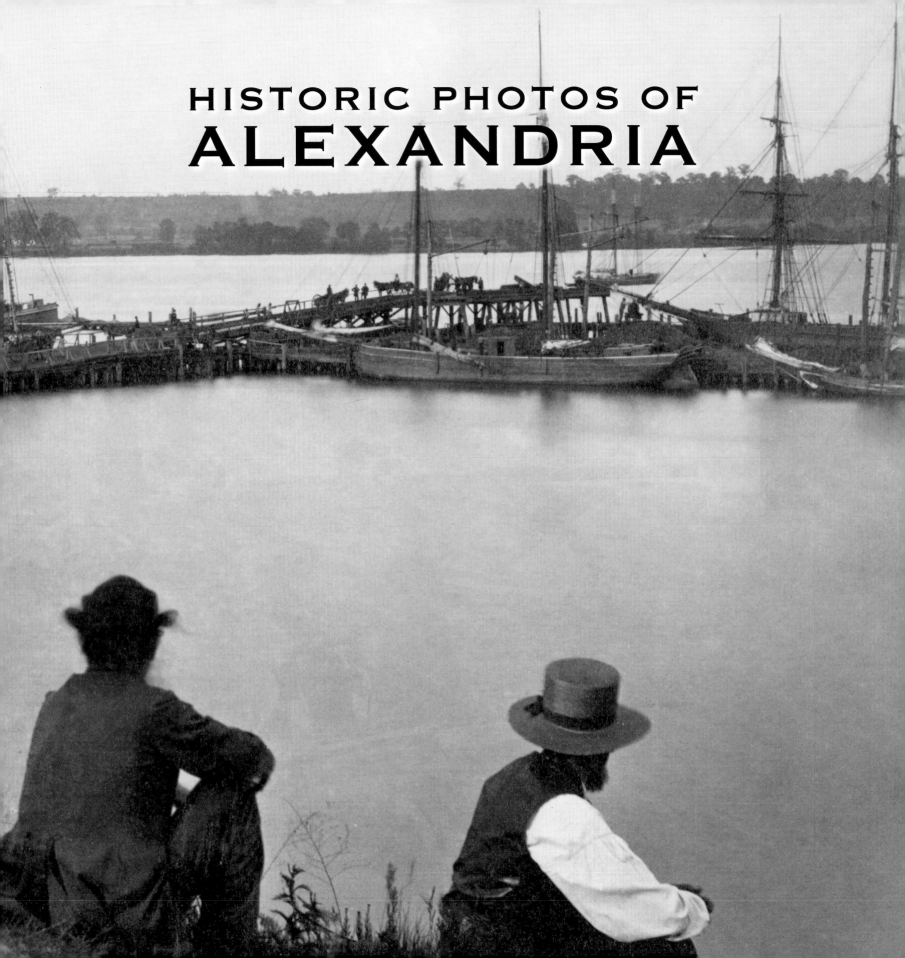

HISTORIC PHOTOS OF
ALEXANDRIA

Turner Publishing Company
200 4th Avenue North • Suite 950 412 Broadway • P.O. Box 3101
Nashville, Tennessee 37219 Paducah, Kentucky 42002-3101
(615) 255-2665 (270) 443-0121

www.turnerpublishing.com

Historic Photos of Alexandria

Library of Congress Control Number: 2007933764

ISBN-13: 978-1-59652-413-2

Printed in the United States of America

08 09 10 11 12 13 14 15—0 9 8 7 6 5 4 3 2 1

CONTENTS

The 1971 T. C. Williams High School Varsity Football team, the Titans. The story of this team winning the state high school football championship was the basis for the movie *Remember the Titans.*

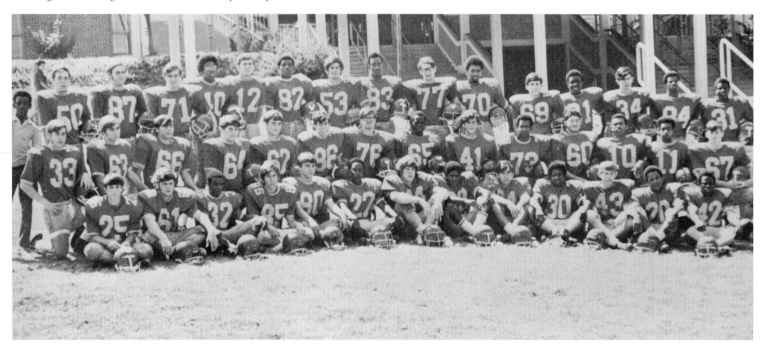

ACKNOWLEDGMENTS

This volume, *Historic Photos of Alexandria,* is the result of the cooperation and efforts of many individuals and organizations. It is with great thanks that we acknowledge the valuable contribution of the following for their generous support:

The Alexandria Library, Special Collections
The Library of Congress

The writers wish to thank George Combs, director of Alexandria Library, Special Collections, for allowing us the time to work on this book, and Michele Lee, Librarian at the Alexandria Library, Special Collections, for her extensive help in editing the manuscript. We also wish to thank the rest of the staff at Special Collections for their support during this project.

PREFACE

Alexandria has thousands of historic photographs that reside in archives, both locally and nationally. This book began with the observation that, while those photographs are of great interest to many, they are not easily accessible. During a time when Alexandria is looking ahead and evaluating its future course, many people are asking, How do we treat the past? These decisions affect every aspect of the city—architecture, public spaces, commerce, infrastructure—and these, in turn, affect the way that people live their lives. This book seeks to provide easy access to a valuable, objective look into the history of Alexandria.

The power of photographs is that they are less subjective than words in their treatment of history. Although the photographer can make decisions regarding subject matter and how to capture and present it, photographs do not provide the breadth of interpretation that text does. For this reason, they offer an original, untainted perspective that allows the viewer to interpret and observe.

This project represents countless hours of review and research. The researchers and writers have reviewed thousands of photographs in numerous archives. We greatly appreciate the generous assistance of the individuals and organizations listed in the acknowledgments of this work, without whom this project could not have been completed.

The goal in publishing this work is to provide broader access to this set of extraordinary photographs that seek to inspire, provide perspective, and evoke insight that might assist people who are responsible for determining Alexandria's future. In addition, the book seeks to preserve the past with adequate respect and reverence.

With the exception of touching up imperfections caused by the damage of time and cropping where necessary, no other changes have been made. The focus and clarity of many images is limited to the technology and the ability of the photographer at the time they were taken.

The work is divided into eras. Beginning with some of the earliest known photographs of Alexandria, the first section

records photographs through the end of the nineteenth century. The second section spans the beginning of the twentieth century through World War I. Section Three covers the years between the wars and the last section covers the World War II era to recent times.

In each of these sections we have made an effort to capture various aspects of life through our selection of photographs. People, commerce, transportation, infrastructure, religious institutions, and educational institutions have been included to provide a broad perspective.

We encourage readers to reflect as they go walking in Alexandria, strolling through the city, its parks, and its neighborhoods. It is the publisher's hope that in utilizing this work, longtime residents will learn something new and that new residents will gain a perspective on where Alexandria has been, so that each can contribute to its future.

—*Todd Bottorff, Publisher*

Star Fire Company, located at 116 S. St. Asaph Street. The company changed its name to the Columbia Steam Fire Engine Company in 1871. (1867)

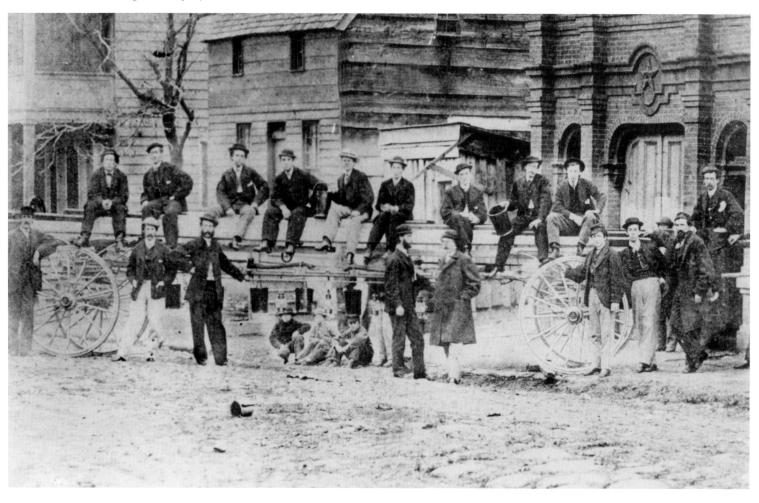

From Civil War to Century's End

(1860–1899)

Alexandria's history as a European settlement dates to 1654 when a land patent was granted to Margaret Brent by the Royal Governor of Virginia. In the 1740s, Phillip and John Alexander, whose family had purchased land in the area in 1669, and other landholders, petitioned the General Assembly for the creation of a town. Alexandria was officially founded in 1749. In subsequent years, the community grew as a seaport and farming community. Land was added by filling in parts of the Potomac shoreline, and lots were sold around town to expand the city limits. In the 1790s, Alexandria was included in a section of northern Virginia that became part of the new District of Columbia. One of the original boundary stones of the capital District still stands at Jones Point, the southern boundary of Alexandria.

Although the ports of Baltimore and Georgetown eventually overtook Alexandria as the primary shipping points for the upper Chesapeake area, the city continued to manufacture and export many goods, including grain and fish. The city eventually became a central railroad hub. Alexandria was also an important link in the domestic slave trade. In 1847, unhappy with the economic stagnation and abolitionist agitations of the District of Columbia, residents of Alexandria County and Arlington voted to separate from the capital city. This retrocession, or return, to Virginia allowed Alexandrians to have the governmental representation they were denied as part of the federal district and to continue to carve an identity that was quintessentially Southern.

Virginia seceded from the Union on April 17, 1861, and Federal troops arrived in Alexandria almost immediately to occupy the city—Alexandria was occupied during the Civil War longer than any other city of the South. Alexandria's superior rail and water transportation networks were put to use by the Federal army. Many large buildings were confiscated for use as hospitals and warehouses, to the great distress of citizens. The Civil War left the economy in shambles and Alexandrians struggled to rebuild. Like other Southern cities, they clung to the few industries left and began slowly to recover from the war during Reconstruction.

Colonel Elmer Ellsworth and James Jackson died at the Marshall House. When Ellsworth removed a Confederate flag from the roof, he was shot by Jackson, the proprietor, who in turn was killed by another Union soldier. (May 24, 1861)

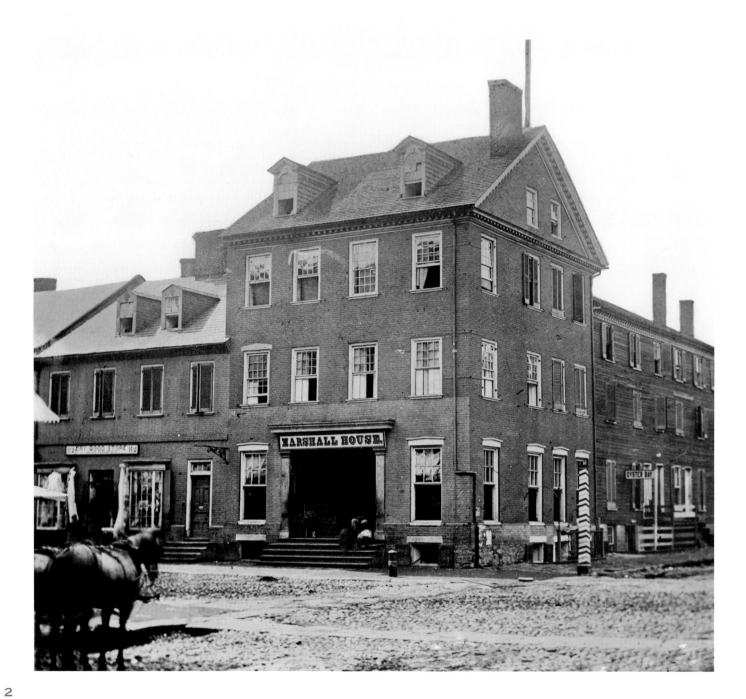

One of many stockades erected, this one was built along Union Street, to prevent Confederate sympathizers from sabotaging the buildings and docks along the waterfront held by the Union. (ca. 1861)

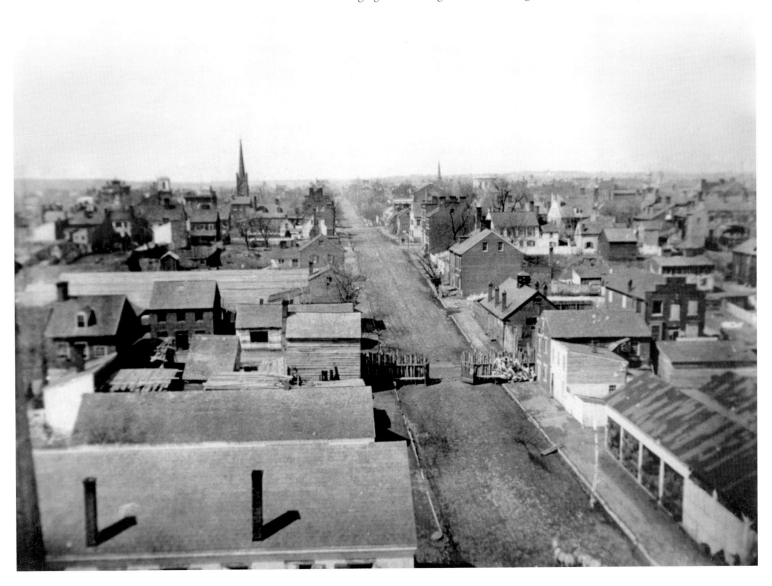

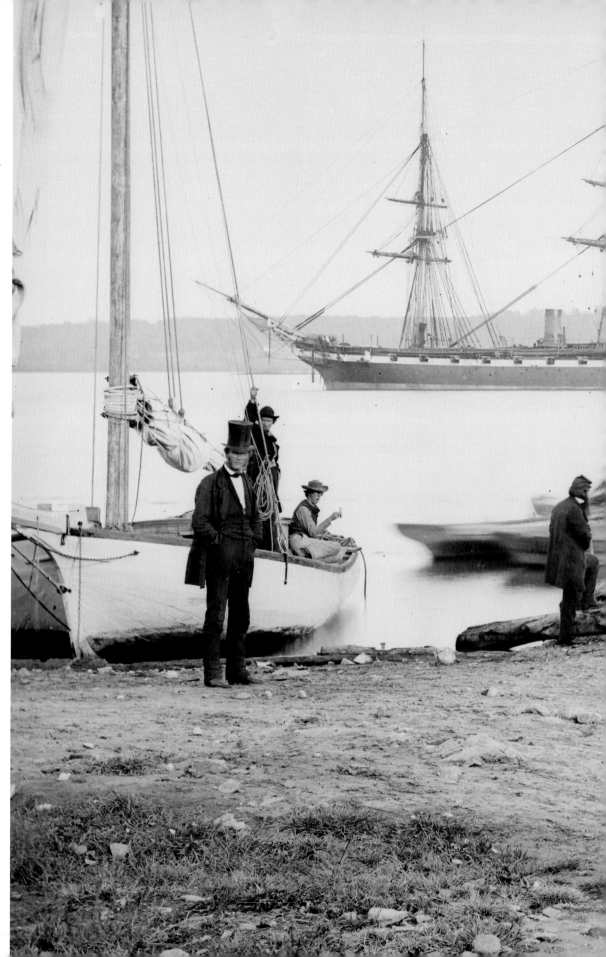

The frigate *Pensacola* lies at anchor in Alexandria Harbor. A second-class steamer, weighing 2,158 tons, the *Pensacola* was built in Florida and completed at the Washington Navy Yard. She was a part of the naval fleet commanded by Admiral David G. Farragut. (ca. 1861)

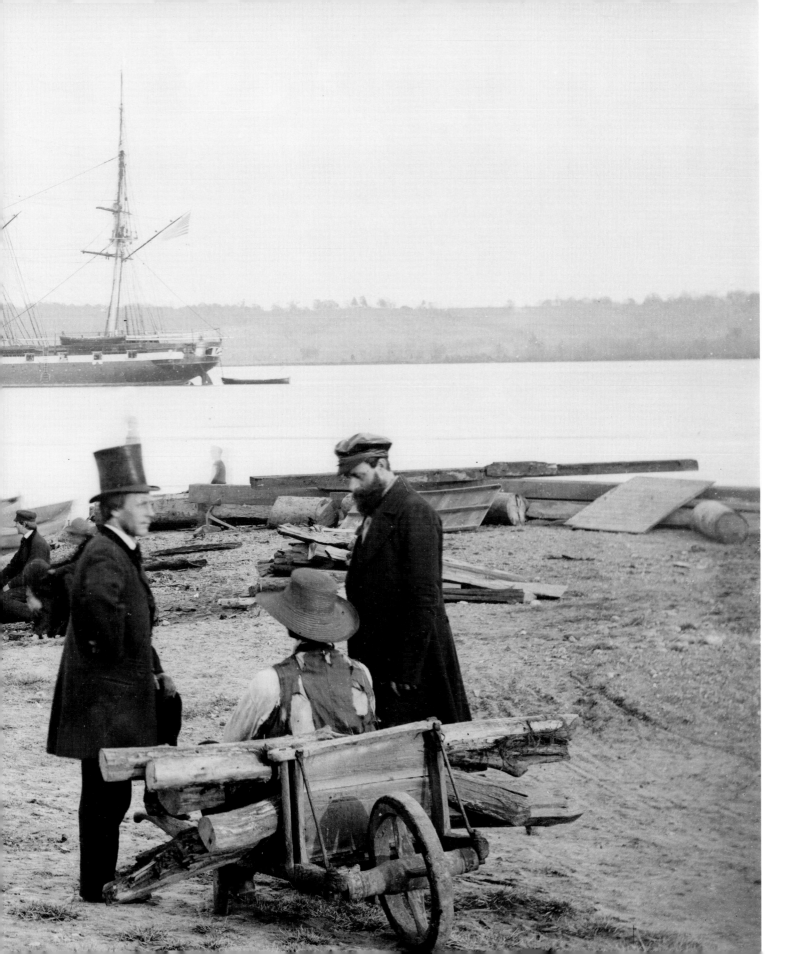

Union soldiers stand at attention outside the Slave Pen in the 1300 block of Duke Street. (ca. 1862)

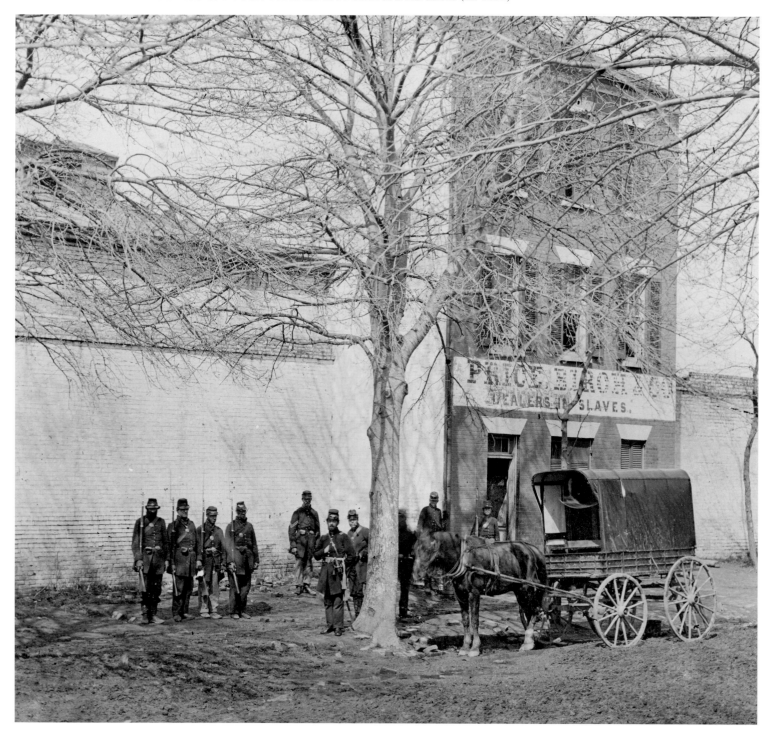

A woman stands beside the Slave Pen located in the 1300 block of Duke Street. (ca. 1862)

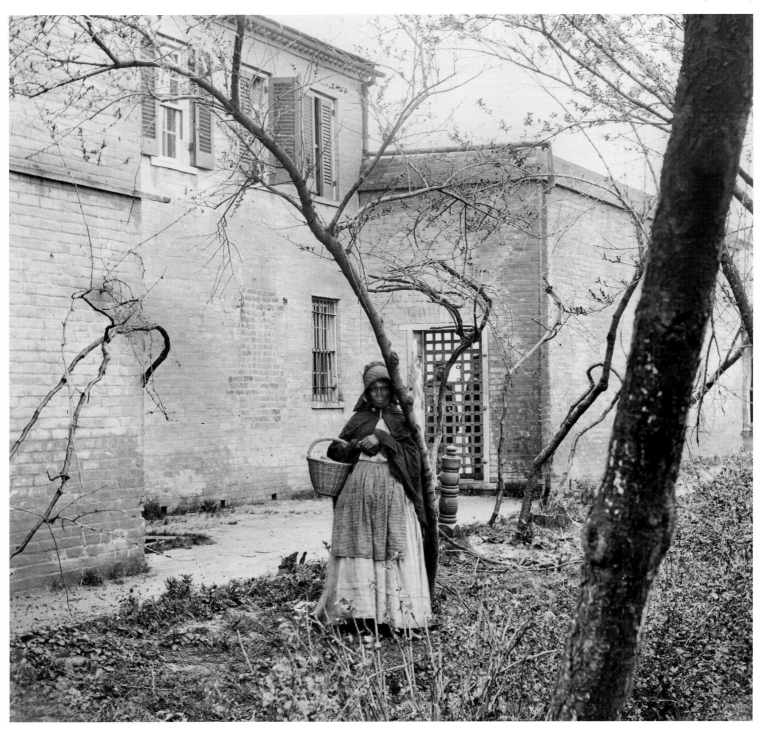

Curious Union soldiers investigate the interior of the Slave Pen on Duke Street. Dirt floors, iron-bar doors, and small, almost windowless cells tell a grim tale. (ca. 1862)

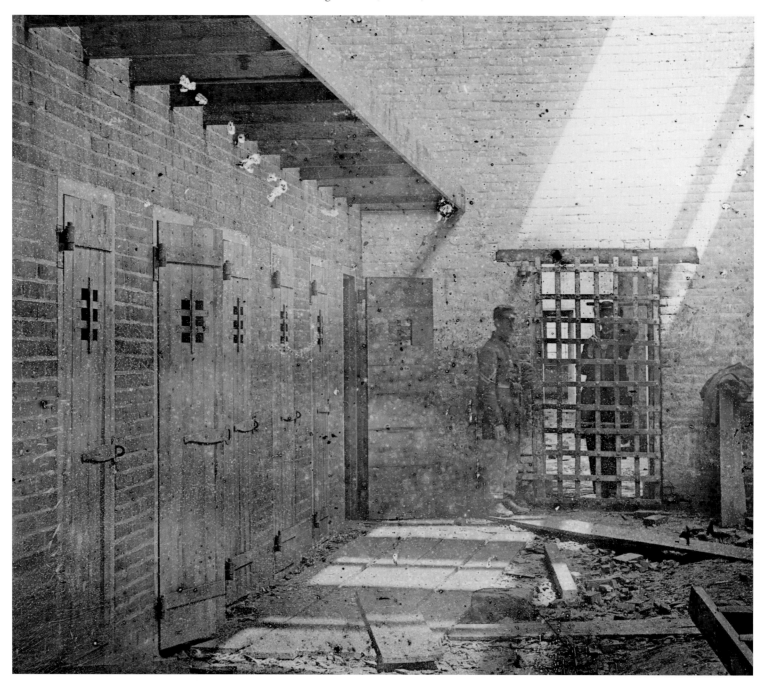

The United States Military Railroad construction corps planes boards along the Alexandria waterfront. (ca. 1862)

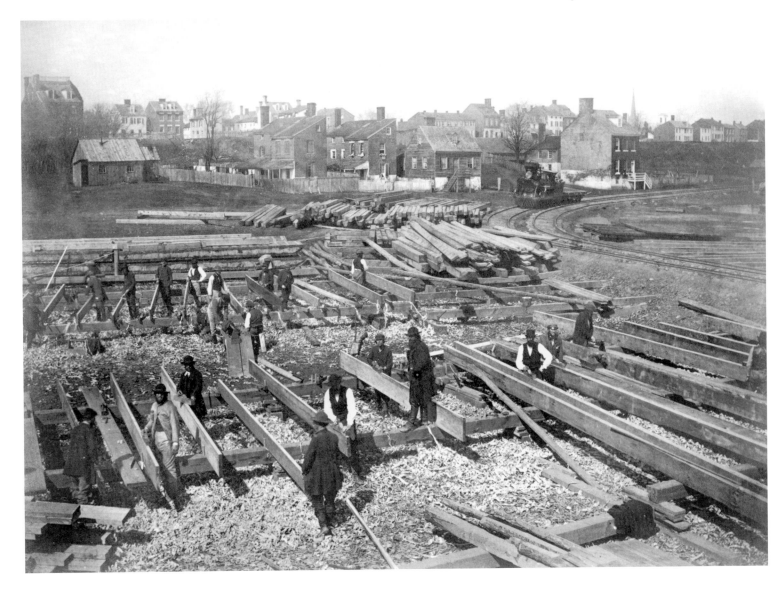

The United States Military Railroad carpenter shop. (ca. 1862)

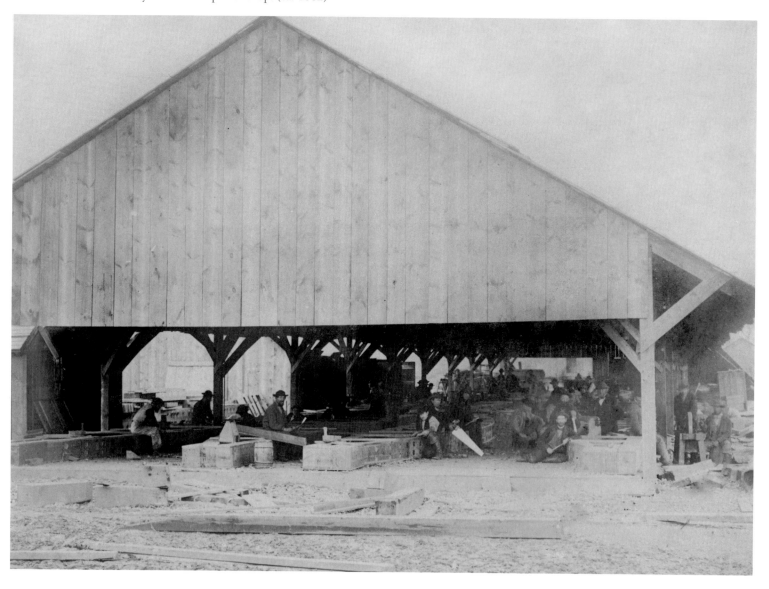

Construction corps workers for the United States Military Railroad complete the building of portable bridge trusses. (ca. 1862)

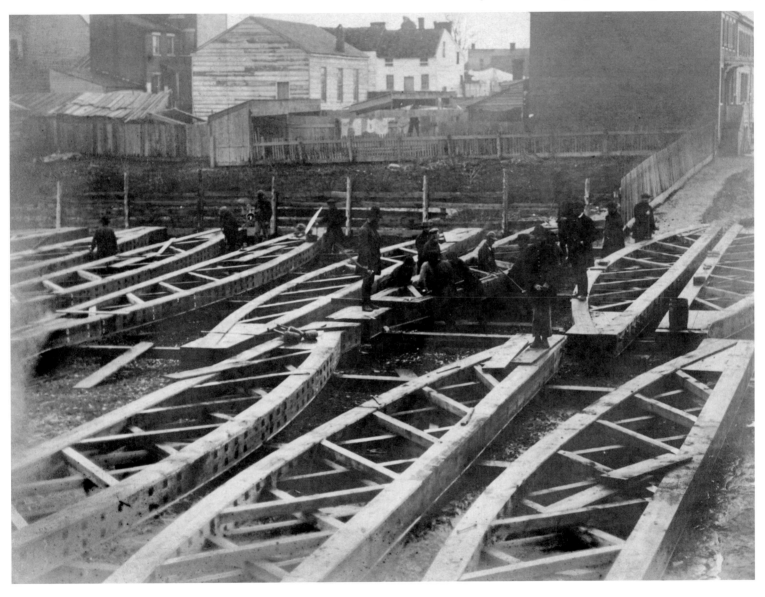

Military personnel inspect the trusses used to build railroad bridges. (ca. 1862)

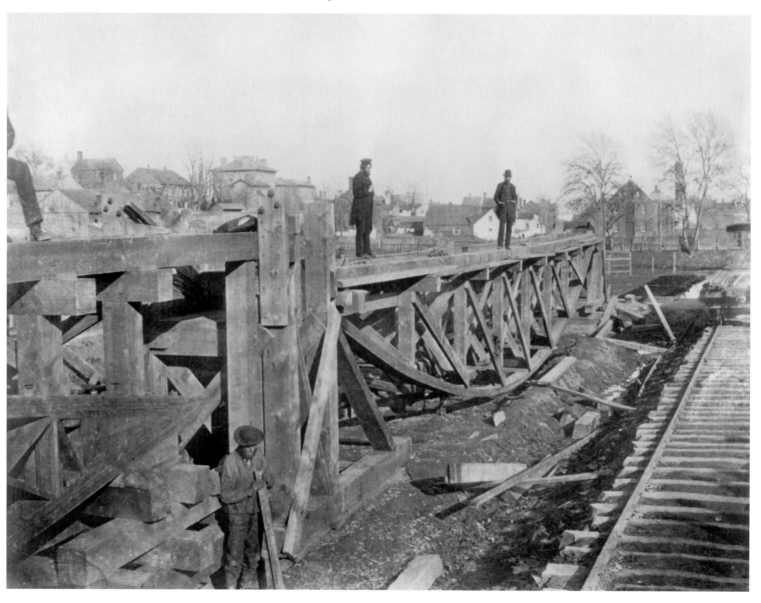

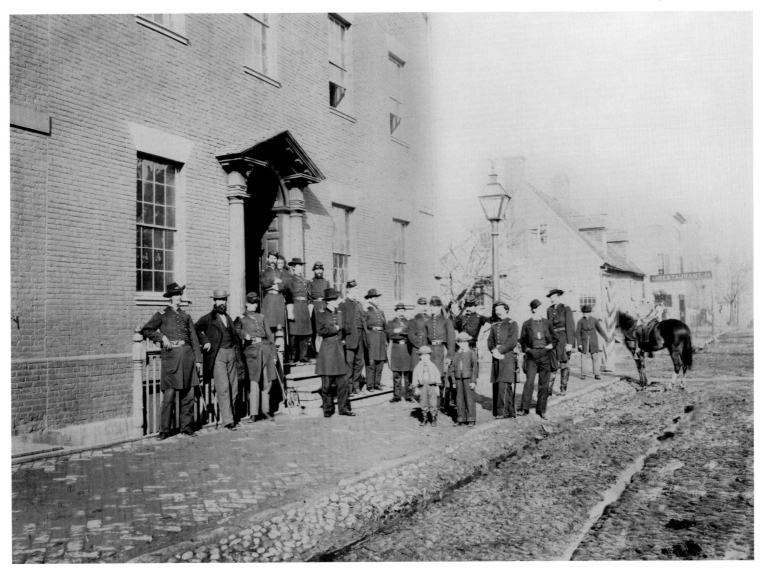

St. Paul's Episcopal Church, located at 228 S. Pitt Street, was used as a Federal hospital during the Civil War. The rectory was used as a commissary. (ca. 1862)

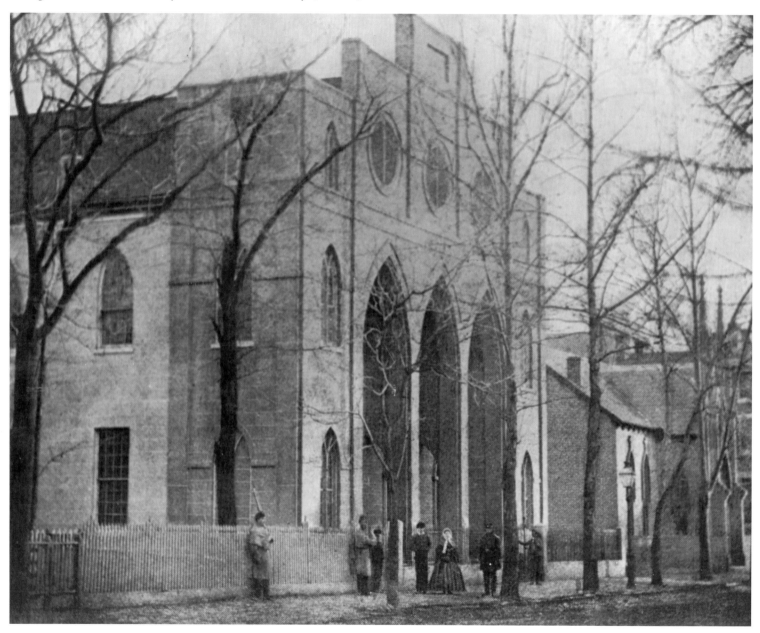

The 44th New York Infantry encampment at the top of Shuter's Hill. This location gave occupying troops an unobstructed view of the Potomac River. (ca. 1862)

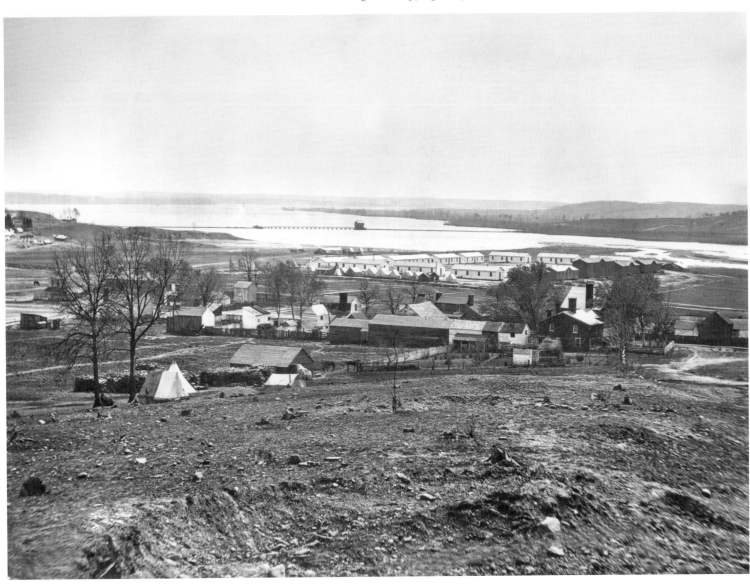

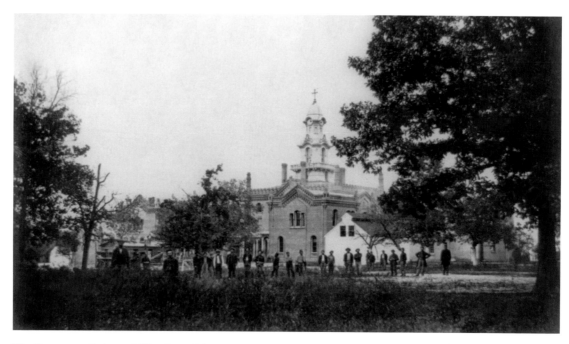

The Protestant Episcopal Theological Seminary. Aspinwall Hall's pagoda-style steeple was and still is a familiar landmark. The hall was used as a Union hospital, and other buildings on the grounds were used for housing. (ca. 1862)

Soldiers and civilians mill around Aspinwall Hall on the grounds of the Protestant Episcopal Theological Seminary. (ca. 1862)

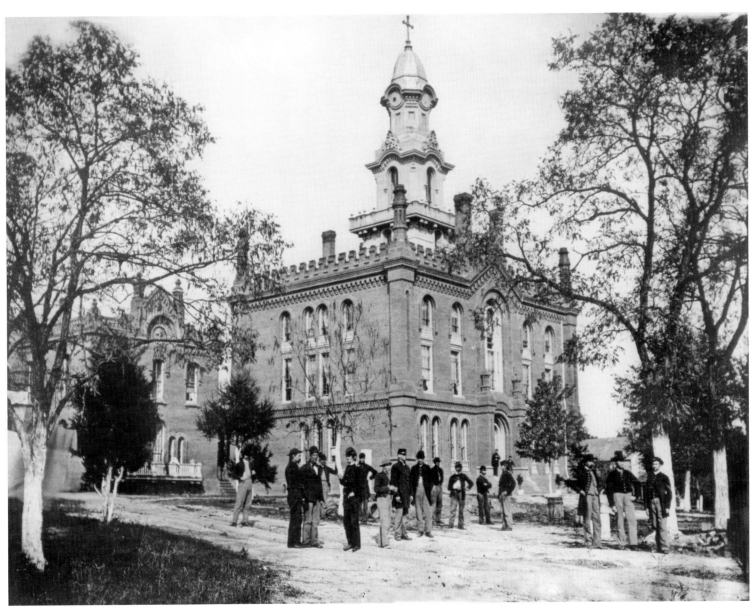

The Tide Lock of the Alexandria Canal during the Civil War. The lock was located between Montgomery and First streets. (ca. 1862)

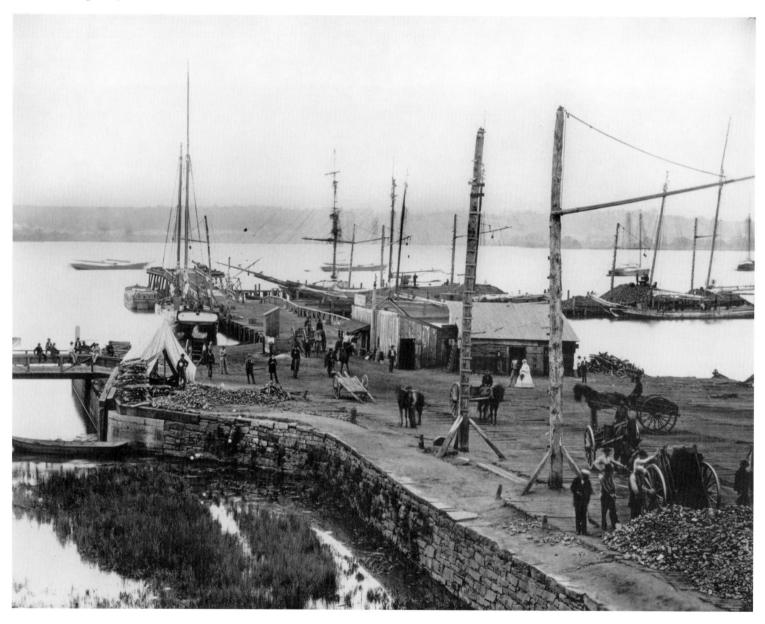

The headquarters of Captain J. G. C. Lee, army quartermaster, were located at the northeast corner of Princess and N. Fairfax streets. (ca. 1862)

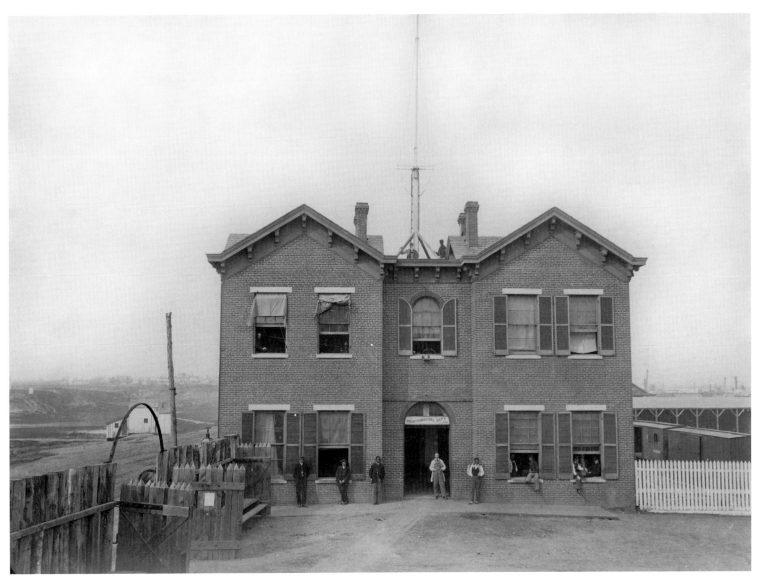

Christ Episcopal Church was attended by George Washington. His pew is still present inside the church. When Union soldiers and sympathizers started holding services here on Sundays during the occupation of Alexandria, most members of the congregation moved to other churches until the occupation ended. (ca. 1862)

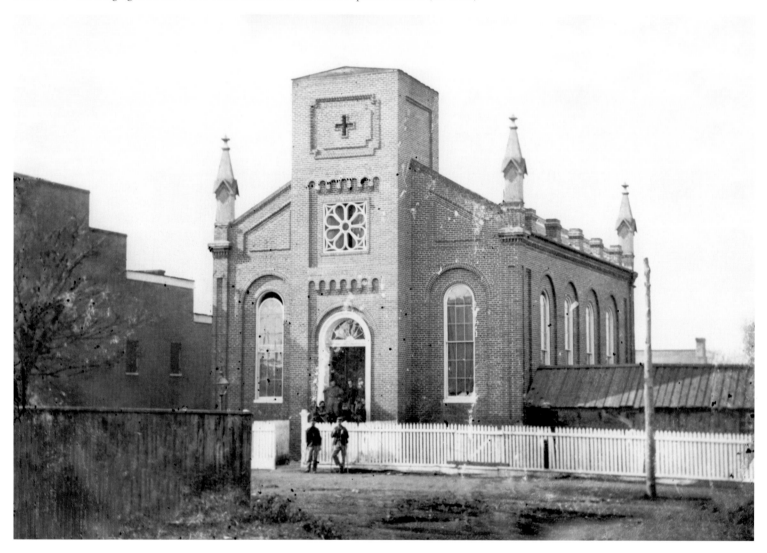

Built in 1812 to house the Mechanics Bank, this building in the 500 block of King Street became the office of the provost marshal for the Union Army. (ca. 1862)

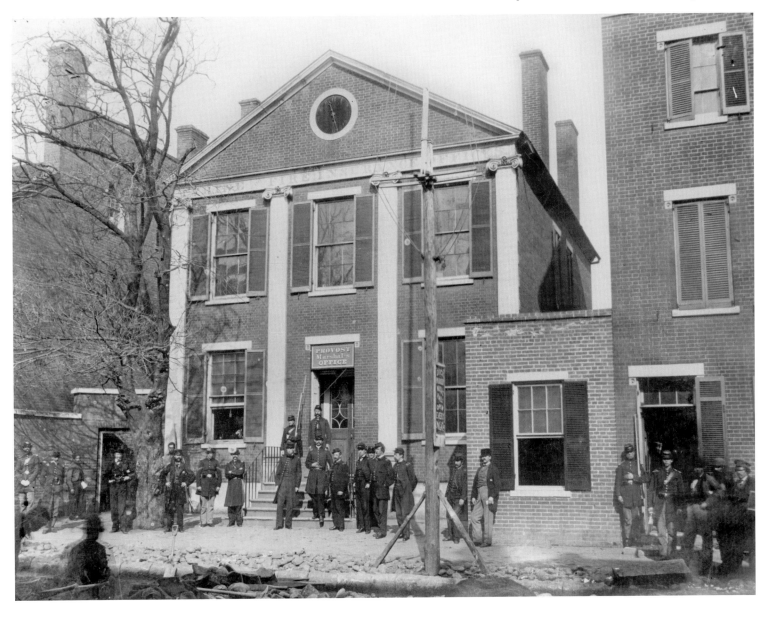

Samuel Heflebower, proprietor of the City Hotel, took the Oath of Allegiance (to the federal government) to stay in business during the Civil War. Citizens, Federal troops, and travelers took advantage of his being open, utilizing the bar in the back that kept Heflebower in business during this time. (ca. 1862)

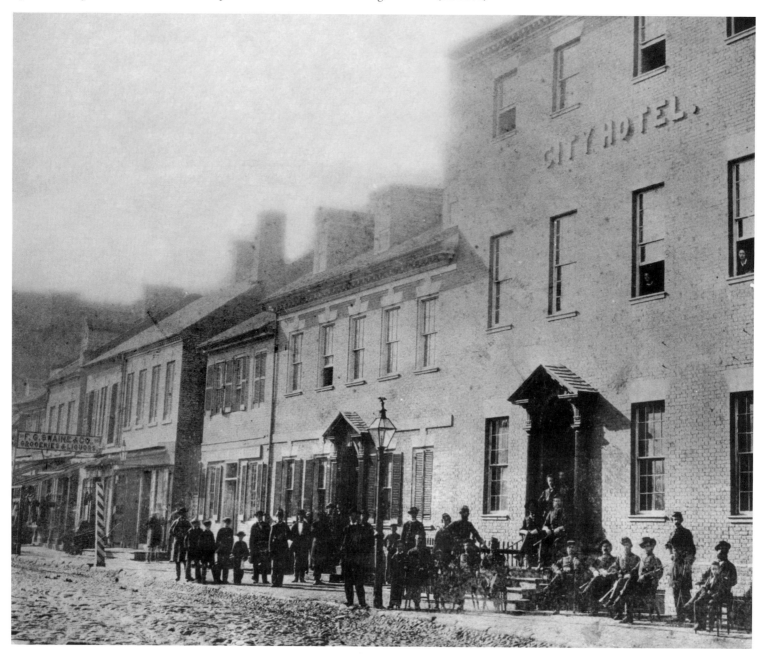

Union officers and soldiers lounge outside Aspinwall Hall on the grounds of the Protestant Episcopal Theological Seminary. One soldier appears to be standing guard. (ca. 1863)

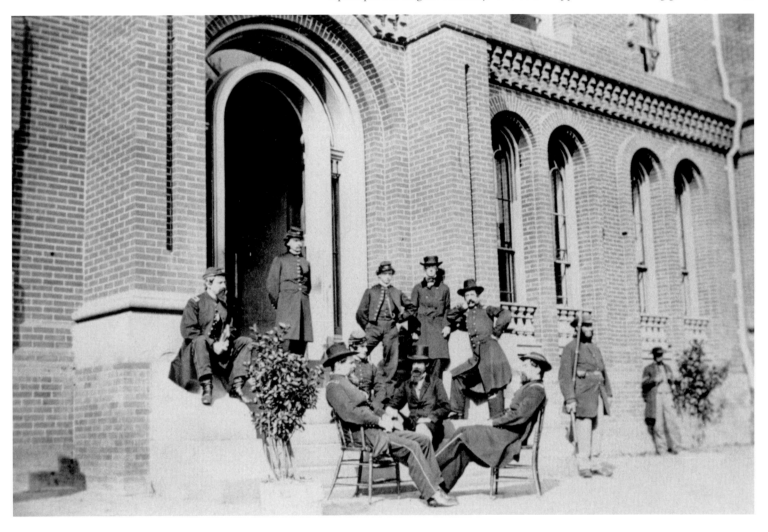

Boxcars sit on side tracks before the large United States Military Railroad engine house. Up to 60 engines could be stored in the huge building. (ca. 1863)

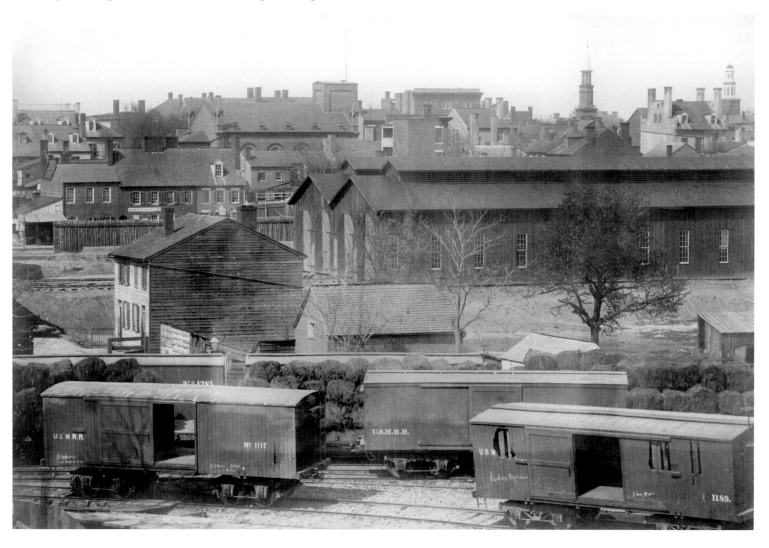

The United States Steam Fire House was established and run by the U.S. Army quartermaster. The fire station was located on the south side of Princess Street between Lee and Fairfax streets. (July 1863)

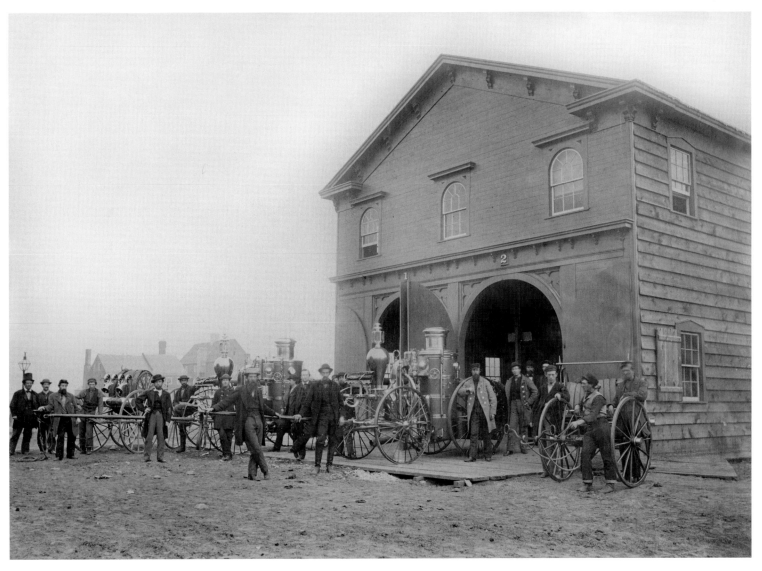

Military staff and visiting relief agents stand in front of the U.S. Sanitary Commission lodge. The commission was responsible for overseeing the care of the wounded and ill. (ca. 1863)

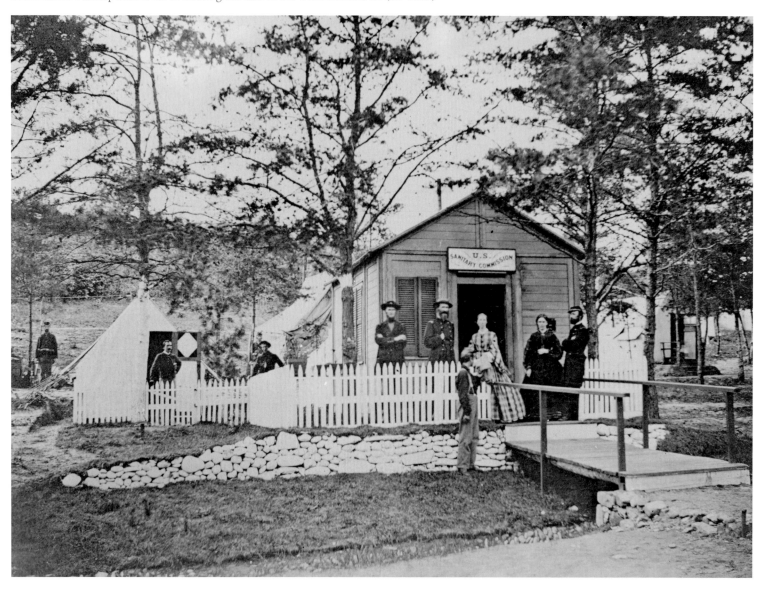

This home, located near Ft. Lyon, was used as headquarters for General Samuel P. Heintzelman. (ca. 1863)

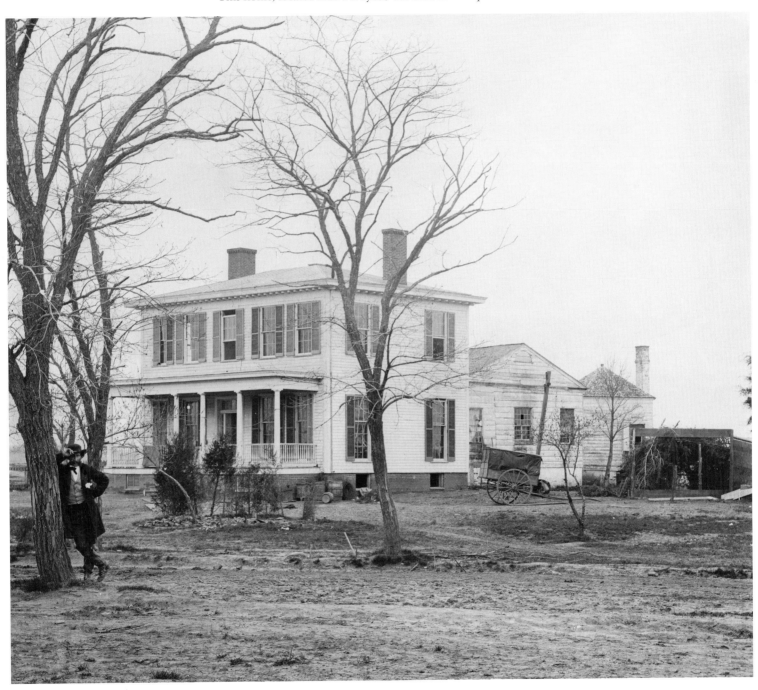

This three-story brick residence, located at 209 S. St. Asaph Street, was used by General John P. Slough, military governor of Alexandria, as his residence and headquarters. Beyond is the post office and the veterans' reserve headquarters. (ca. 1863)

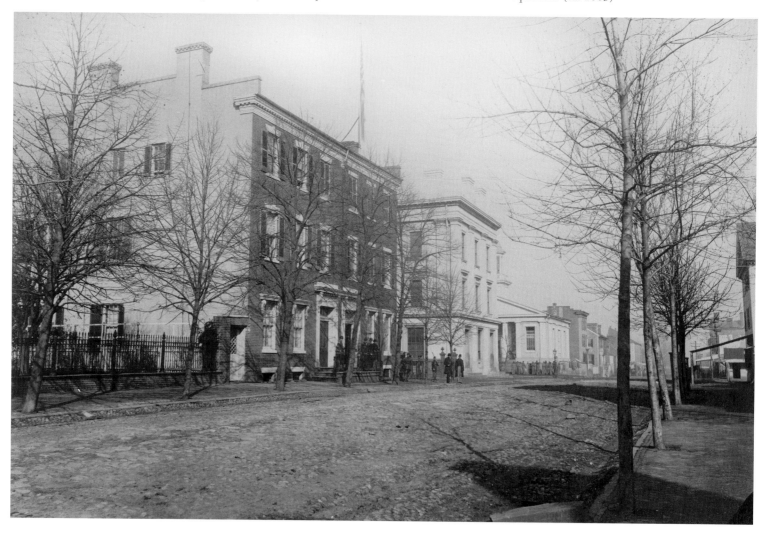

A deck view of the Russian frigate *Osliaba*, anchored in Alexandria Harbor. (ca. 1863)

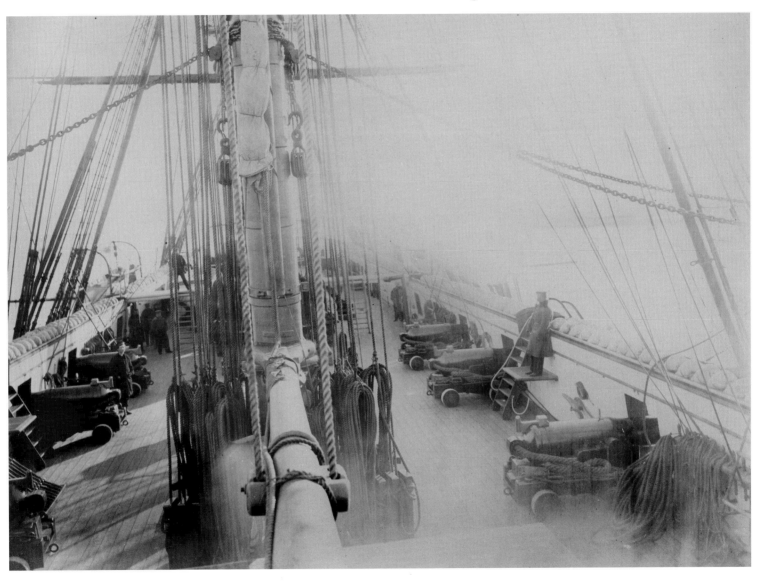

Sailors on board the Russian frigate *Osliaba* while making a port call at Alexandria. (ca. 1863)

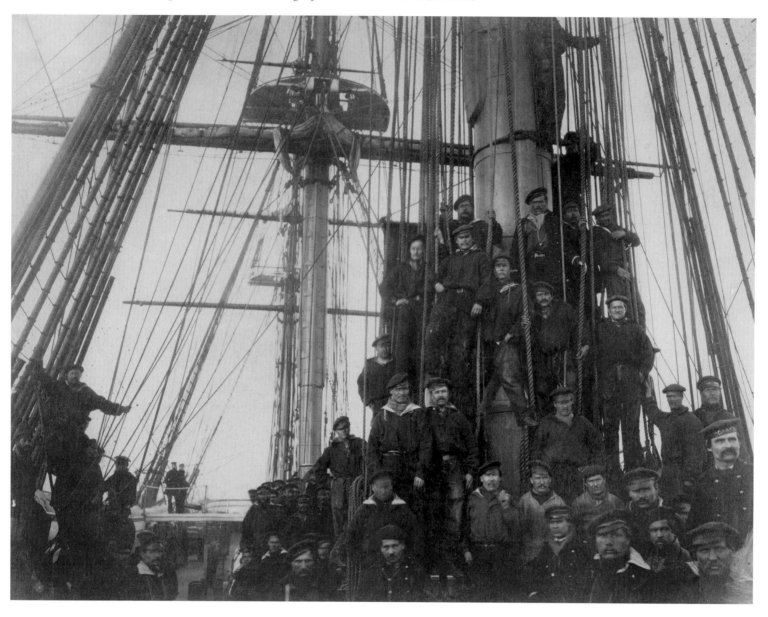

Battery Rodgers, located on the western shore of the Potomac River between Fairfax, Green, and Jefferson streets near Jones' Point. Erected in 1863, it provided protection from river attacks. The doors led to magazines where ammunition was stored. (ca. 1863)

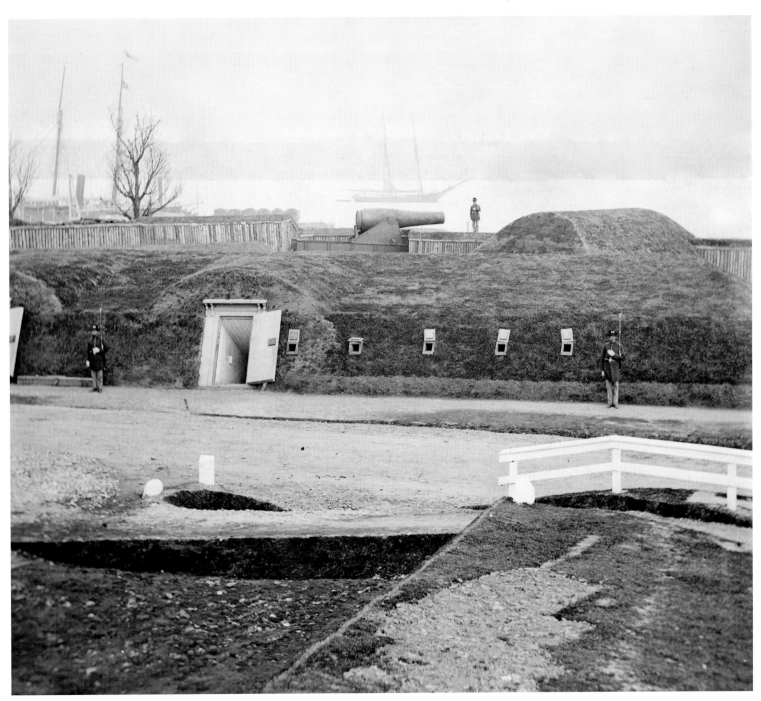

Battery Rodgers was originally named Battery Water. The name was changed to Rodgers in 1863 to honor Captain George W. Rodgers, U.S. Navy. (April 15, 1864)

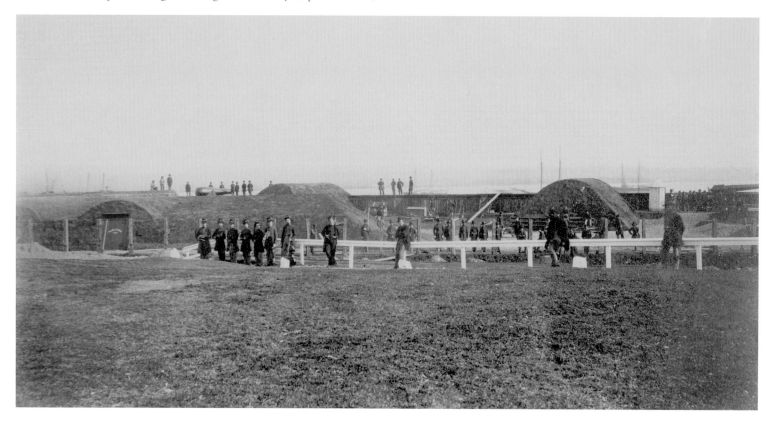

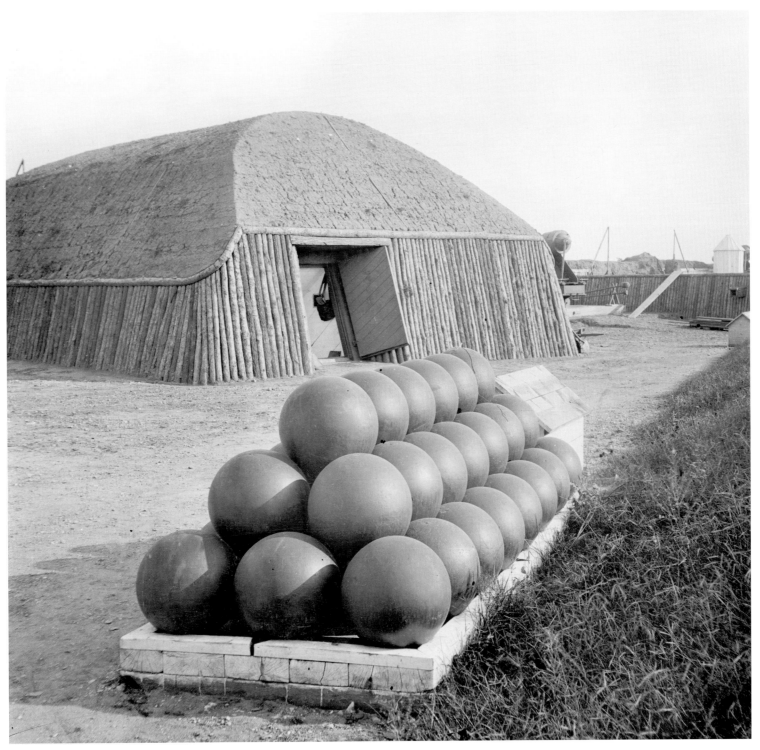

Magazines at Battery Rodgers for a 200-pound Parrot (rifled) gun. (1863)

Young boys play atop the fence surrounding Grace Episcopal Church and adjacent cemetery. The church was the only one in Alexandria not used as a hospital, instead holding services for Federal troops. (ca. 1863)

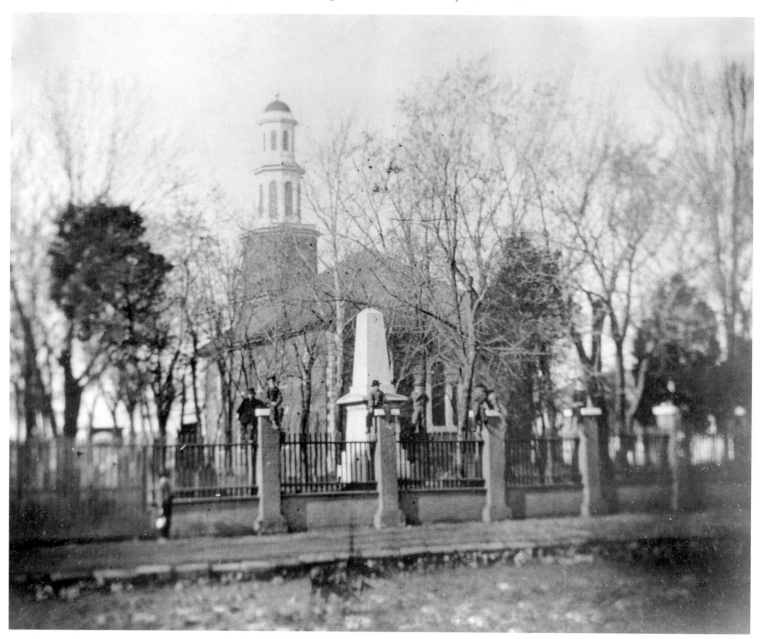

General Samuel P. Heintzelman with a group of family and friends at
Convalescent Camp. (ca. 1863)

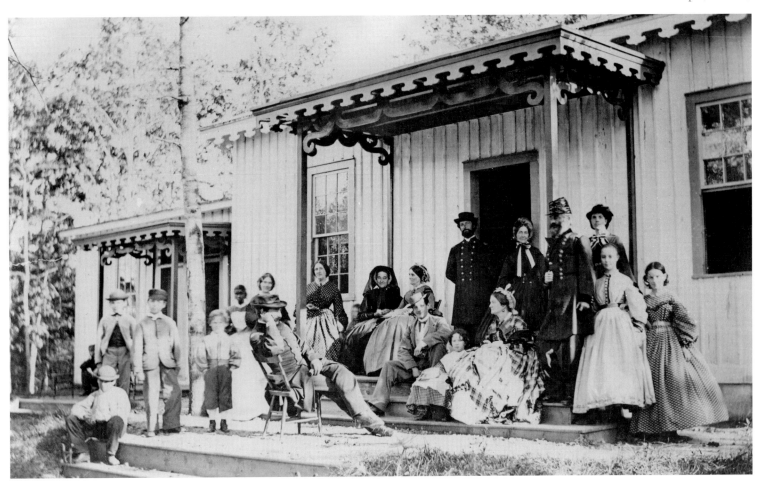

The remains of a train disabled by Confederate forces are readied for transport back to Alexandria. (ca. 1863)

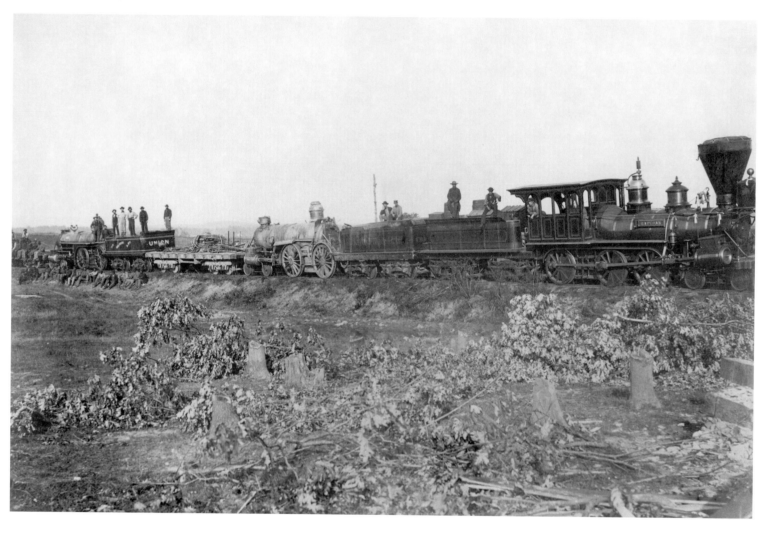

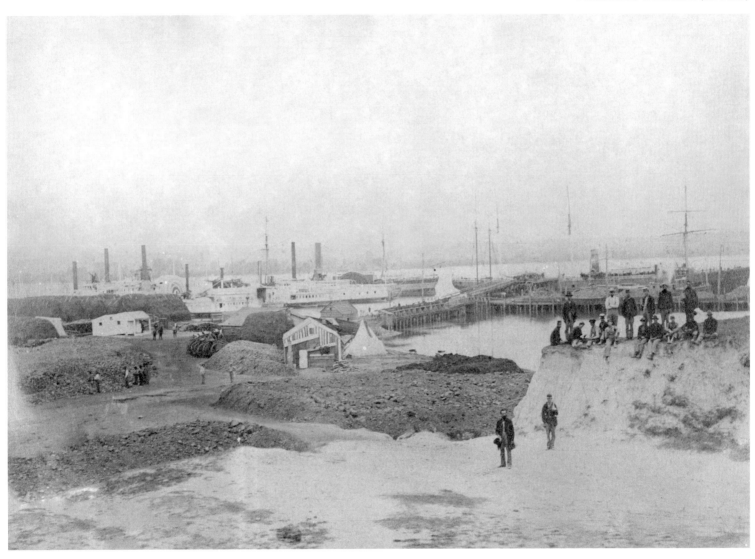

Camp Convalescent was located on the slope of Shuter's Hill. In this view, ambulances and buggy wait in front of the camp's entrance. Conditions inside were described as "squalid and horrible," earning the camp the nickname "Camp Misery." (ca. 1863)

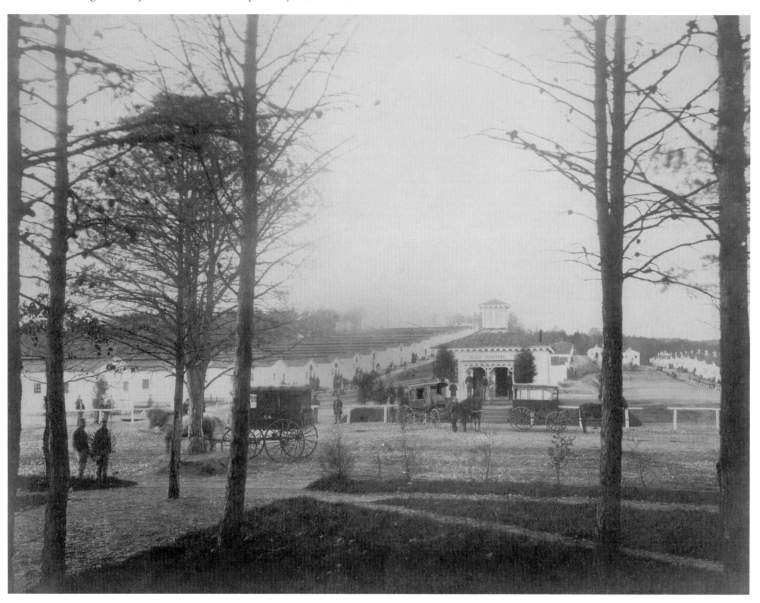

The hospital barracks of Camp Convalescent where the wounded and ill were treated. (ca. 1863)

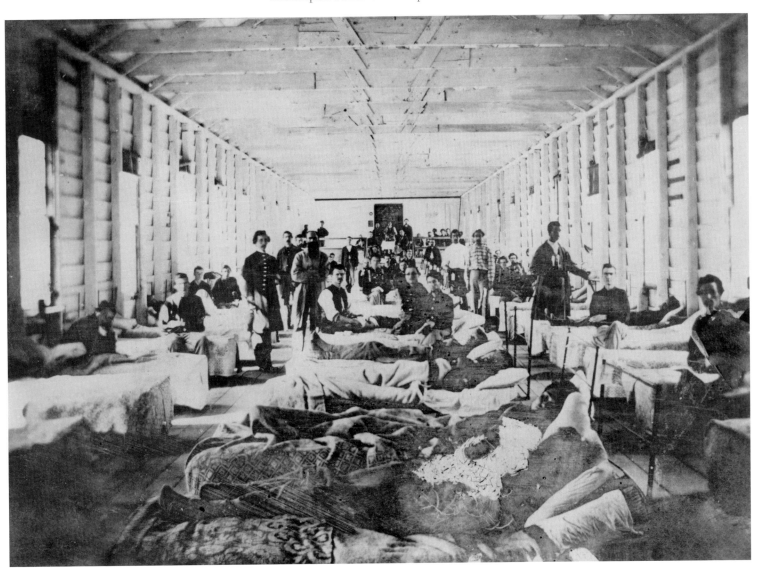

On the Alexandria waterfront, men assemble arks (flatboats). Here they apply pitch to canvas, which was laid on the bottom of the boat to make it watertight. These boats were made inexpensively to be used for transporting supplies. (ca. 1863)

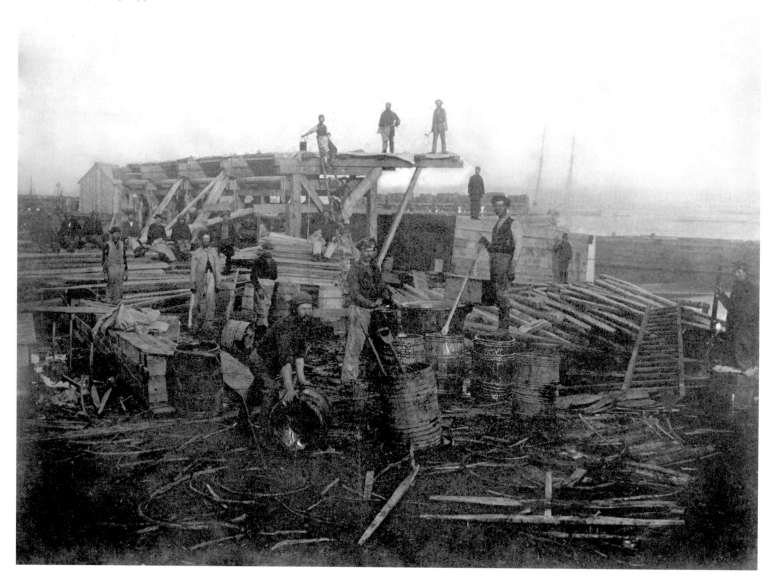

The hub of the United States Military Railroad. Administration offices, the yards, and the roundhouse of what had been the Orange and Alexandria Railroad prior to the Civil War. (ca. 1864)

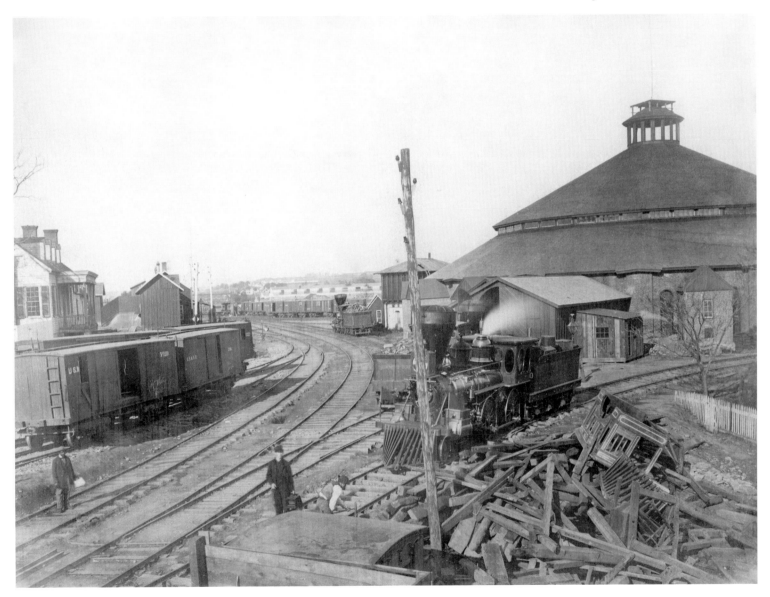

A view of Alexandria from Ft. Ellsworth. The Military Railroad and roundhouse are visible. (April 1864)

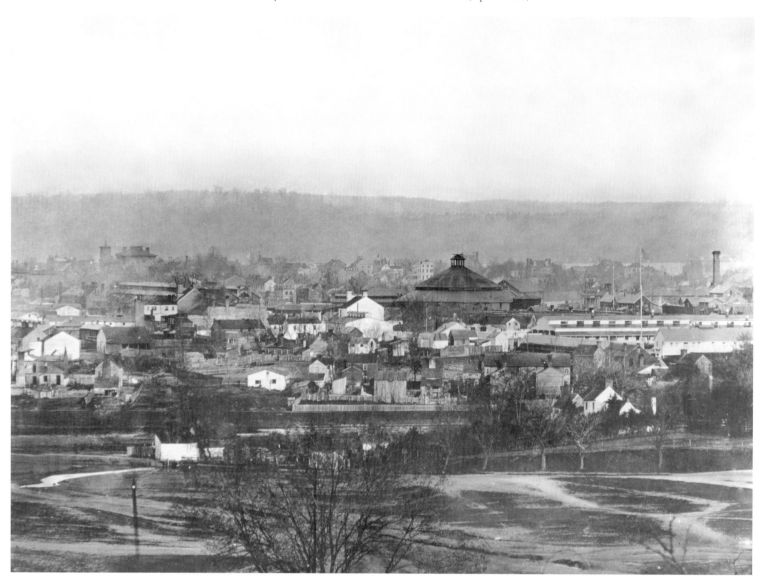

This two-story, towered brick home at 508 Wolfe Street was used as a Union hospital from January 1862 through February 1865. The house is no longer standing.

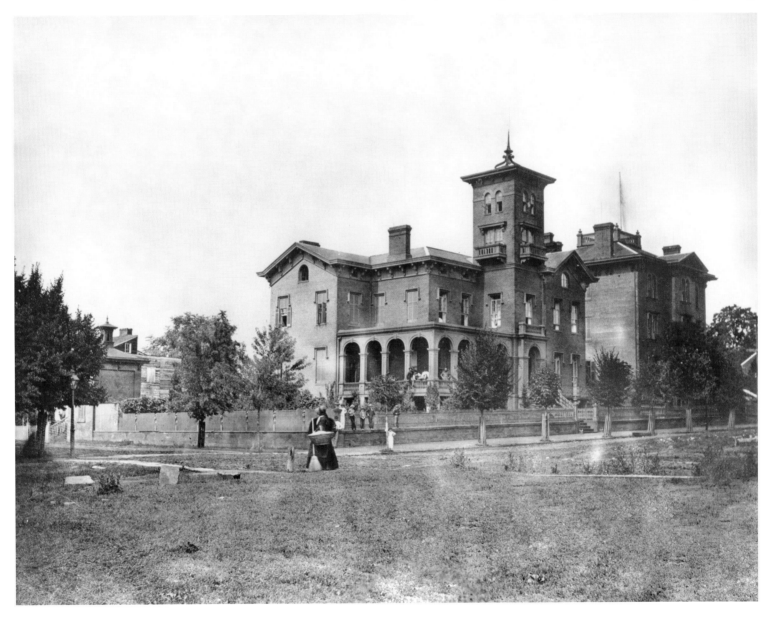

Soldiers and others wait outside the Sanitary Commission Lodge for Invalid Soldiers in July 1864. These temporary shelters provided care prior to sending the wounded and ill to hospitals.

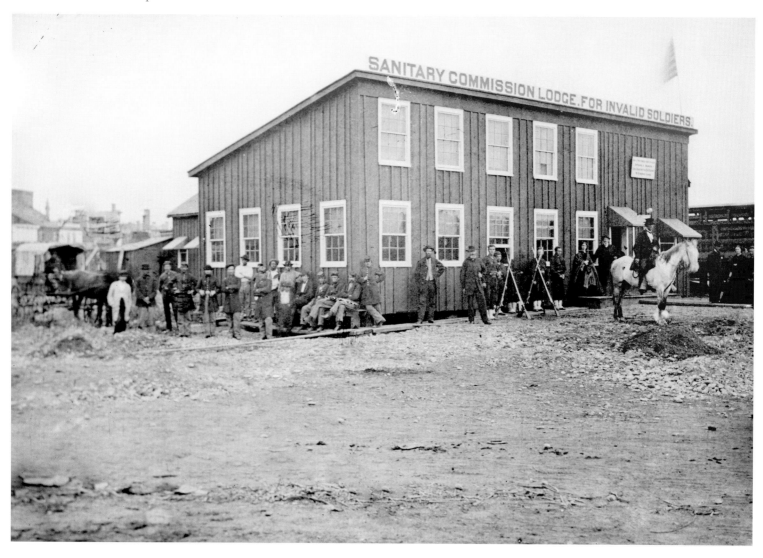

This 15-inch Rodman gun was located at Battery Rodgers. Made of cast iron, the gun fired a 440-pound shot. (May 18, 1864)

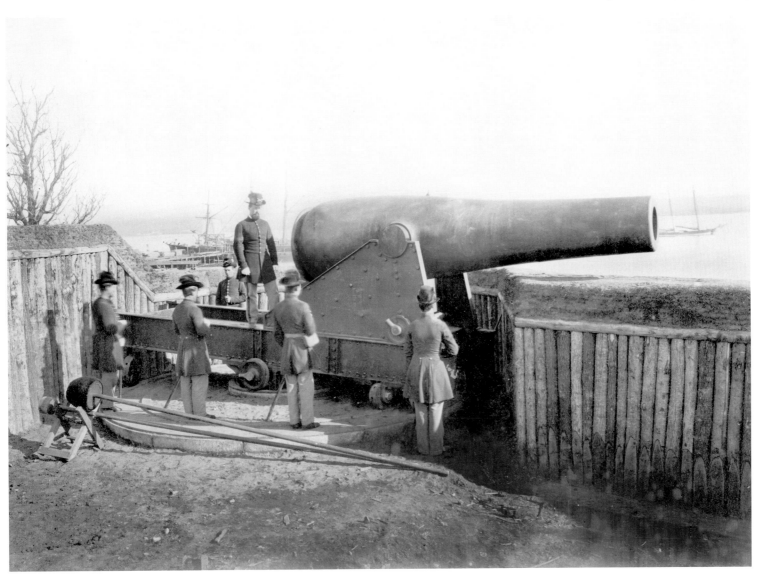

Market House on Royal Street, facing south. (ca. 1865)

President Lincoln's railcar was built in government shops in Alexandria for his travel use. Before he was able to use the car, he was assassinated. The car was refitted to become the funeral car that took his body from Washington to Springfield, Illinois. (1865)

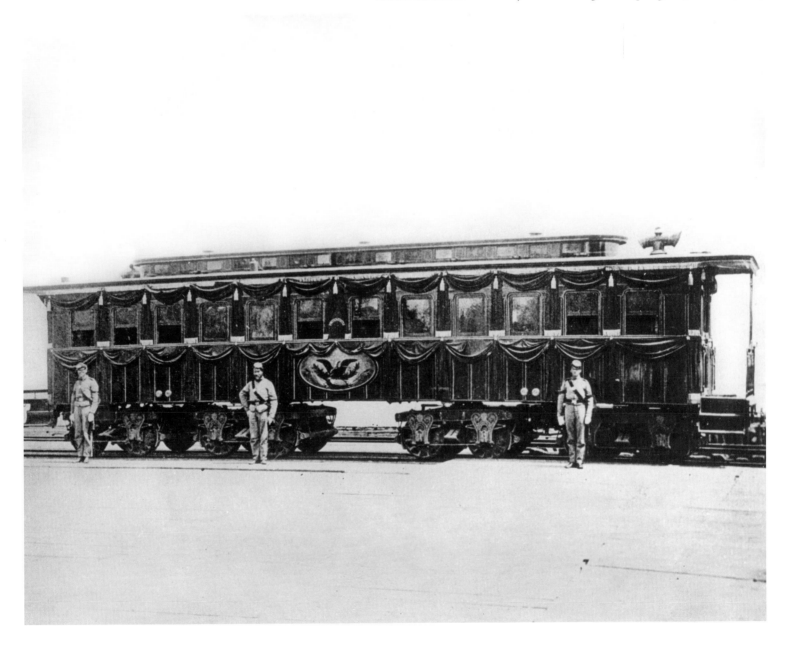

A view from the six-story Pioneer Mill located on the south end of the waterfront. Ships of all sizes and shapes docked at Alexandria. (May 1865)

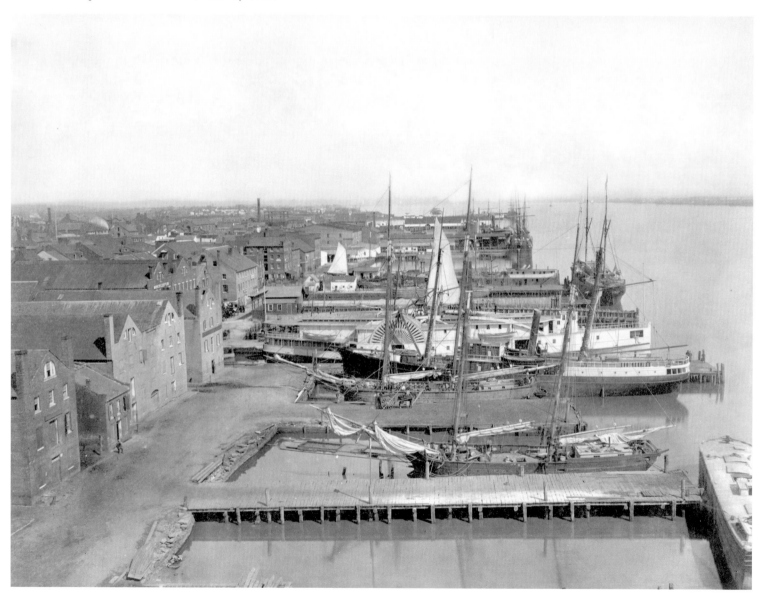

Wooden markers designate the individual graves of Federal soldiers, both black and white, who are buried in the Alexandria National Cemetery. The wooden markers were later replaced with stone markers. There are nearly 3,600 interments. (ca. 1865)

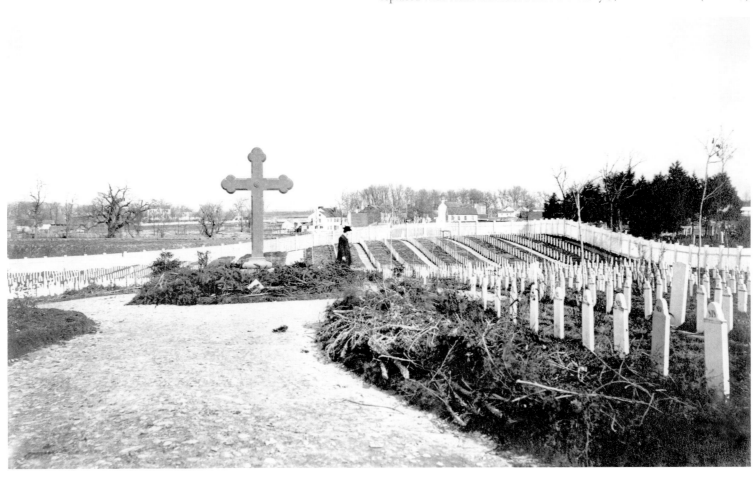

Cooks prepare food for convalescing soldiers in the kitchen at Soldier's Rest. (July 1865)

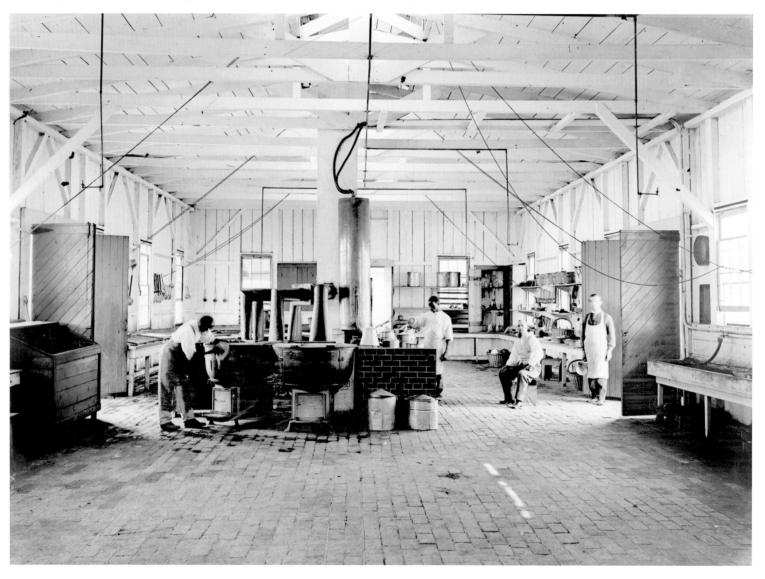

The hardware business of J. T. Creighton & Sons was located at the corner of King and N. Royal streets. Creighton most likely took the Oath of Allegiance, because he remained in business throughout the Civil War. (ca. 1865)

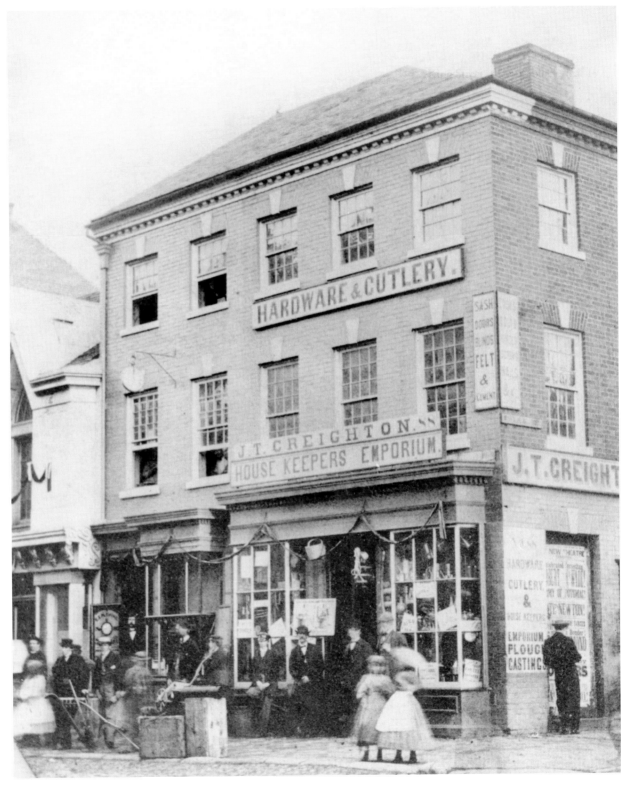

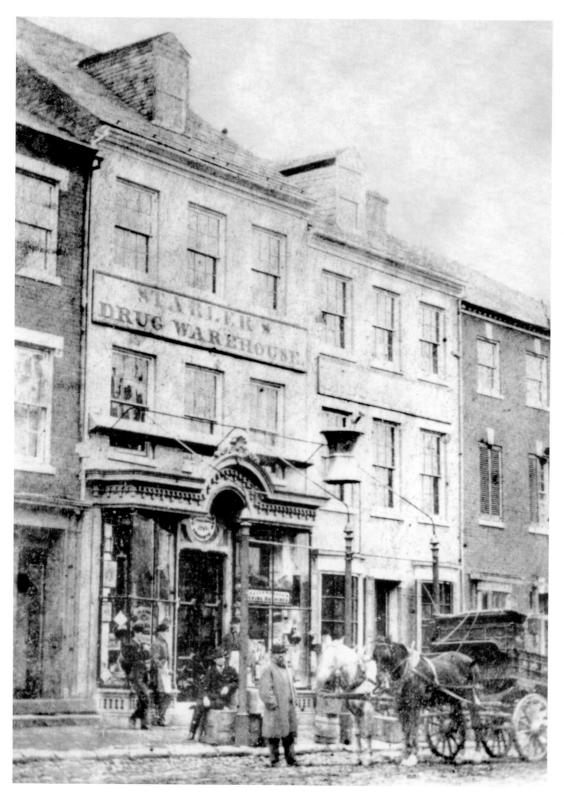

The Stabler-Leadbeater Drug and Apothecary shop at 107 S. Fairfax Street, early on known as Stabler's Drug Warehouse. In business beginning in 1796, Edward Stabler advertised himself and his business as an "Apothecary and Druggist." The business operated for 137 years, closing in 1933 during the Great Depression. (ca. 1870)

A snowy King Street and the north side of the 400 and 500 blocks, facing west. (ca. 1870)

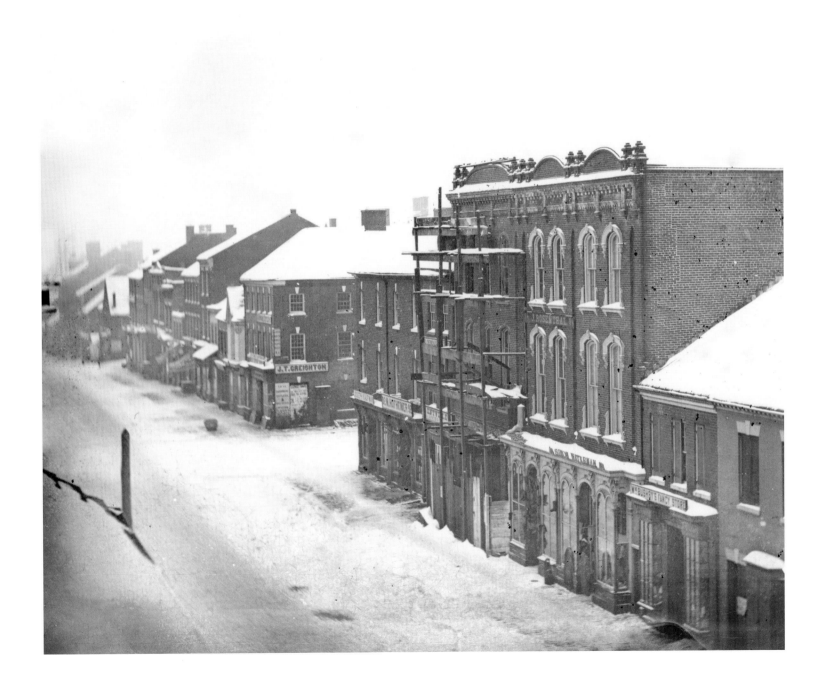

A cobblestoned Cameron Street. Eastward is Christ Episcopal Church. The three-story brick home on the right at 607 Cameron was built in 1799 and is known as the Fairfax House. It was home to Lord Fairfax in 1830. (ca. 1880)

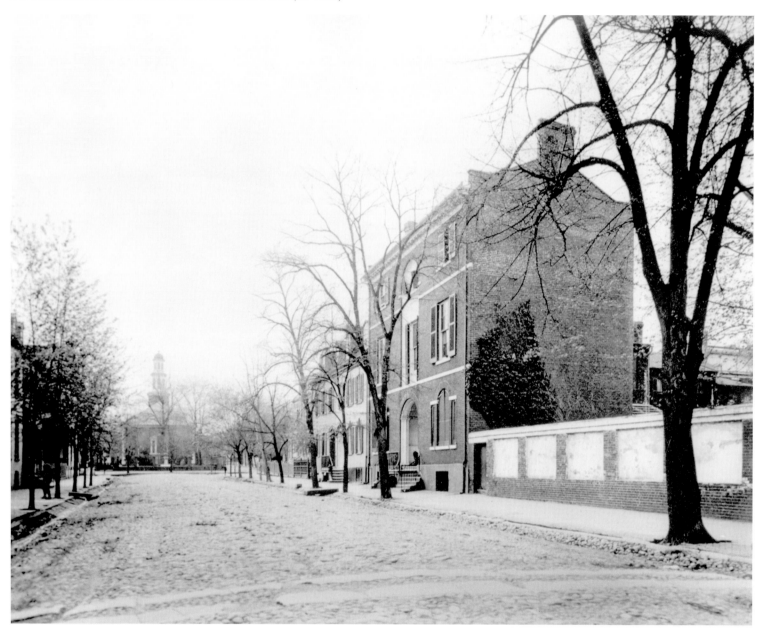

Public wells and pumps, for fresh water, were once found on street corners throughout Alexandria. Children considered it a treat to fetch water in the summer—the pump was a hub for socializing. (ca. 1880)

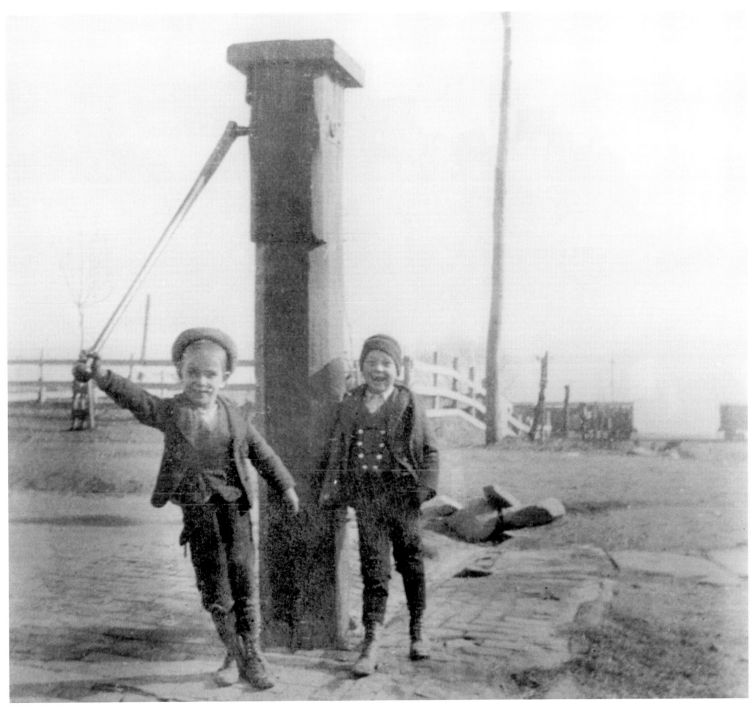

The Prince Street Wharf off the Strand. (1883)

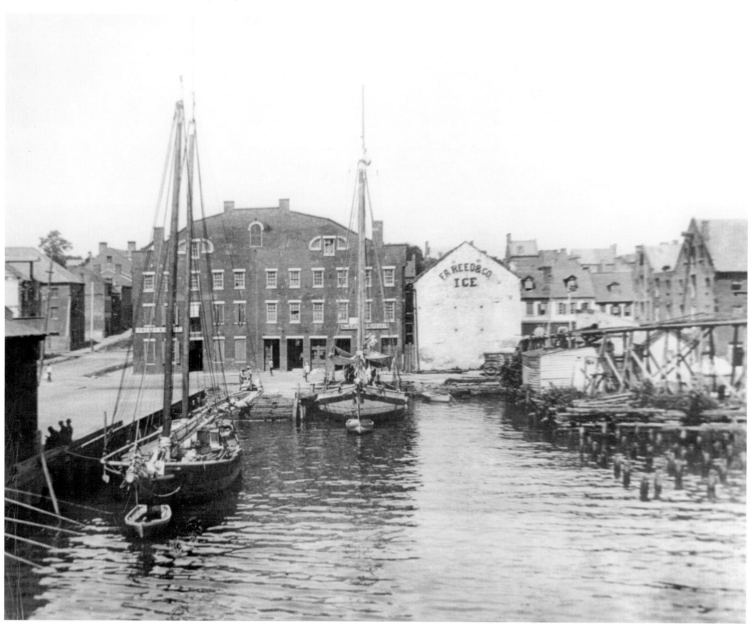

J. T. Creighton and Son Hardware, at 328 King Street, was one of Alexandria's longest-running businesses. Among the items advertised on this storefront are "Shovels, Plow Castings, Spades, Forks & Rakes."

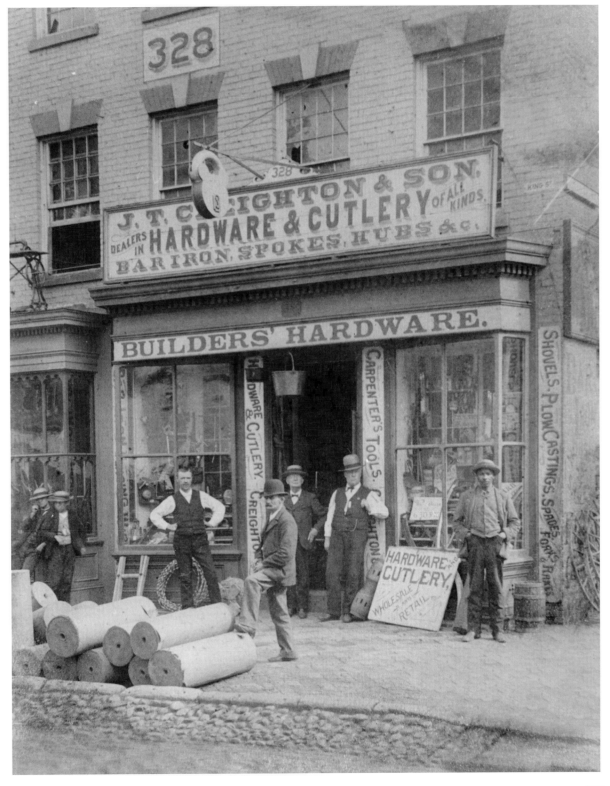

The old steam engine pumper inside
Columbia Fire House Company No. 4.
(ca. 1885)

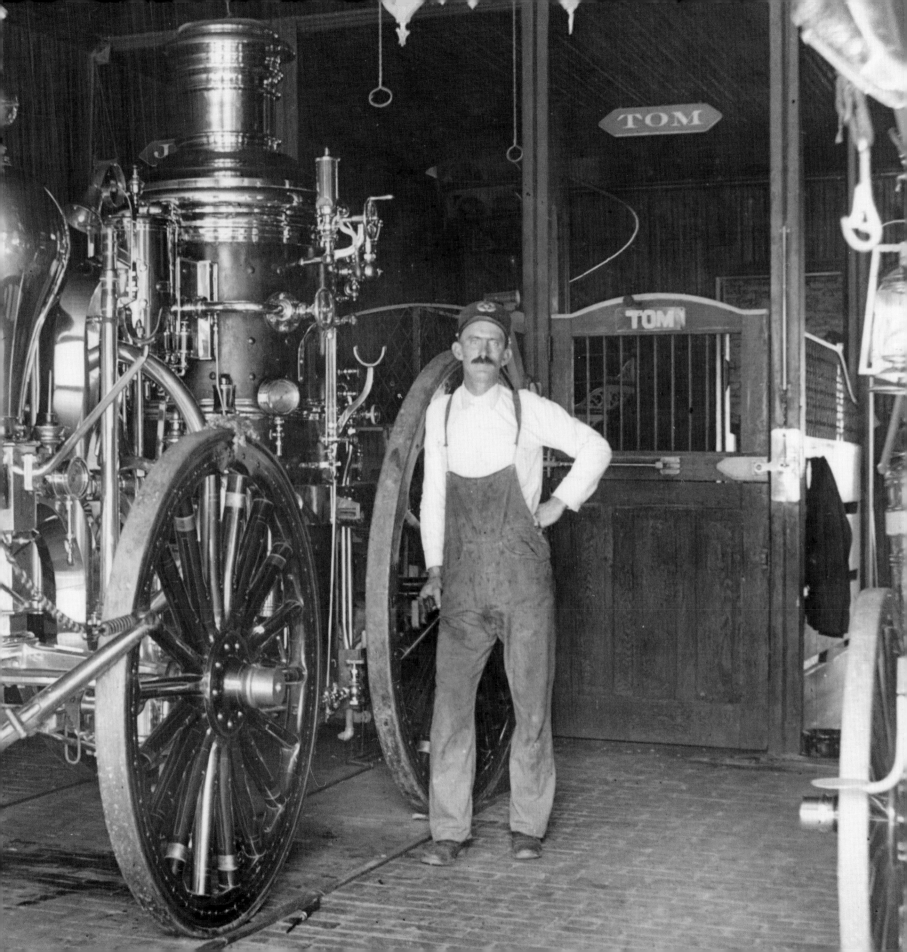

At the corner of King and Peyton streets stood the Old Virginia House, in business since 1823.
The hotel offered "large" bedrooms, dining rooms, a bar, and a parlor for travelers, and cost about
a dollar a day. Damaged by fire and a tornado, it was razed around 1930. (ca. 1888)

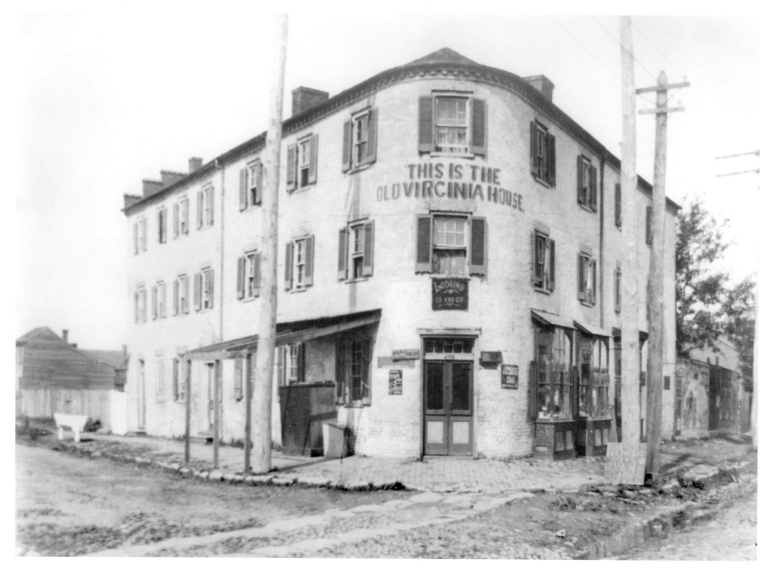

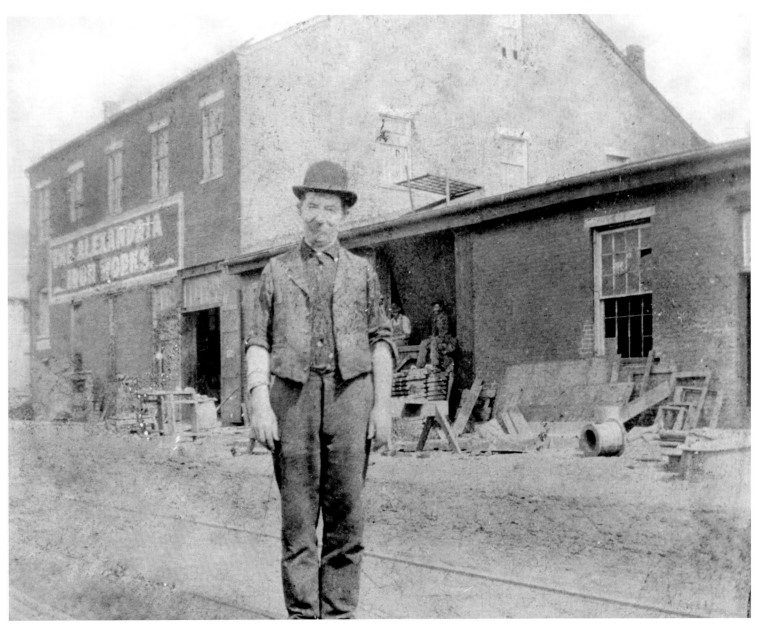

The Alexandria Iron Works at S. Royal and Wilkes Street. (ca. 1890)

King Street, facing east from the 700 block. (ca. 1890s)

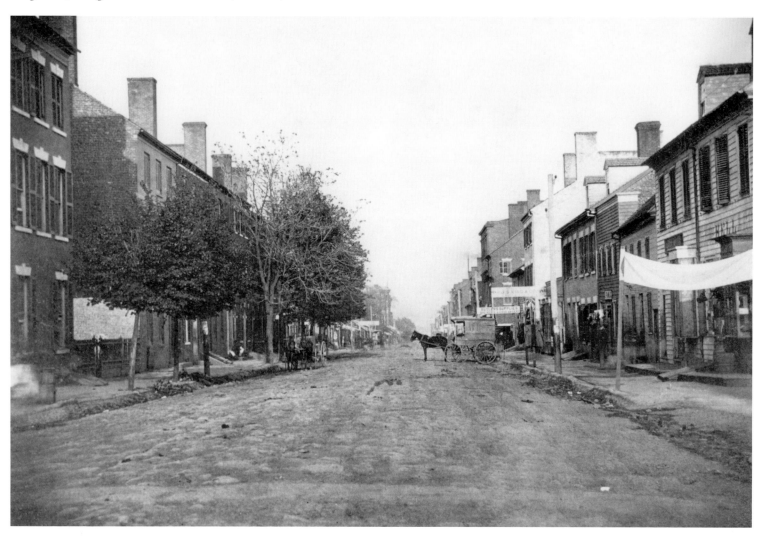

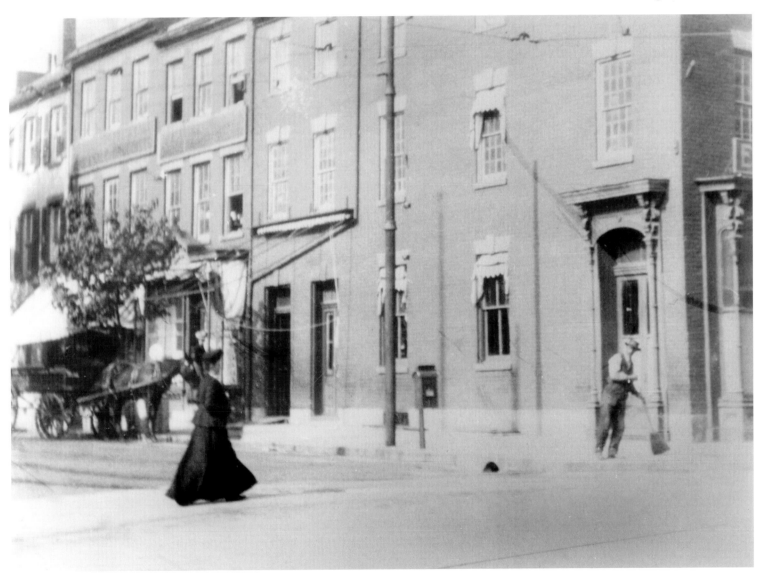

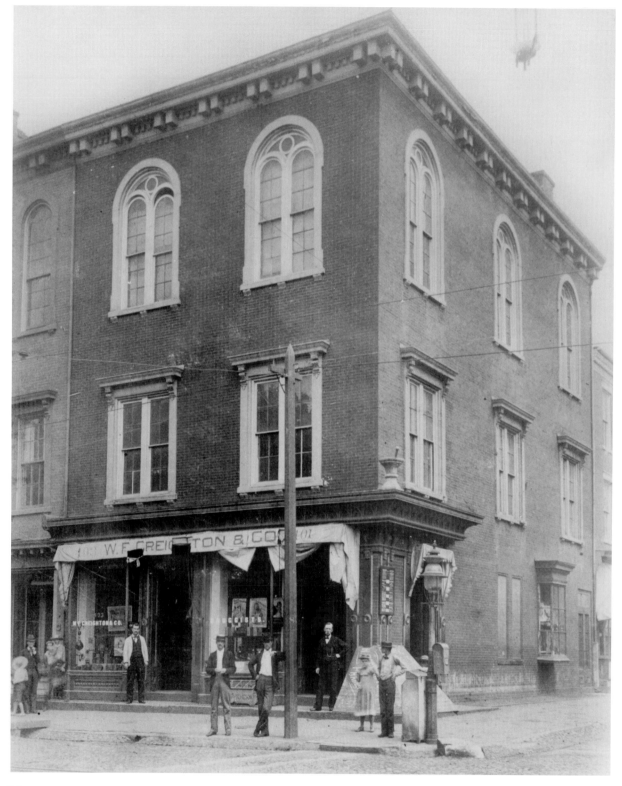

W. F. Creighton's, at
King and N. Royal
streets. (ca. 1895)

The Potomac Shoe Company was owned by Frederick Paff. The name was later changed to the Paff Shoe Company. (ca. 1885)

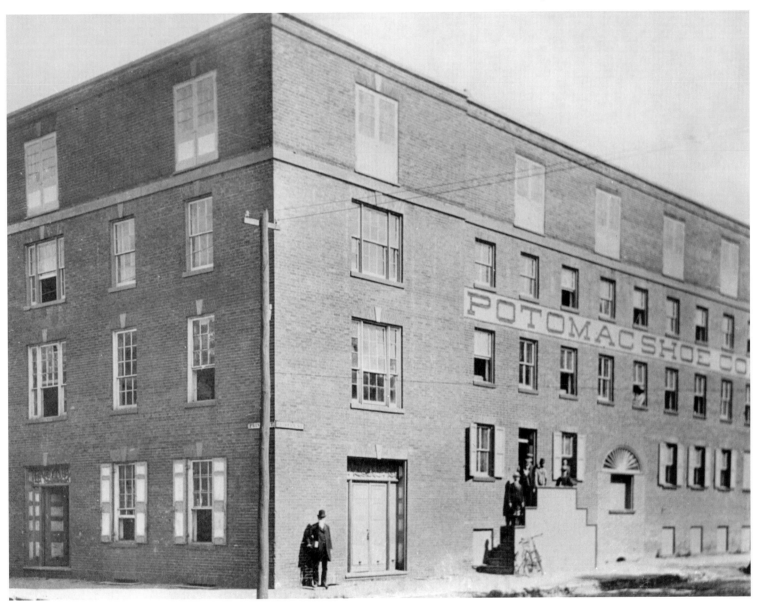

Children play along Duke Street, in front of the former Slave Pen. (ca. 1895)

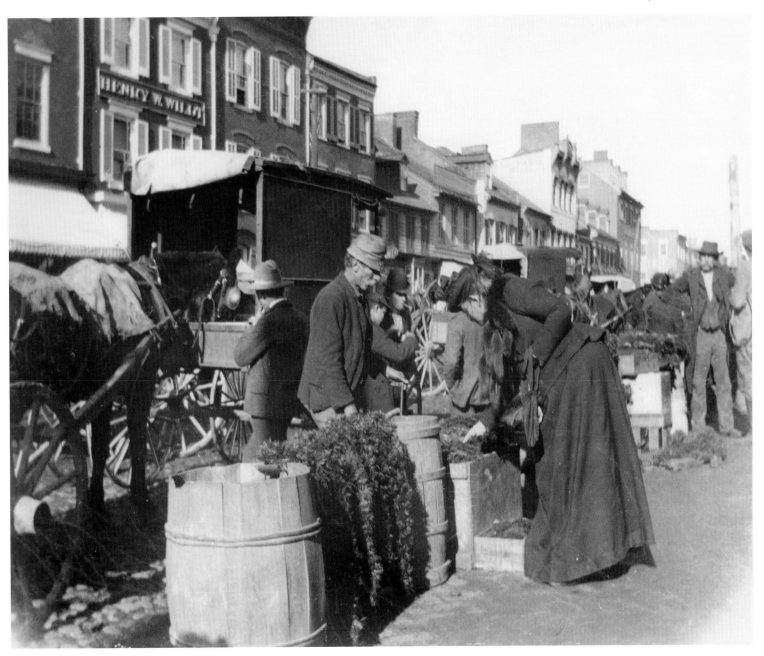

A street market in the 100 block of N. Royal Street. (ca. 1895)

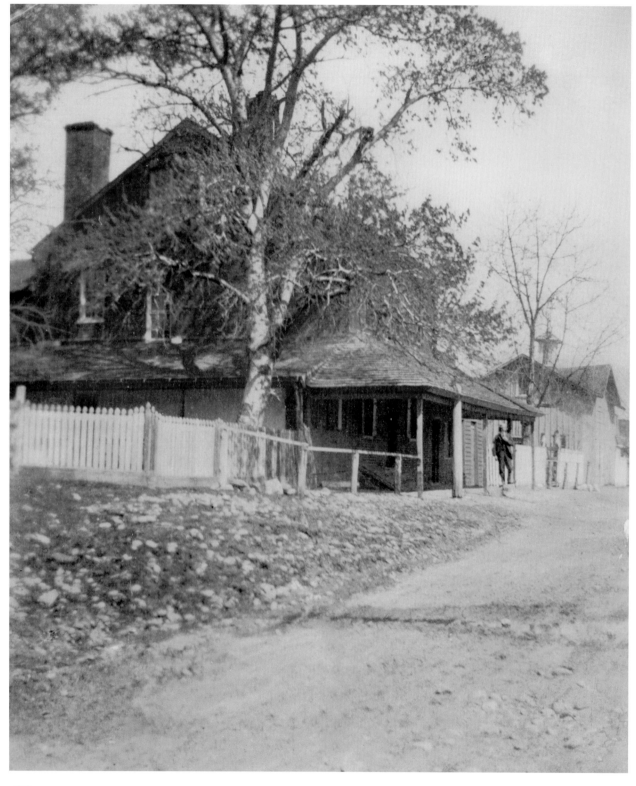

Established in 1815, Catt's Tavern was located at Diagonal Road and Duke Street and attracted a clientele of drovers and others. Cattle and slaves were sold here. Local elections and political meetings for the eastern part of Fairfax County brought patrons from both Alexandria and Fairfax County. (ca. 1890)

At the passenger depot in the 200 block of N. Fayette Street, the Toonerville Trolley (so-called by the locals) waits for passengers to board, amid piles of snow. The trolley ran between Alexandria and Washington, D.C. (ca. 1897)

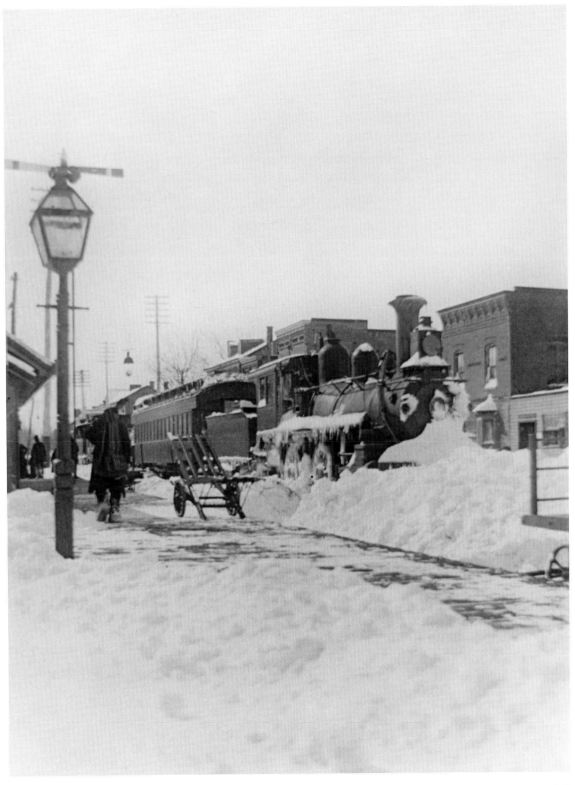

Sesquicentennial festivities along King Street. (1899)

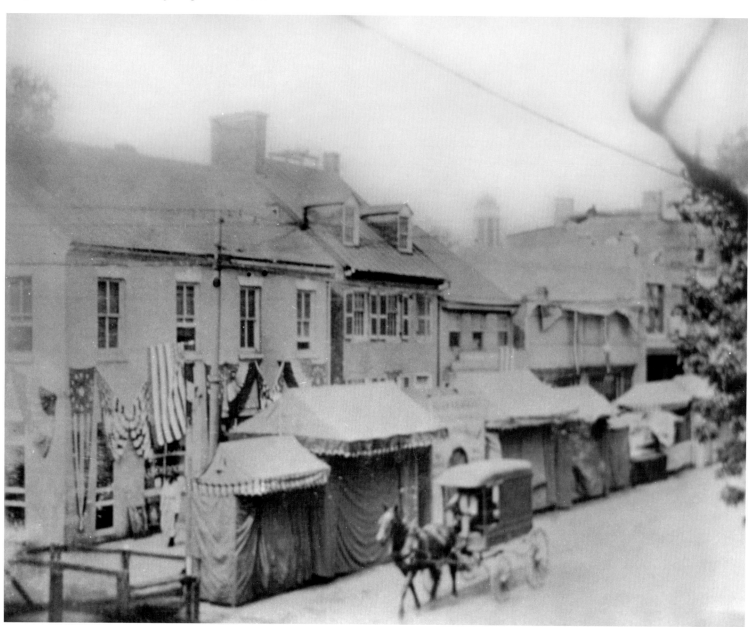

Alexandrians loved parades. Flags and bunting adorned buildings, and marching groups of every description participated in the parades of the nineteenth and early twentieth centuries. The sesquicentennial celebration shown in this 1899 image was no exception.

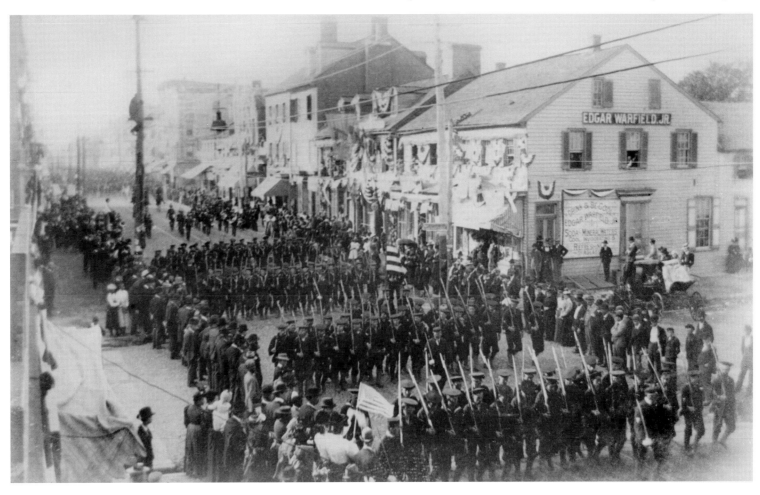

Banners and bunting festoon the drugstore owned by Edgar Warfield
during the sesquicentennial parade in 1899.

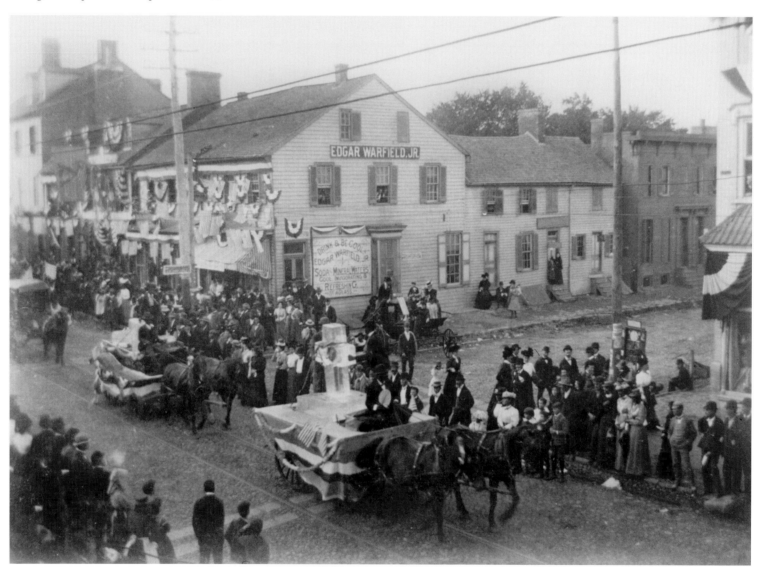

Dressed in the latest fashion, a group of young women and two gentlemen pose playfully for the camera. (ca. 1899)

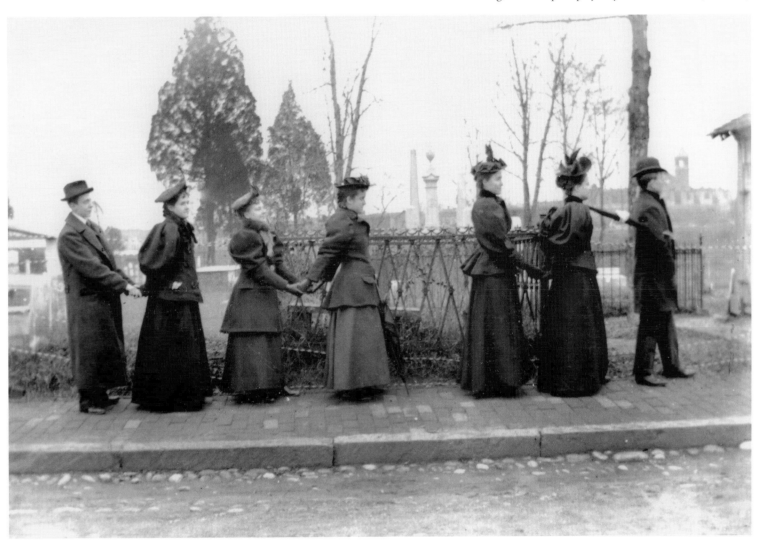

The musical group Sharps & Flats is shown here after a presentation of *H.M.S. Pinafore.* Organized in the mid 1880s, the group presented light opera and plays until disbanding in 1923. (ca. 1897)

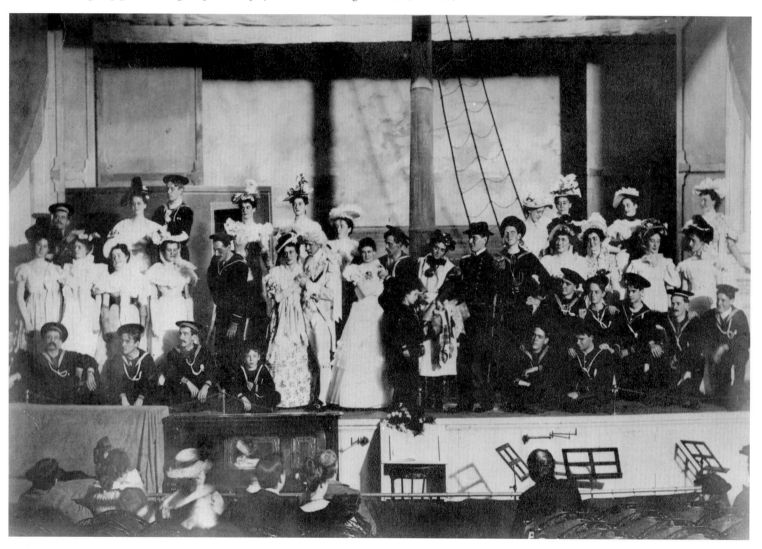

A New Century and a World War

(1900–1919)

Alexandria was slow to recover from the Civil War. By the early 1900s, the city had only a modest industrial sector. During the early part of the century, new residential areas expanded outside the main commercial district. The neighborhoods of Rosemont, Braddock Heights, Del Ray, and St. Elmo's were established (though the latter two did not officially become part of Alexandria until 1929, when portions of Arlington were annexed). The residents of these new "bedroom" communities commuted to their jobs and activities on the Washington, Alexandria, and Mt. Vernon Rail Company's electric trolley, which ran the length of Commonwealth Avenue until the 1930s. Alexandrians were also able to catch ferry steamer service to Norfolk and Baltimore or commute to Washington, D.C., by regular ferry service.

Potomac Yards, one of the largest rail facilities in the country, got its start in 1906. It handled thousands of rail cars and employed many Alexandrians. So too did the Mutual Ice Company, which manufactured ice to cool perishable produce that traveled through Alexandria by way of railcar on its way from southern to northern states. A few new factories and businesses sprang up including several glass factories, which supplied bottles to the Portner Brewing Company.

World War I brought out the patriotism of Alexandrians and infused much-needed economic activity to the city. The Alexandria Light Infantry was called up in late 1917 and sent to Alabama for basic training before traveling to the European theater of war. In the city, new industries were created as part of the war effort. Ships were built at Jones Point, the Briggs Aeroplane Company opened, and the Atlantic Life Boat Company began operations. Construction on the most famous war-related building, the Torpedo Factory, began in 1918. The first torpedo was produced in 1920, too late to help win the war, but extremely important to the next world war only two decades later.

The Post Office and Customs House, on the southwest corner of Prince and
St. Asaph streets. (ca. 1900)

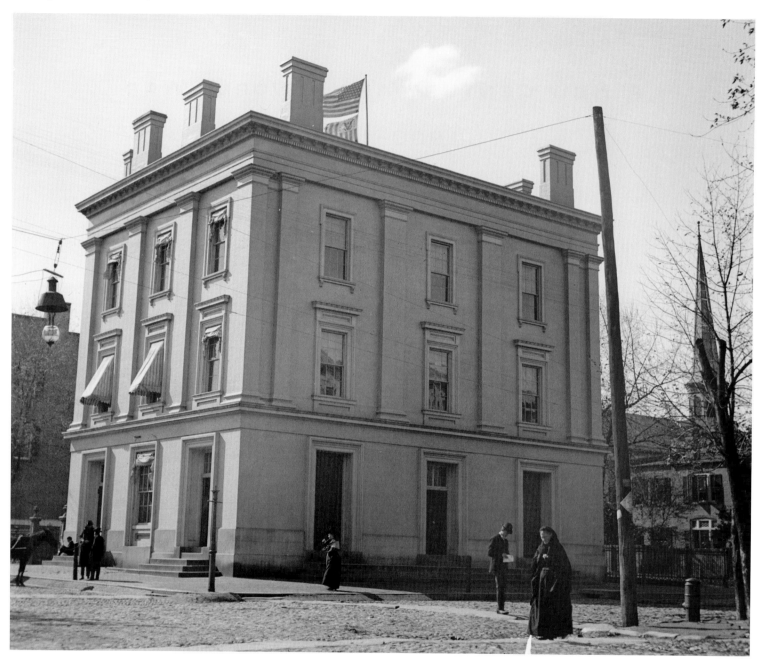

After returning from sea, docked schooners unloaded their catch onto the piers, where workers cleaned the fish. This area of the waterfront was known as Fishtown. (ca. 1900)

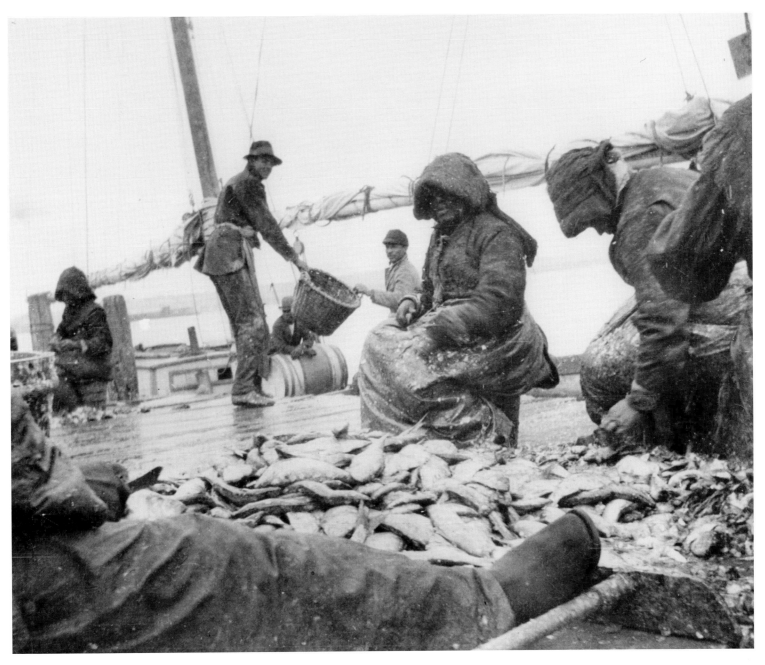

The former District Courthouse for Alexandria was located in the 300 block of N. Columbus Street. Designed by architect Robert Mills, the Greek Revival–style building and its grounds occupied the entire block. The building was demolished in 1905. (ca. 1900)

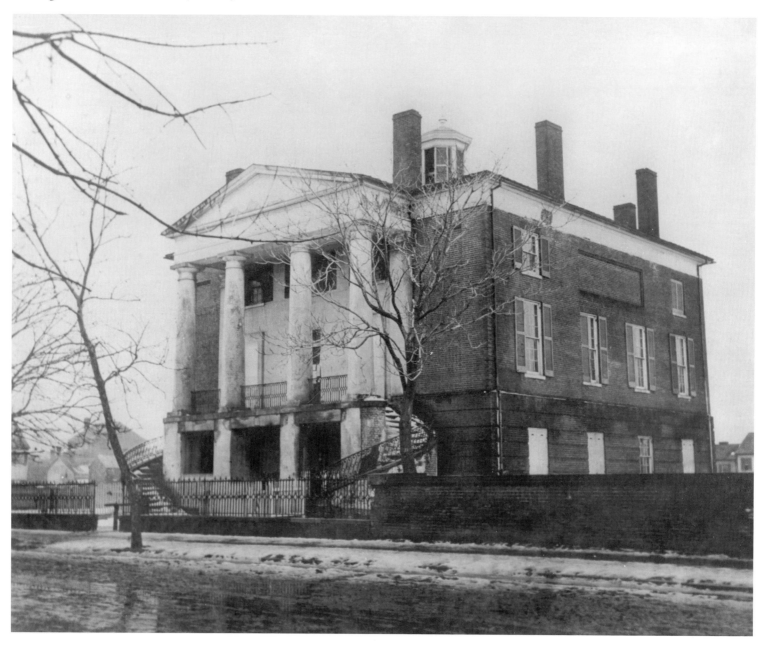

Ladies try their hand at "string and hook" fishing off one of the many piers on the waterfront. The gentleman is ready with net—if the fish bite! (ca. 1900)

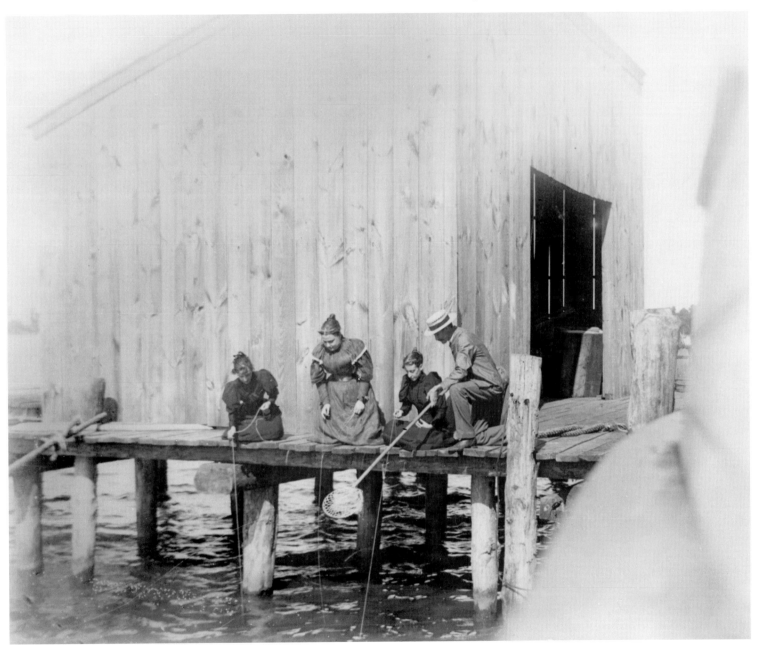

Alexandrians gather for a photo beside the Customs House and Post Office. Built in 1858, the first floor housed the post office, the second contained the customs offices, and the third a courtroom. (ca. 1900)

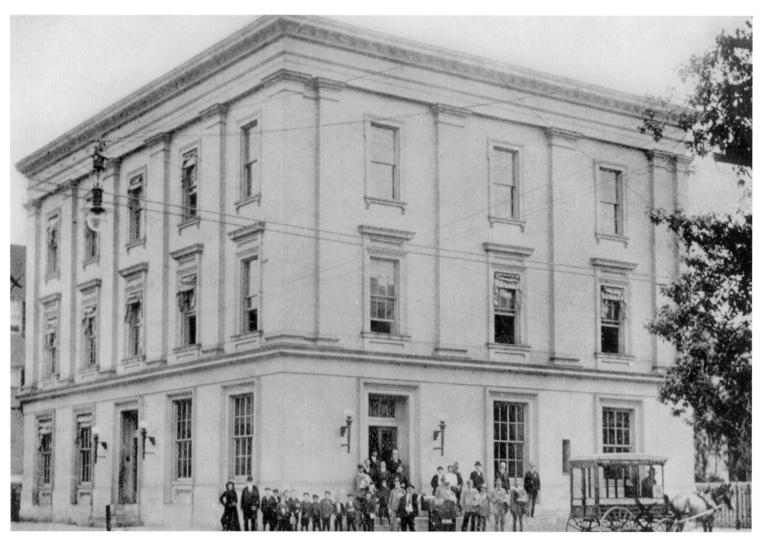

An interurban, at Rosemont Station. (ca. 1900)

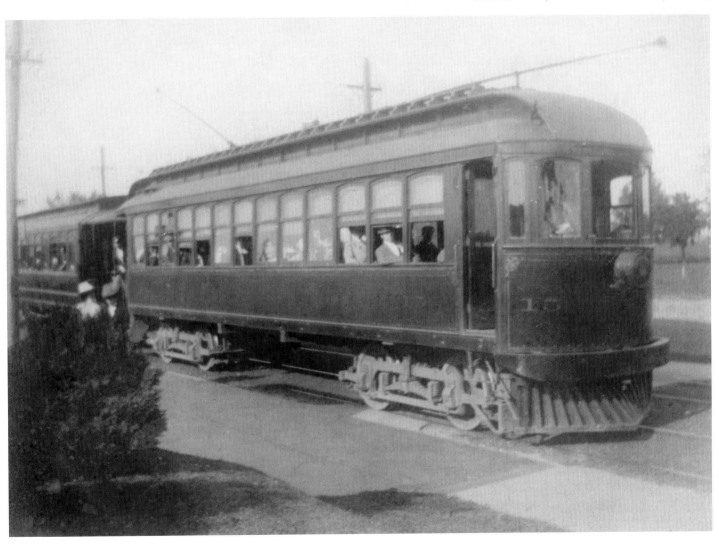

All manner of debris created a never-ending cleaning job for the street cleaners of
King Street. (ca. 1900)

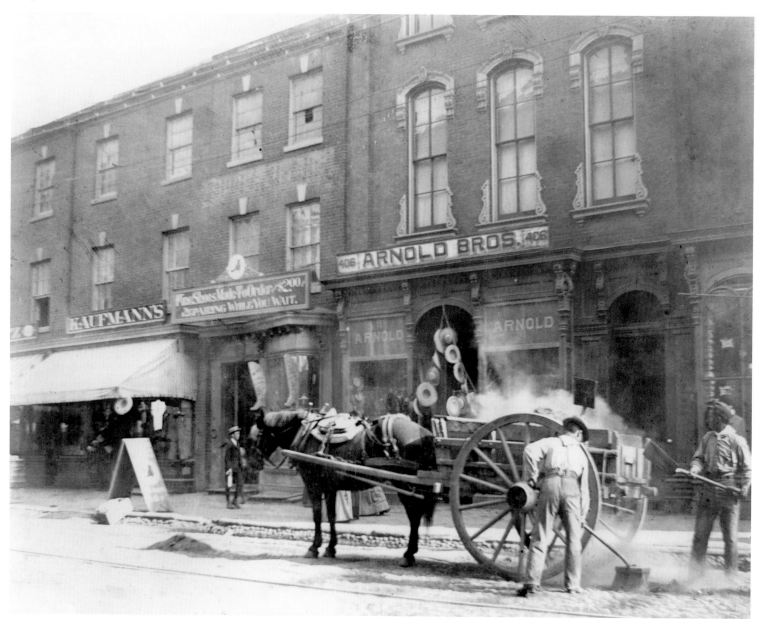

Alexandria's railroads were a source of employment for many citizens. Here a group of workers pose around one of the many steam engines. (ca. 1900)

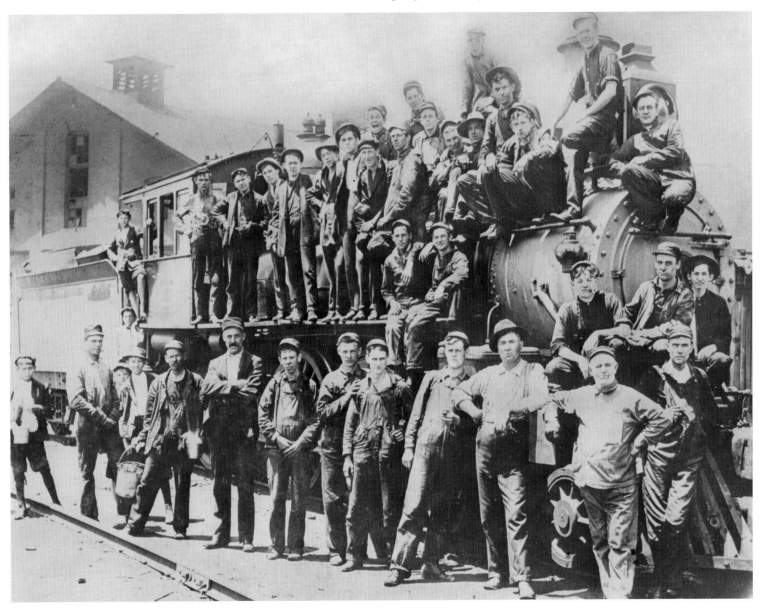

Once operated by John Gadsby, the City Hotel on Royal Street remained unchanged for many years. In 1900, it was still a primary destination for lodging and dining. It is now Gadsby's Tavern and Museum.

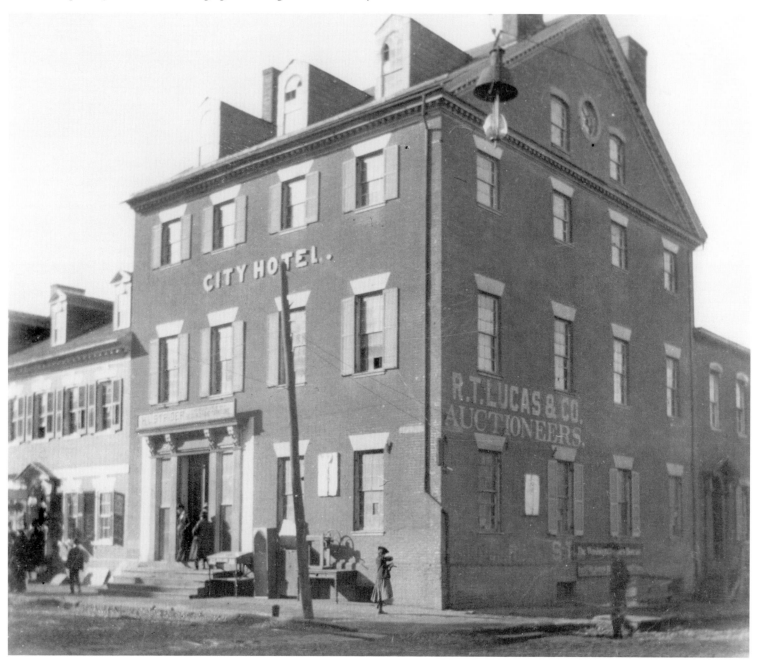

Horse and buggy were still the primary mode of transportation in 1900. This rig pauses in front of the Kretol Chemical Company at 202 S. Fairfax Street.

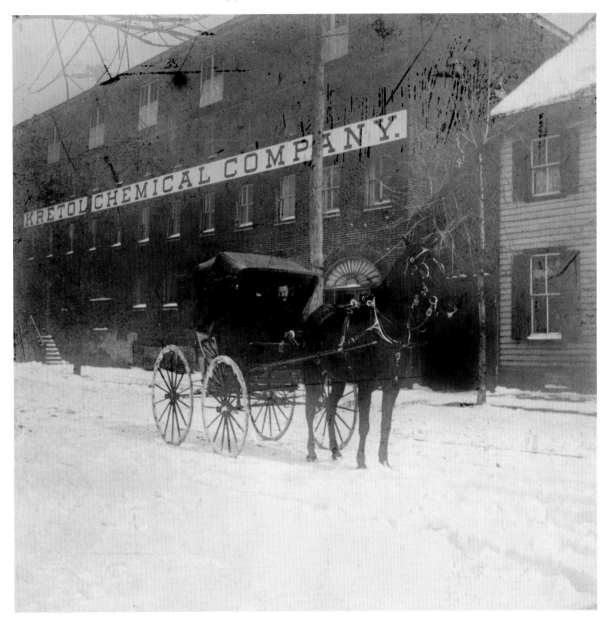

A horse-drawn steam pumper stands in front of the Columbia Engine House #4. (ca. 1900)

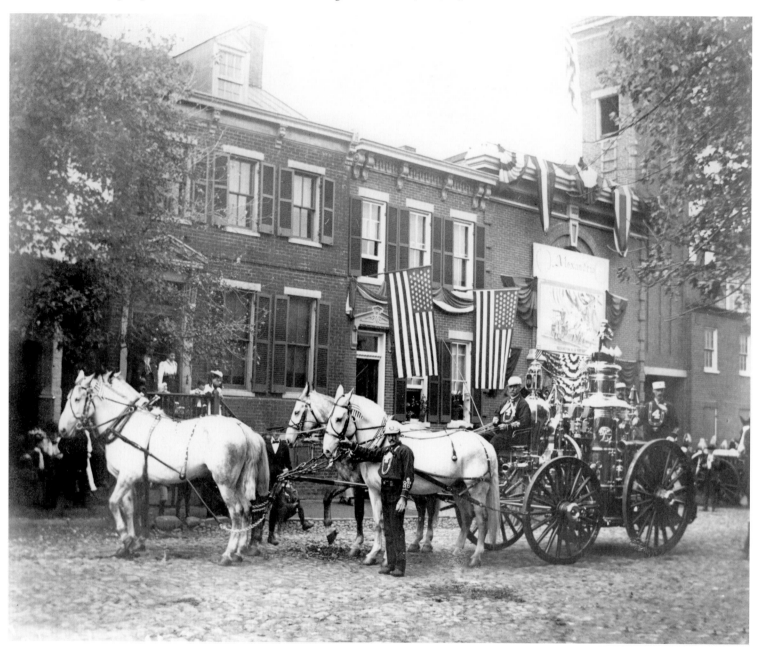

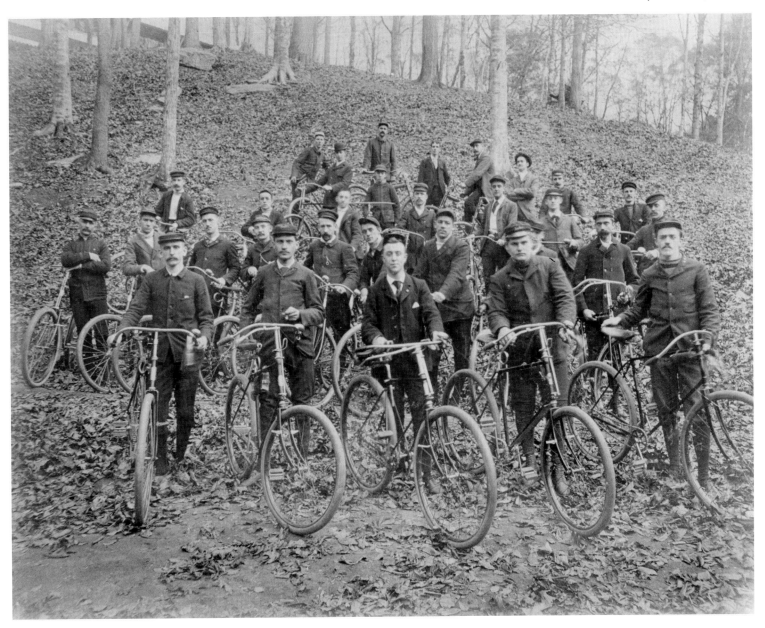

The Alexandria Bicycle Club. (ca. 1905)

The aftermath of a fire that destroyed the W. A. Smoot & Company planing mill and lumberyard. (May 13, 1909)

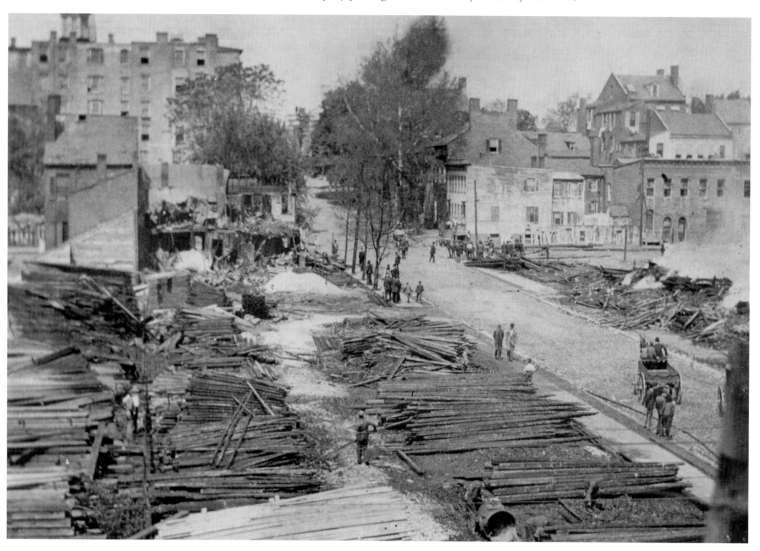

Michelbach Furniture on King Street was one of Alexandria's leading retailers for many years. Here the building has been draped with bunting in preparation for one of the city's many parades. (ca. 1910)

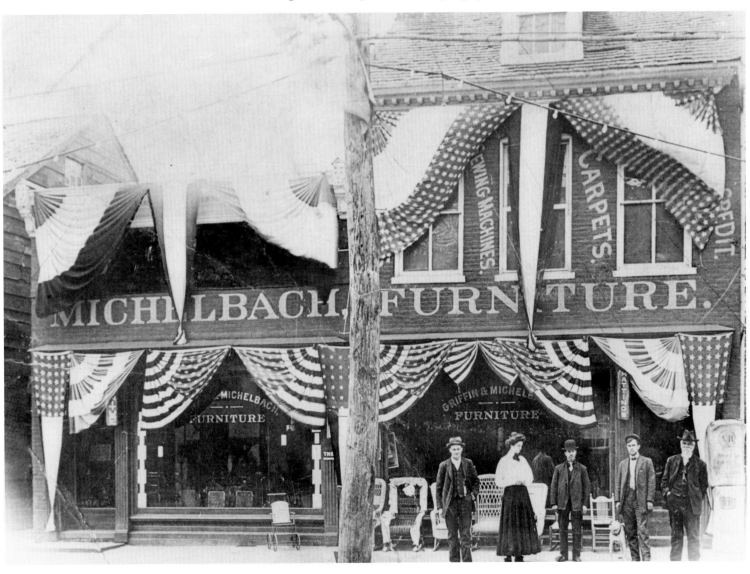

The surviving veterans of the 17th Virginia Regiment proudly pose in front of 806 Prince Street, the Robert E. Lee Camp Hall. The group deeded the hall to the local chapter of the United Daughters of the Confederacy. It is now a museum honoring the men of the 17th and the Confederacy. (ca. 1910)

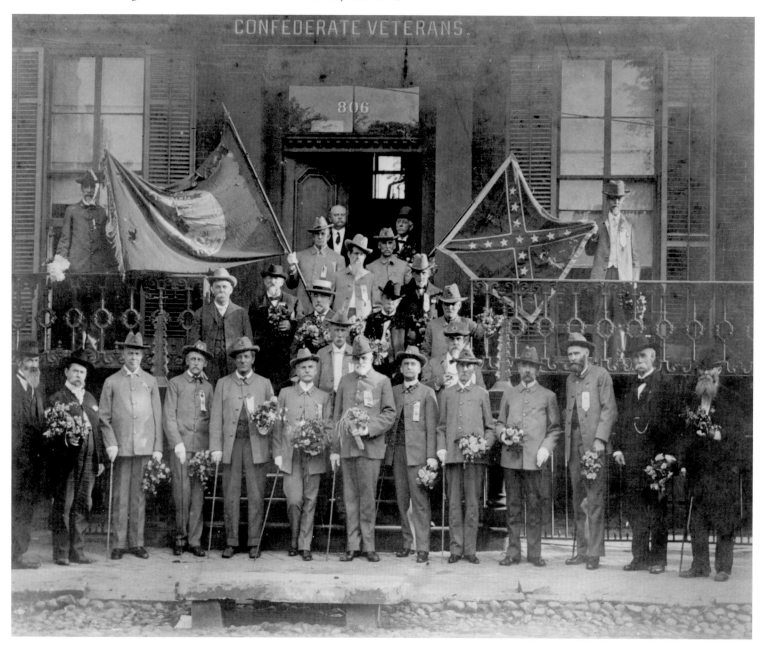

While fire burns the Smoot lumberyard, men check the roof of the Henry Knox Field lumberyard for flying embers. The Field yard survived the fire. Fire engines and a fireboat from D.C. assisted the Alexandria Fire Department in putting out the fire. (May 13, 1909)

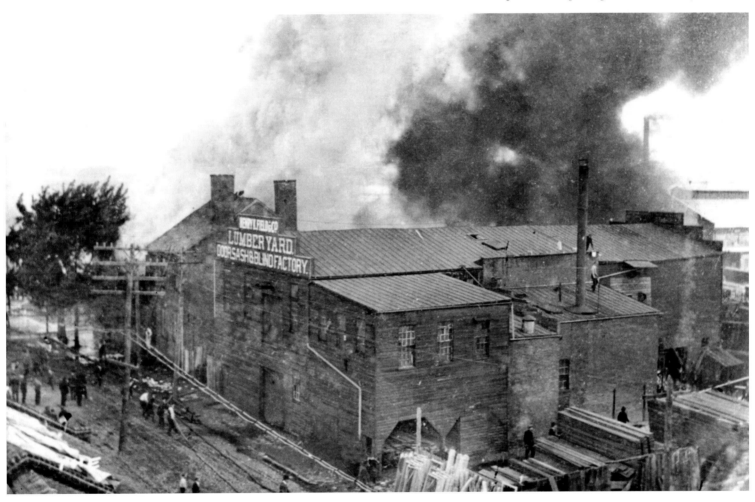

Horses were not the only means of pulling wagons. Here "Uncle Jack" guides the ox pulling his bare-bones wagon across Humes Spring. Mrs. Edith Snowdon looks on from the bank. (ca. 1910)

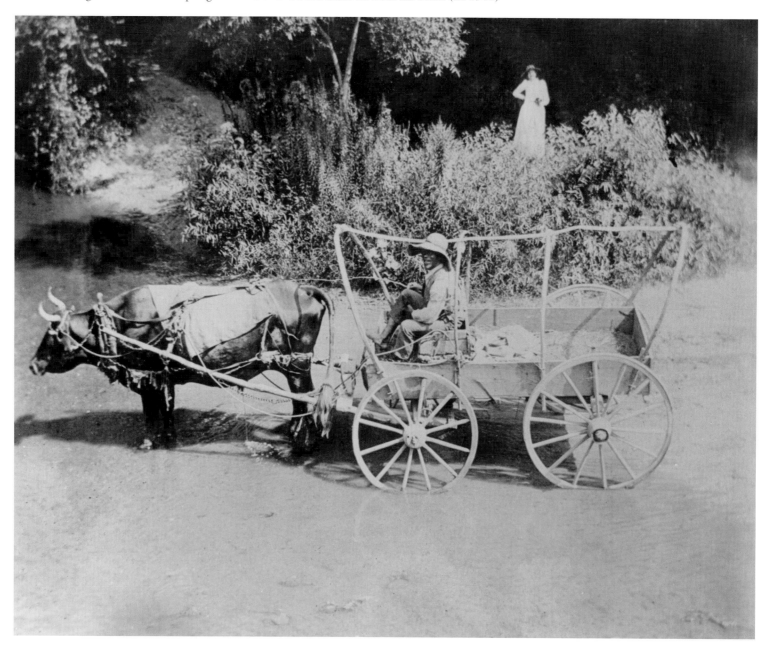

Rather small and dark by today's standards, the interior of this turn-of-the-century grocery is utilitarian and functional. Fresh fruits and vegetables, and staples such as flour, salt, and sugar, provided customers their daily meals. (ca. 1910)

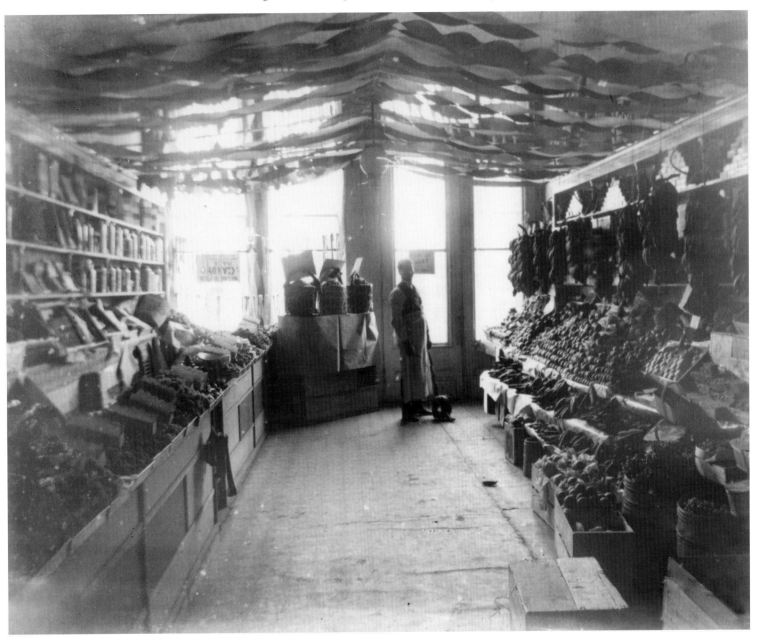

Two large trees frame the home of Dr. M. M. Lewis on the corner of Cameron and N. Washington streets. This unusual photo was taken from the graveyard of Christ Episcopal Church. (ca. 1910)

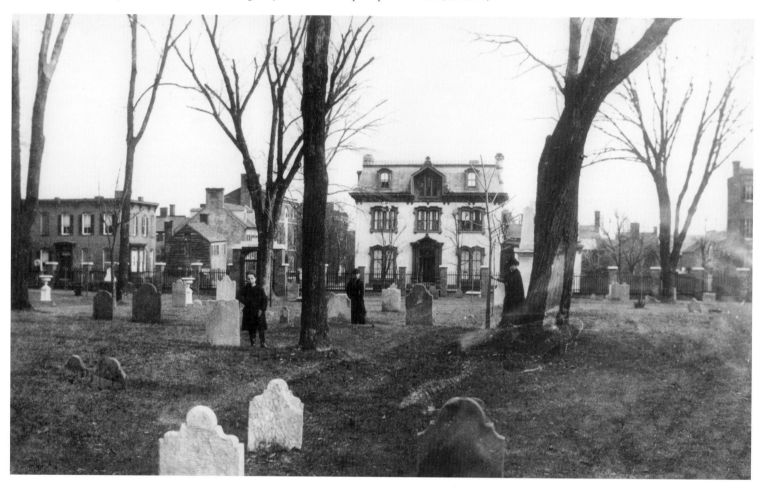

Shoe-shine stations along a busy Alexandria street. (ca. 1910)

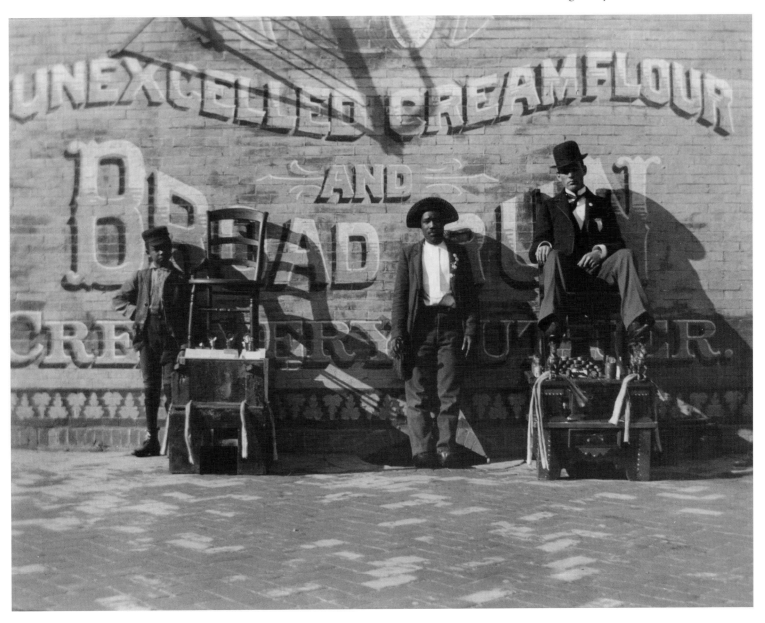

Firemen and fire departments were an important part of life in Alexandria. In 1910, Alexandria hosted the Virginia State Volunteer Fireman's Association Convention. Pictured here is the Luray Fire Department during the convention's parade. (August 23-26, 1910)

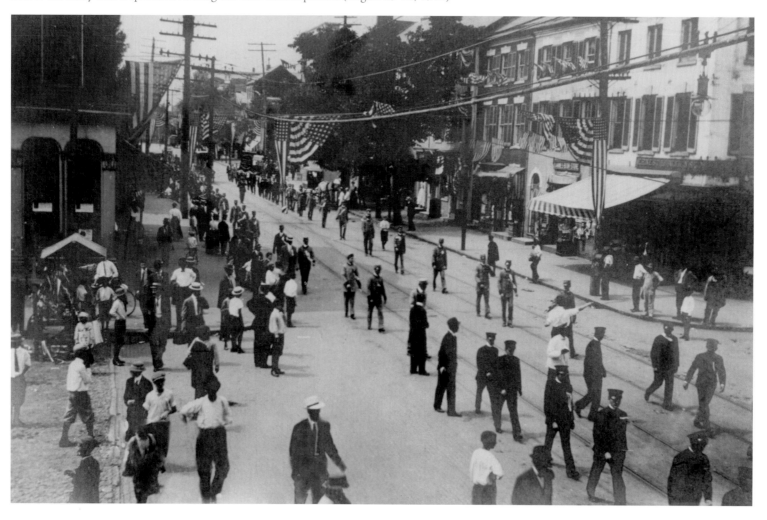

Before enactment of child labor laws, Alexandria glass factory workers included youths. (June 1911)

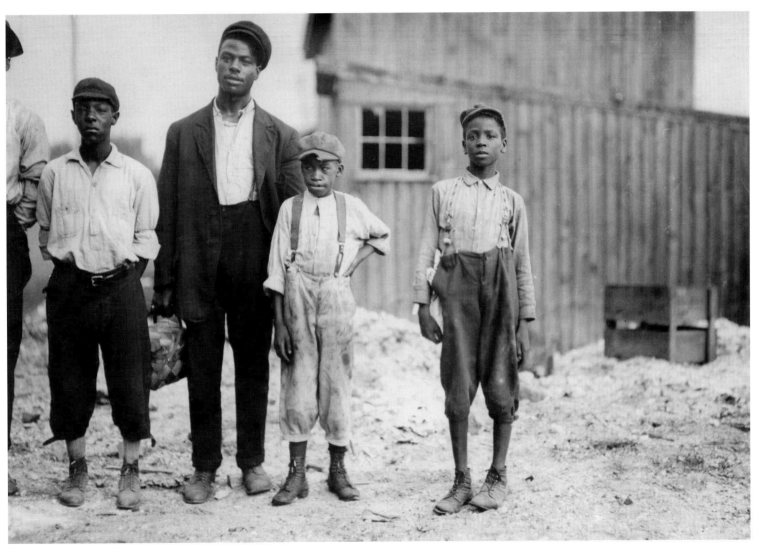

The "carrying-in boy" at a glass factory. He took completed objects from the finisher to the tempering oven. (June 1911)

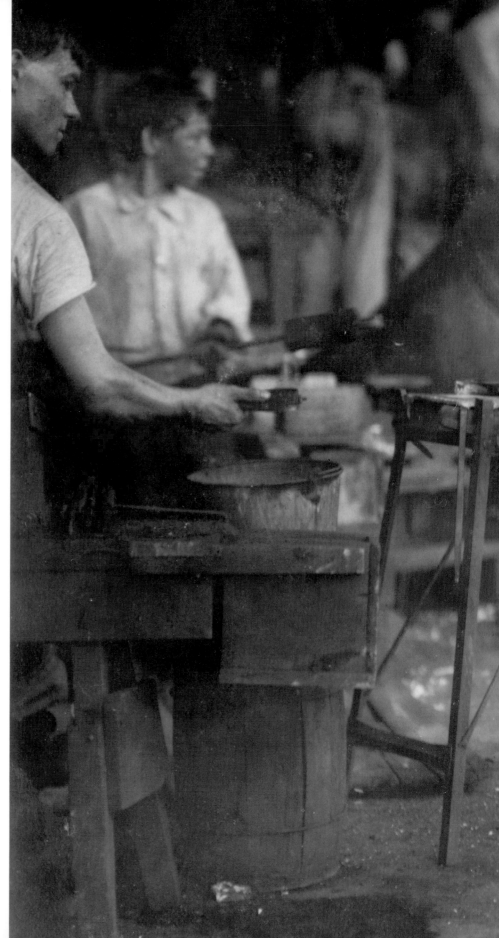

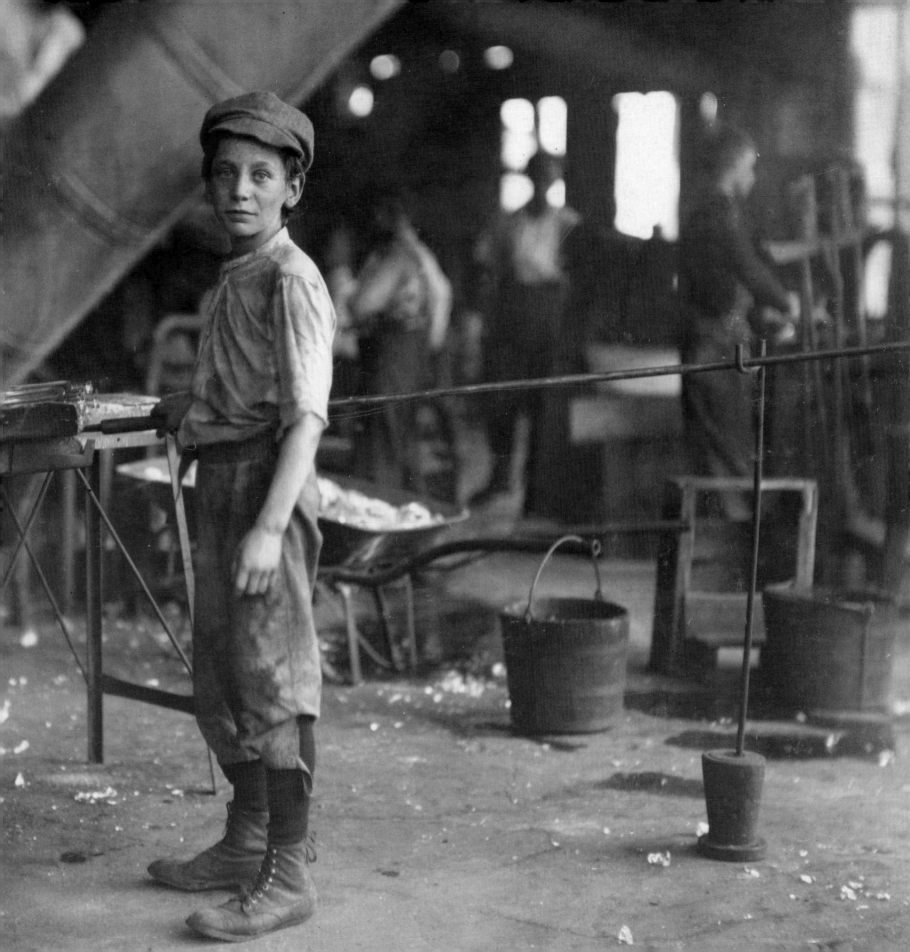

When repairs to the cobblestone streets in Alexandria became too expensive, the stones were removed and stored at Cameron and Henry streets. Here a stone crusher breaks up the stones into gravel for road work. (ca. 1912)

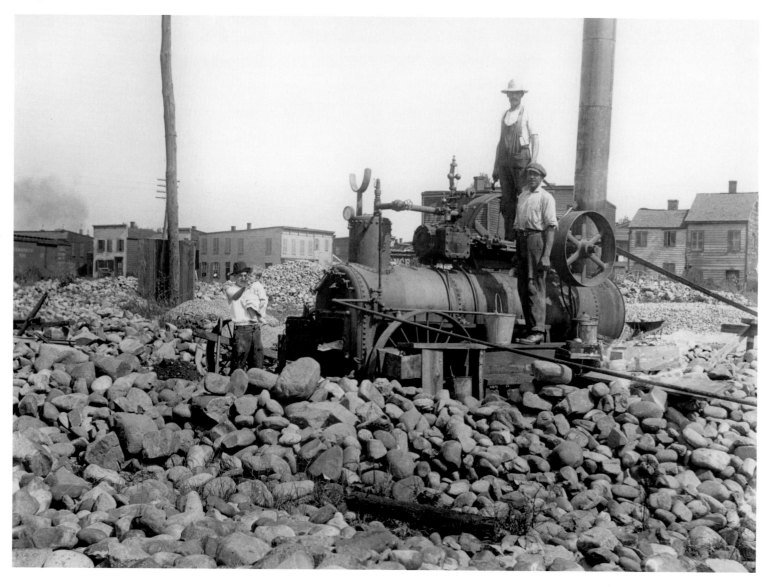

From 1914 through the 1920s, Alexandria was home to various manufacturers of airplanes and airplane parts. This factory was located at the foot of Duke Street and is now the home of Robinson Terminal warehouse. (ca. 1915)

This panoramic view of the Virginia Ship Building Corporation shows offices and work areas. The company was located at the foot of Wolfe Street on the Potomac River and was in business for approximately 25 years. (ca. 1918)

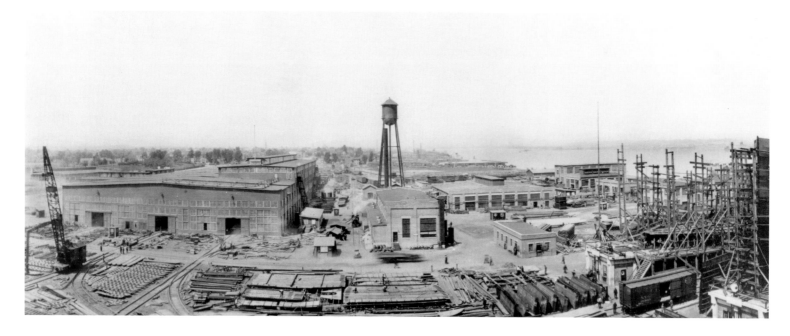

Joseph B. Drew's Saloon at 109 S. Pitt Street offered a summer garden where customers could sit outside and enjoy a drink. Wildfowl hang on the line in front of the establishment, ready to be plucked by the cook for the next meal. (ca. 1915)

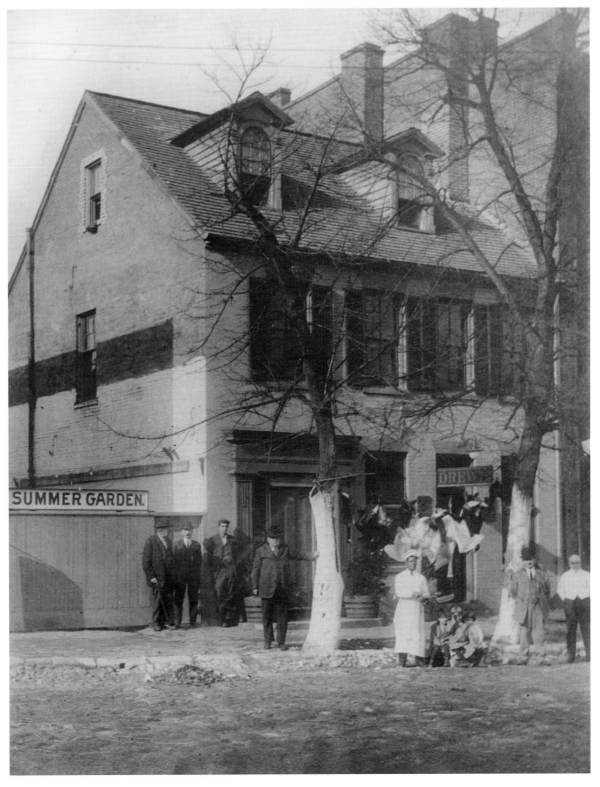

Fishing was not the only activity seen by this house and others like it, located north of Alexandria on Daingerfield Island. Bootleggers and gamblers plied their trade here as did ladies of the evening. (ca. 1910–1915)

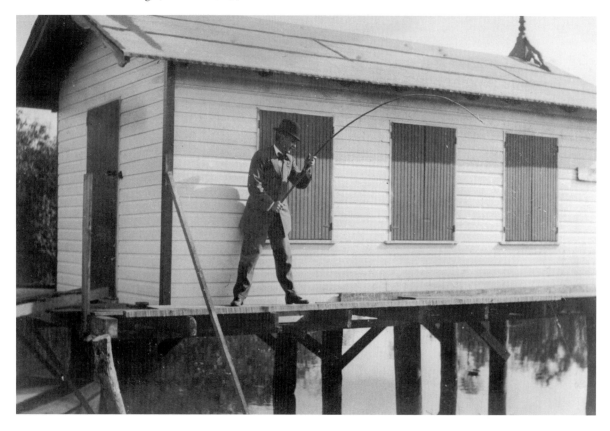

Flooding is a part of life for a city located on the Potomac River. In this 1917 photo, the river has inundated the lower part of King Street. The trolley tracks in the foreground lead to the ferry slip in the distance.

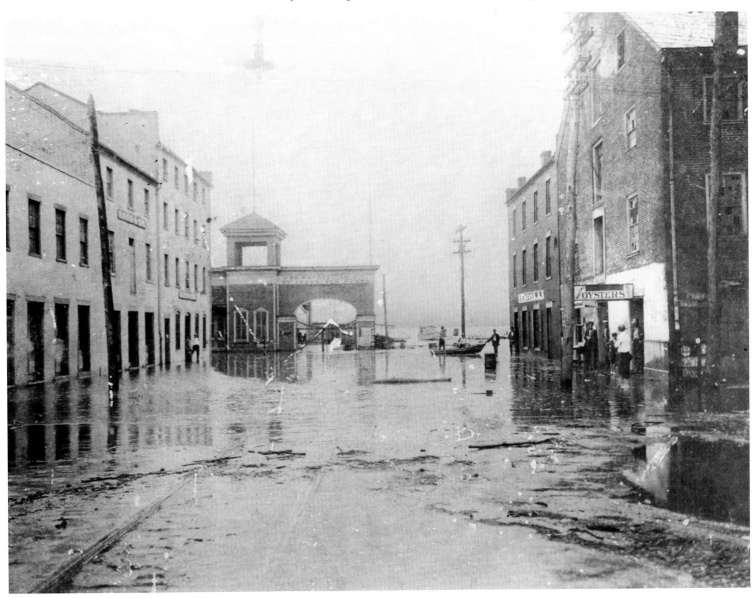

Alexandria soldiers went to Camp Humphries in Virginia during World War I. The arrangement of screens between beds was intended to prevent the spread of influenza. (1918)

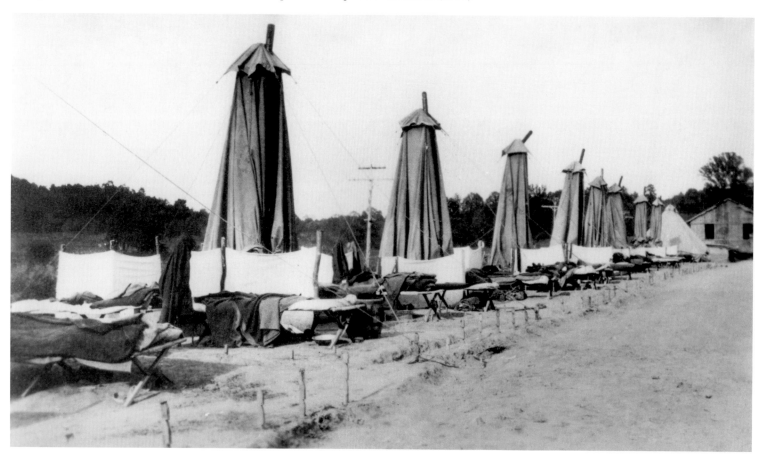

The Virginia Ship Building Corporation at the foot of Wolfe Street. Cranes, tracks, and scaffolding surround a vessel under construction. (ca. 1915)

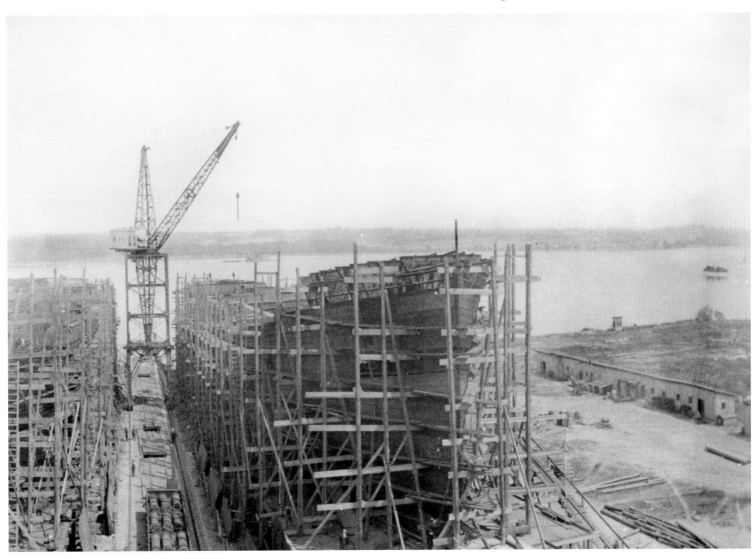

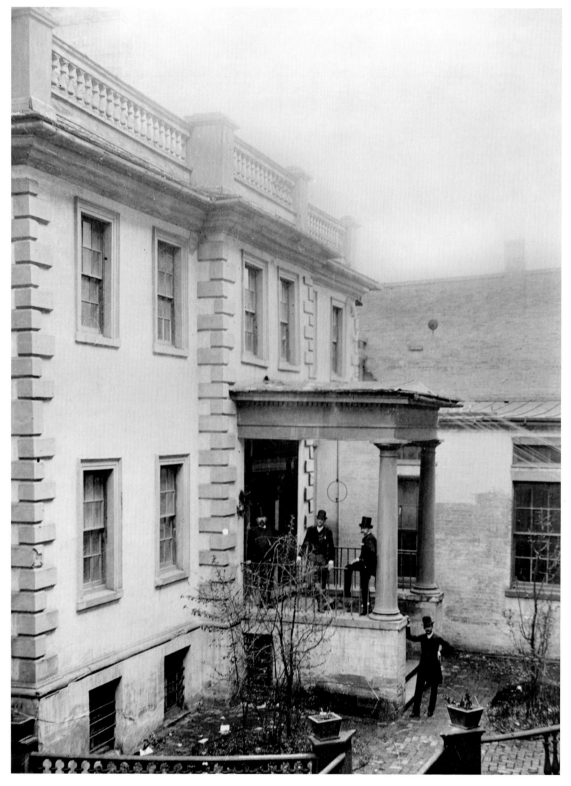

The front of Carlyle House, built in 1751 by John Carlyle. The house is located on Fairfax Street and is now a part of the Carlyle House Historic Park. (ca. 1918)

HARD TIMES AND ECONOMIC CHALLENGES

(1920–1939)

Despite the brief economic boost provided by World War I, Alexandria faced renewed economic challenges. Its citizens struggled to make a living, much as they had after the Civil War and Reconstruction. Prohibition came to Alexandria, as it did throughout the nation, shutting down Portner's Brewery, Alexandria's largest employer in 1916, but others found ways to skirt the new laws. The low-water line of the Potomac River in Alexandria was considered the boundary with Maryland, a state strongly opposed to prohibition. The edge of the river in Alexandria was also a place where Maryland authorities would have difficulty enforcing their own laws. Bars, restaurants, and other houses of ill-repute were built on stilts in the river and provided patrons with drinking and gambling opportunities.

In 1921, the Virginia Ship Building Corporation, whose principals were accused of fraud and misuse of government funds, filed for bankruptcy and closed down, adding to the economic woes of the city. Shipbuilders had been producing boats in Alexandria since 1762 and the Virginia Ship Building Corporation was the last shipbuilder to call Alexandria home. This closure had a real impact—many citizens were laid off and it was also a symbolic loss for the city.

In the 1920s, the Alexandria American Legion purchased the Old City Hotel, also known as Gadsby's Tavern, to use as a museum and headquarters. Eventually Gadsby's Tavern reopened to the public, commencing with a costume ball in 1932, the 200th anniversary of the birth of George Washington, who with Thomas Jefferson, John Adams, and other leaders was among its early patrons. The purchase and restoration of the building can be seen as the nascency of the local preservation movement.

On January 1, 1930, Alexandria gained more than seven square miles of land and nearly 5,500 residents as a result of the annexation of land from Arlington and Fairfax counties. This extension of Alexandria's boundary came after a long court battle and many previous boundary skirmishes with its neighbors.

The opening and dedication of the George Washington Masonic Memorial in 1932, on Washington's birthday, was a highpoint in an otherwise challenging era. The George Washington Memorial Parkway, linking Mt. Vernon to Washington, D.C., and running for several miles through downtown Alexandria, also opened that year.

A horse-drawn pumper takes part in a parade. (ca. 1920)

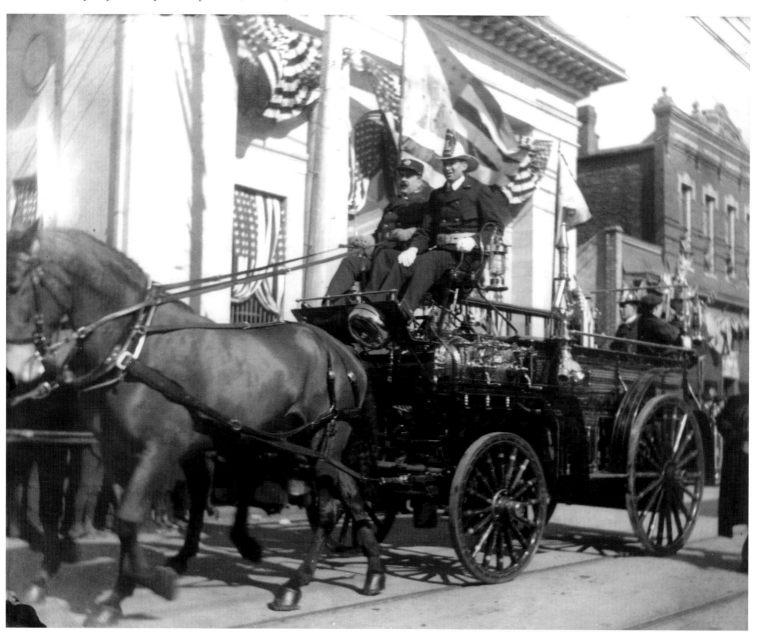

Behind Market square are the remnants of bygone days. Old vehicles, debris, and empty stalls suggest a formerly busy area of Alexandria. (ca. 1920)

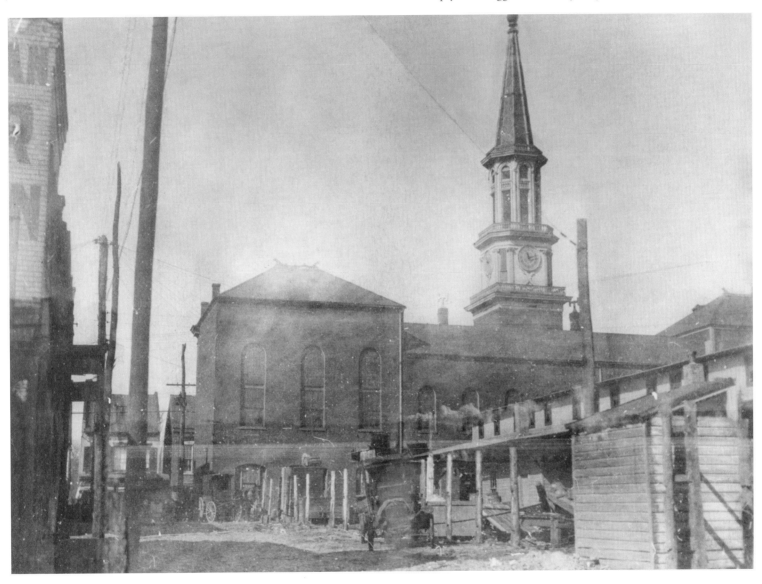

The Confederate Monument, erected in 1889 to honor the fallen, stands at the intersection of Prince and Washington streets. This was the point from which soldiers left Alexandria at the beginning of the Civil War. (ca. 1920)

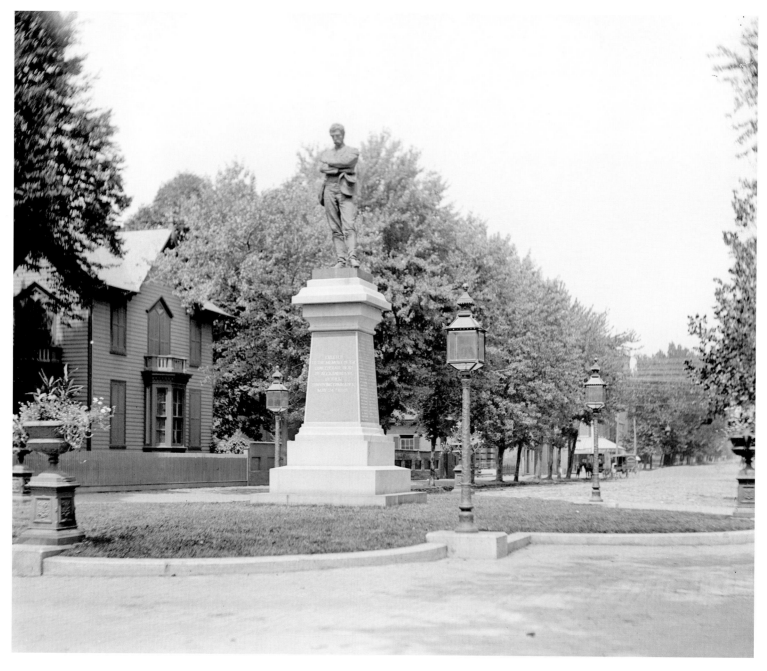

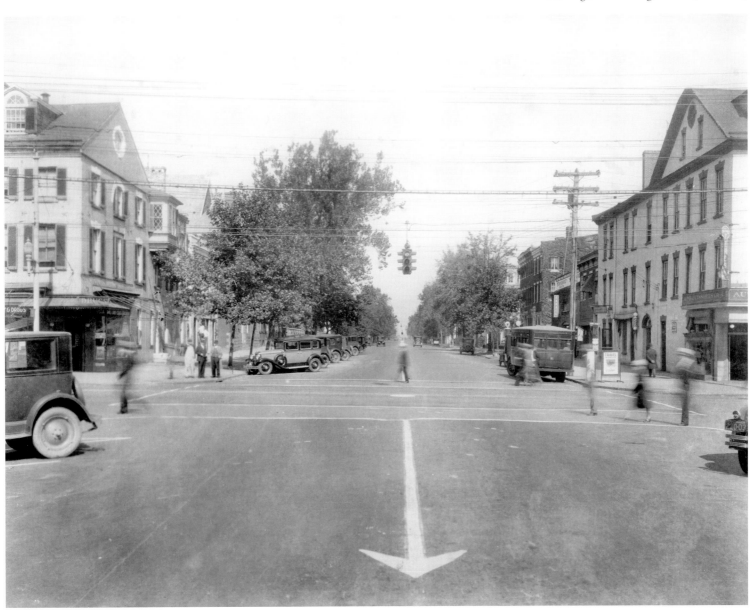

Washington and King streets. (ca. 1920s)

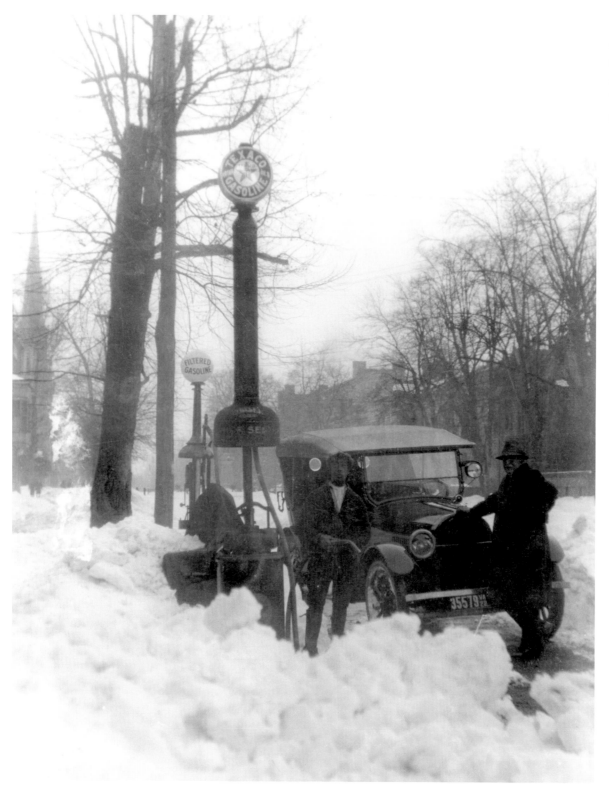

Shoved into piles, snow surrounds the gas pumps at the Alexandria Auto Supply Company and Texaco Gas Station after a severe snowstorm in 1922.

The Alexandria Light Infantry Band in front of Armory Hall on Royal Street near Prince Street. (ca. 1920)

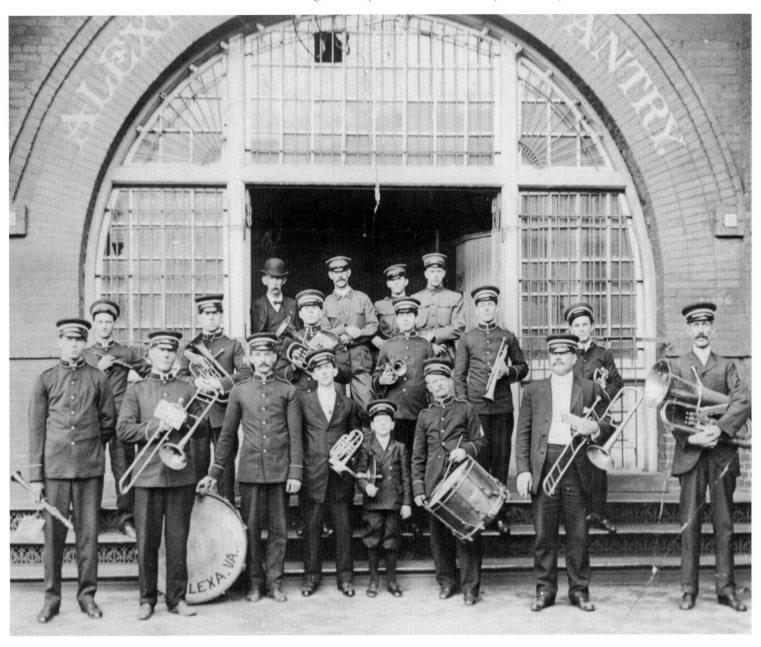

Street clearing is under way on the 400 block of King Street after a severe snowstorm in 1922.

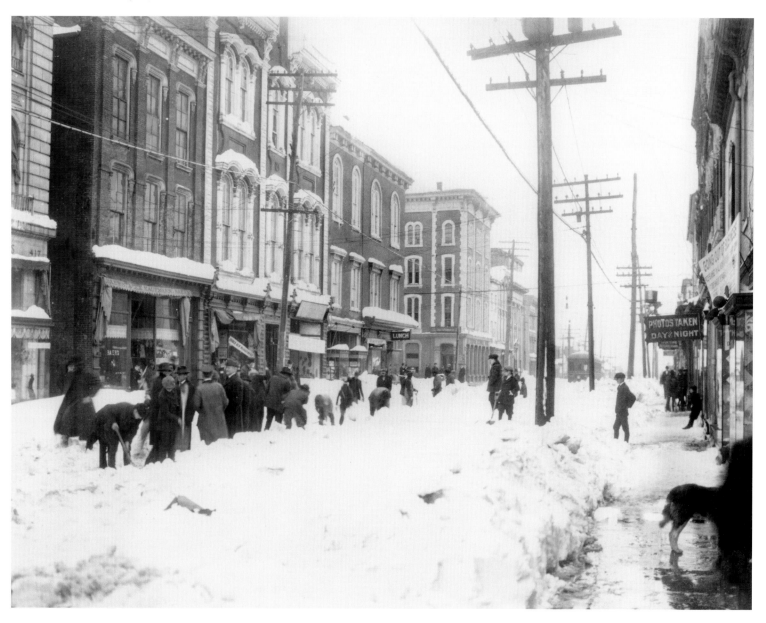

Men with shovels work hard to make King Street passable following
the 1922 storm.

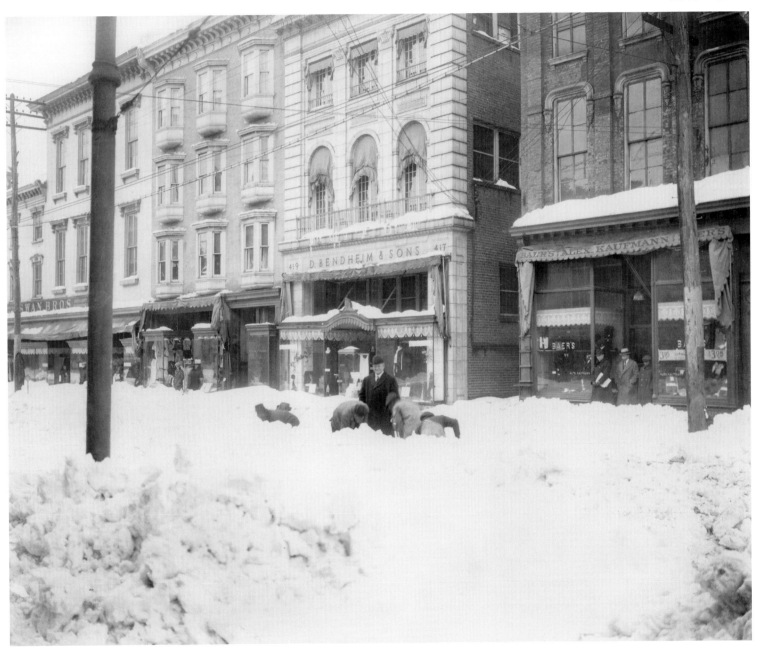

Tin lizzies cross the intersection of Duke and S. Peyton streets. (1923)

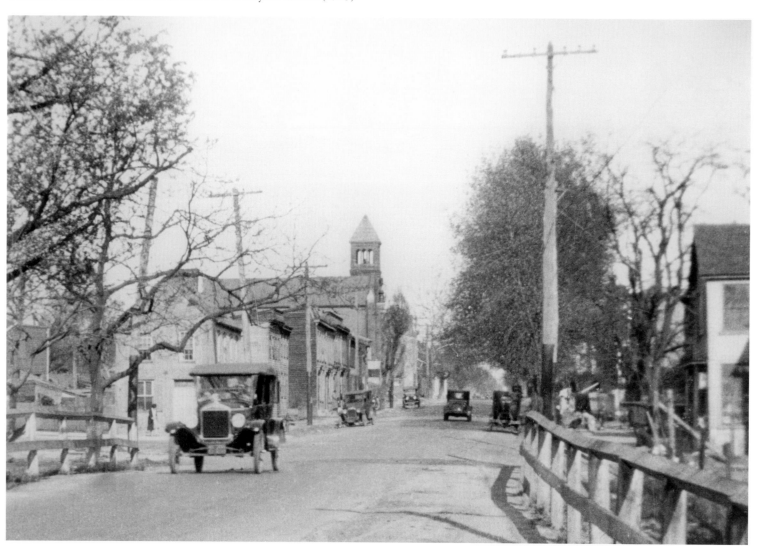

The Parker-Gray School at 900 Wythe Street opened in 1920 for African American boys and girls through 8th grade. The school was eventually destroyed by fire and the Charles Houston Recreation Center now occupies the site.

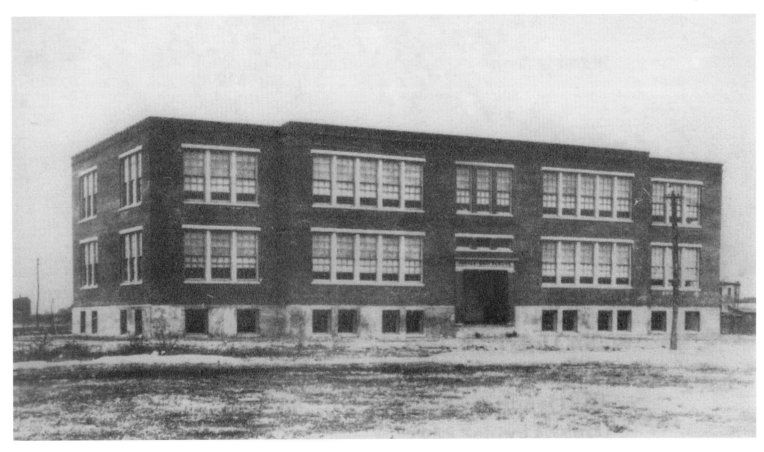

Alexandria Auto Supply Company at 104 S. Washington Street. (ca. 1924)

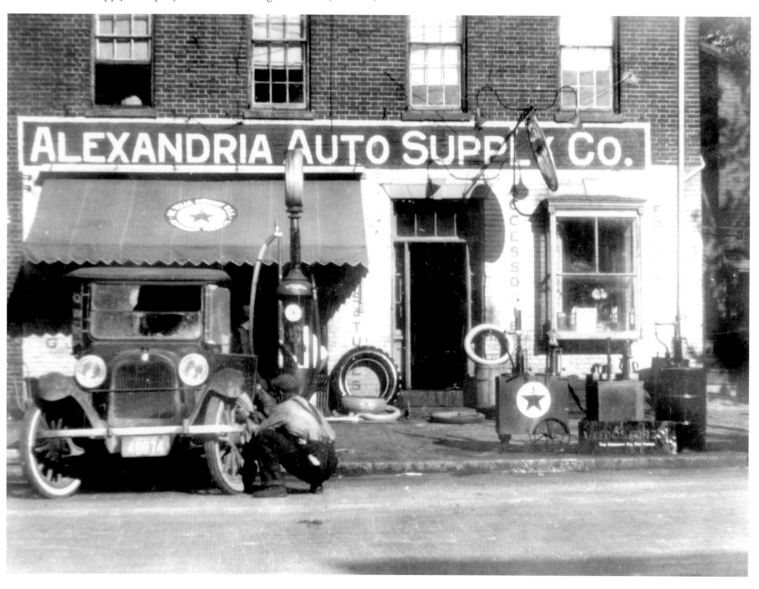

President Calvin Coolidge (standing at right with top hat) and the First Lady attend the cornerstone-laying ceremony at the George Washington Masonic National Memorial. (November 1, 1923)

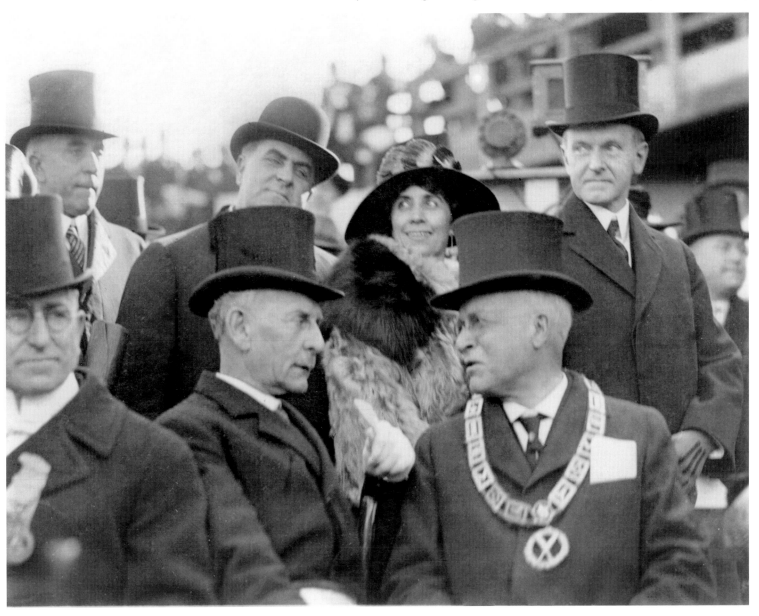

Horses and wagons were still in use in Alexandria in 1924. This scene on King Street shows the blend of old and new.

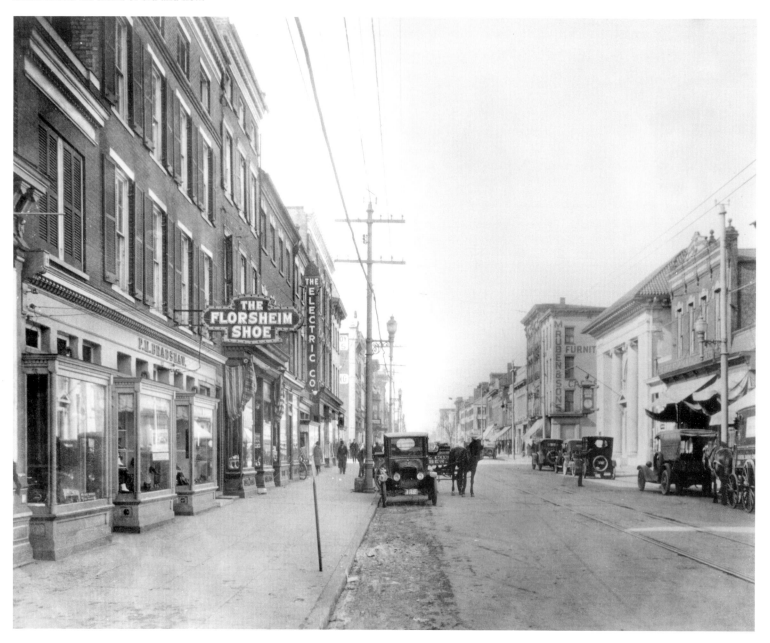

Captain's Row, 100 block of Prince Street, in 1924. In earlier days, sea captains built their Federal-style homes close to the river and work. In 1827, both sides of the entire block were destroyed by fire, but most homes had been rebuilt by 1835.

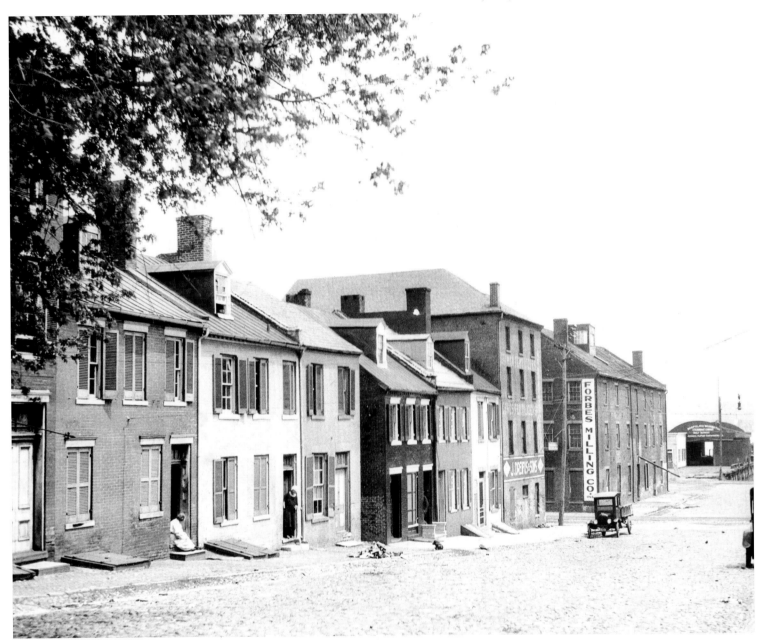

This building at 515 N. Washington Street has a long history. Built in 1847, it was used as a cotton factory, a prison during the Civil War, a bottling factory for a brewery, and was later converted to manufacture spark plugs. (ca. 1925)

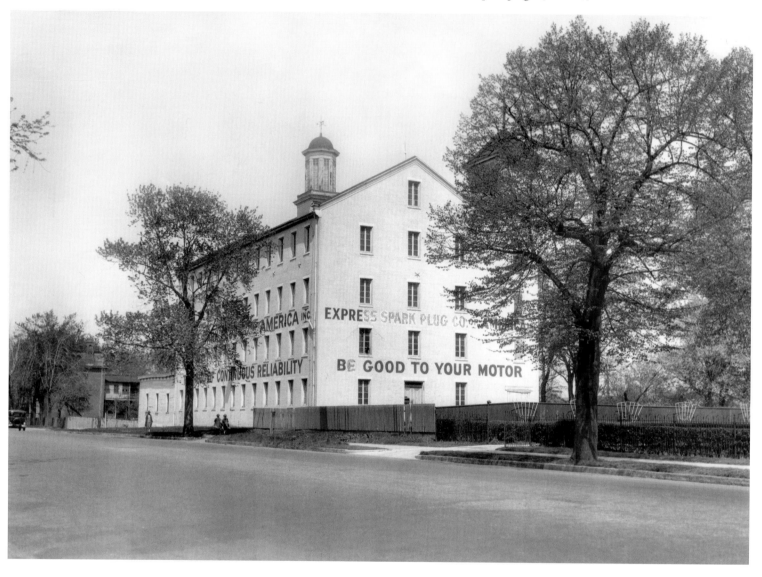

Girls on roller skates pose in front of Wise's Tavern, built between 1777 and 1778 at 201 N. Fairfax. John Wise was proprietor from 1788 to 1792. Originally used as a tavern and stable, it was converted to two dwellings in the early nineteenth century. From 1916 to 1974, it served as the Anne Lee Memorial Home. (1925)

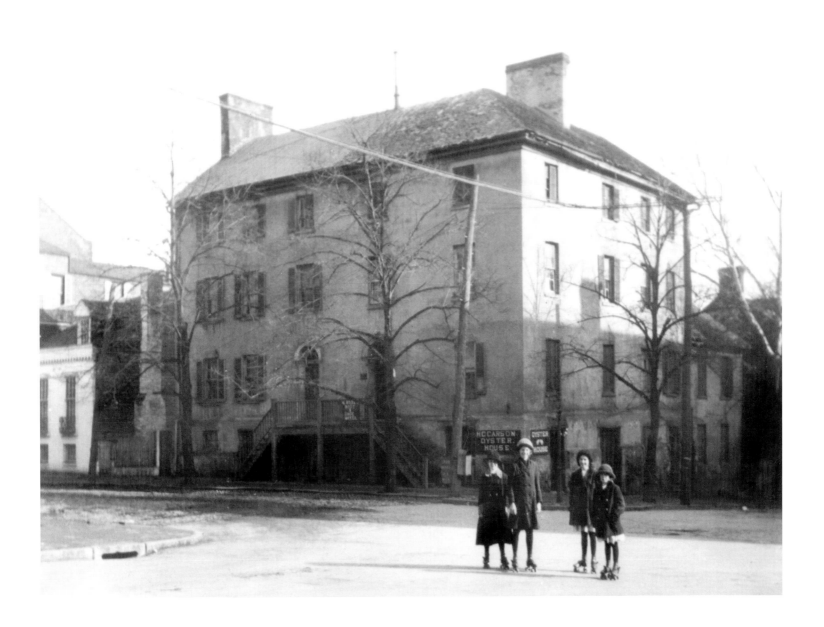

Inside Warfield's Drug Store on King Street, one could order a Coca-Cola at the soda fountain. (ca. 1925)

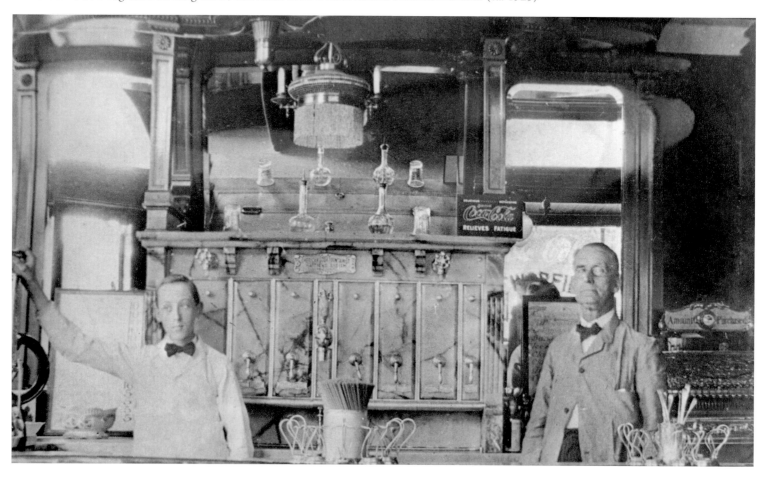

Both men and women were employed at the Express Spark Plug Factory on N. Washington Street. (ca. 1925)

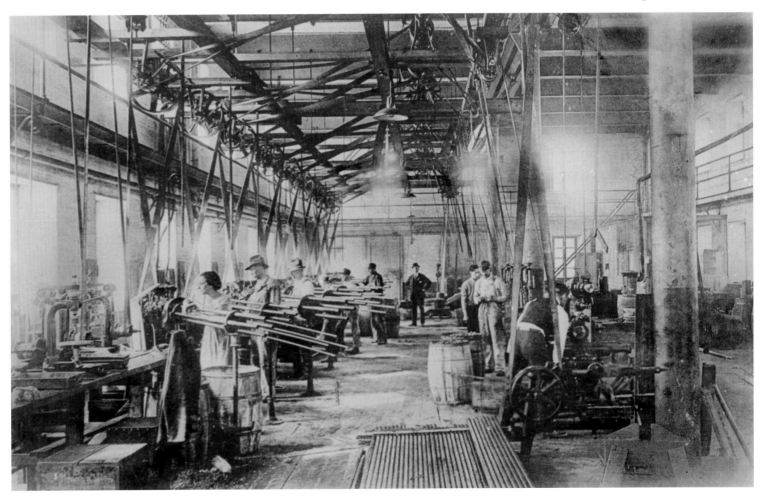

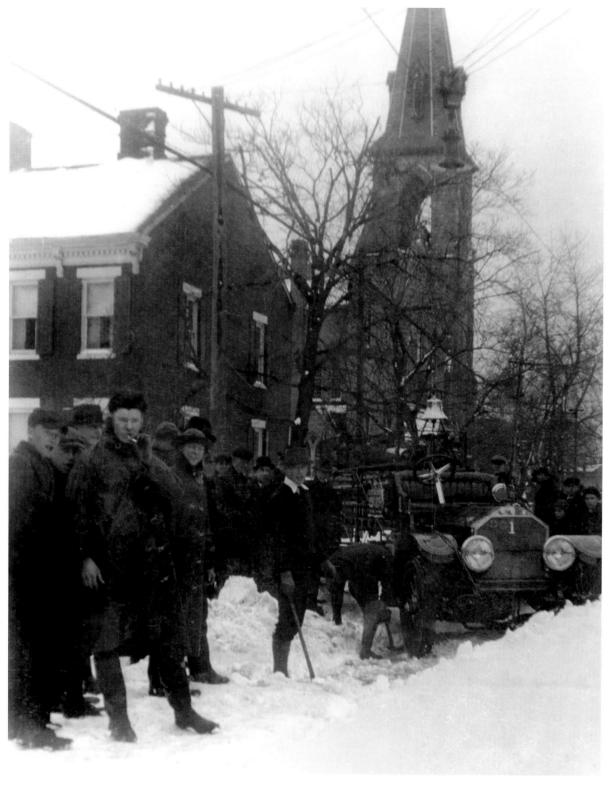

Clearing snow on Royal Street. (ca. 1925)

A garlanded old pumper provides a grand ride and parade entry. The Women's Auxiliary of the Alexandria Fire Department follows behind. (ca. 1925)

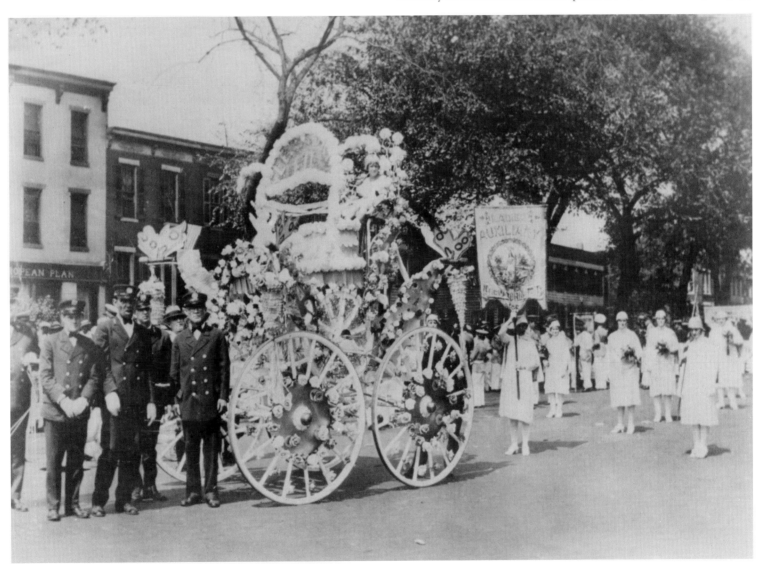

The south side of the 300 block of King Street. (ca. 1925)

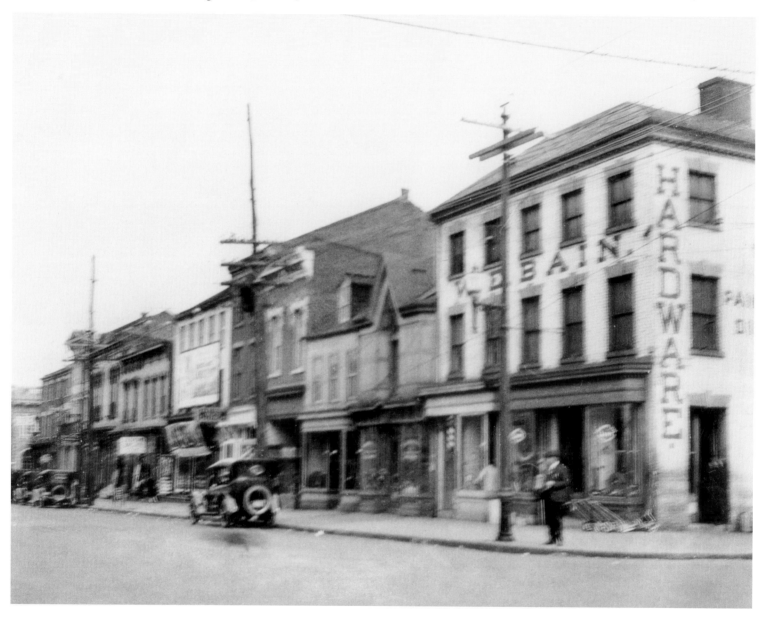

The corner of King and Royal streets. (ca. 1925)

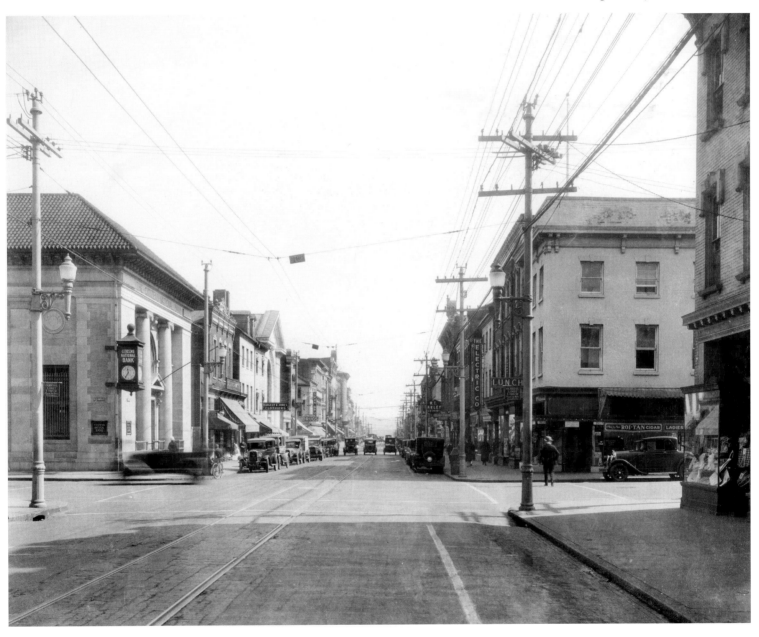

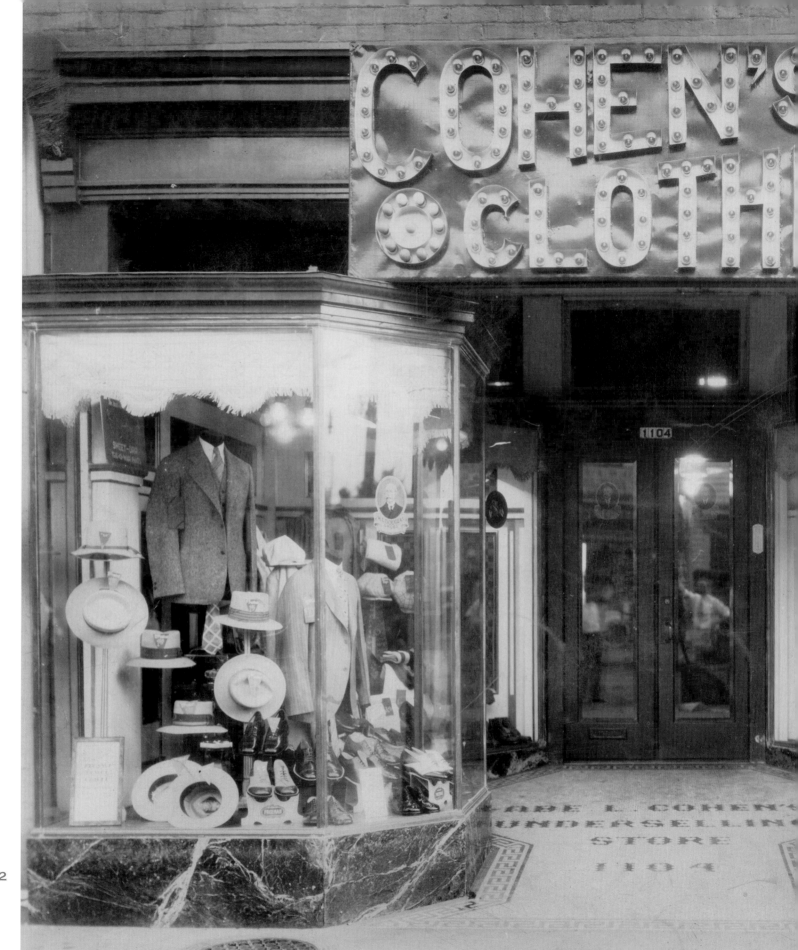

Cohen's Clothing at 1104 King Street carried all the latest attire for the well-dressed man. (ca. 1925)

133

King Street, the 400 block. (ca. 1925)

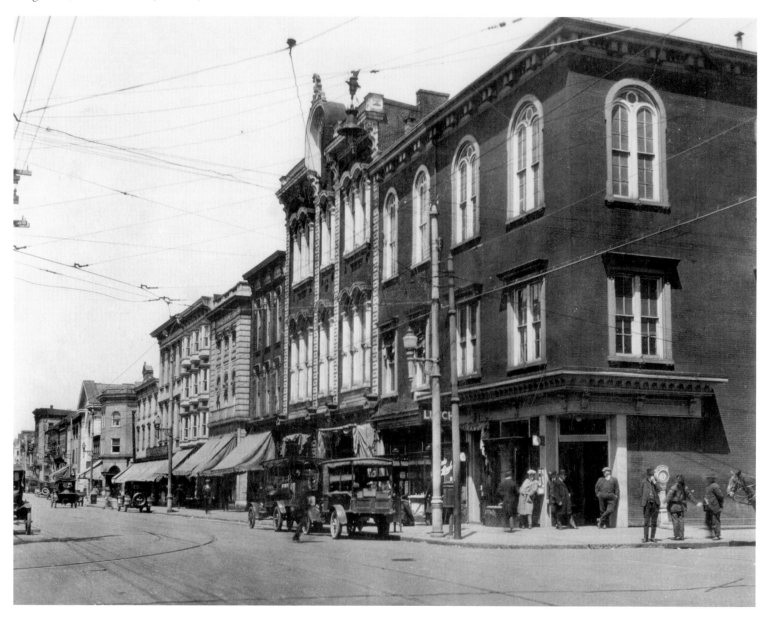

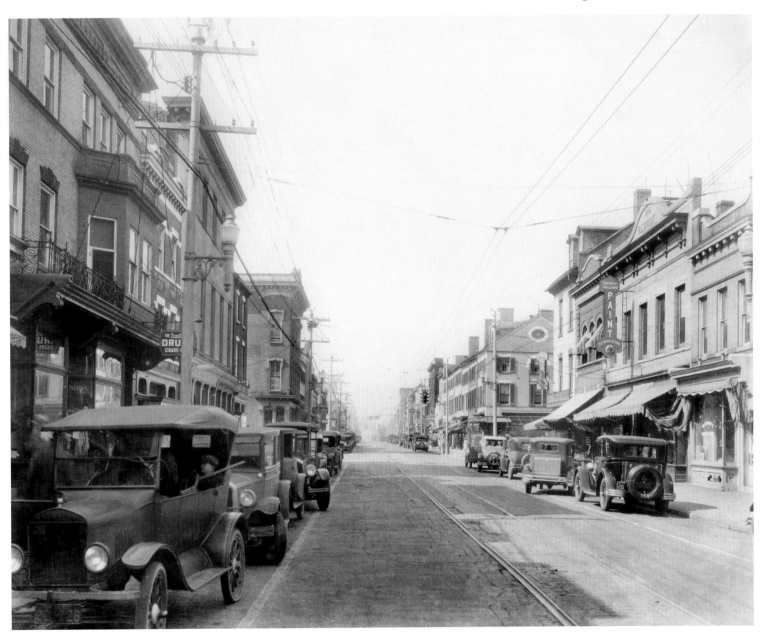

Built before 1785, the Ramsay House is thought to be the oldest house in Alexandria. Once used to manufacture cigars, it was later a tavern called Ma's Place. Today it is the Alexandria Tourist Council and Visitors Center. (1926)

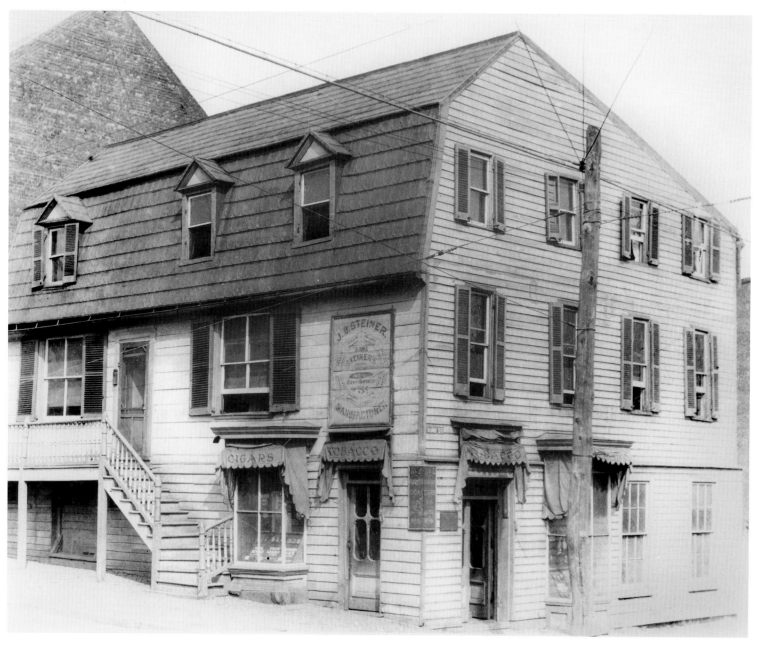

Victorian-era storefronts grace the 400 block of King Street. The sign beneath the streetlight says "Parking Limit 1 Hour." (ca. 1926)

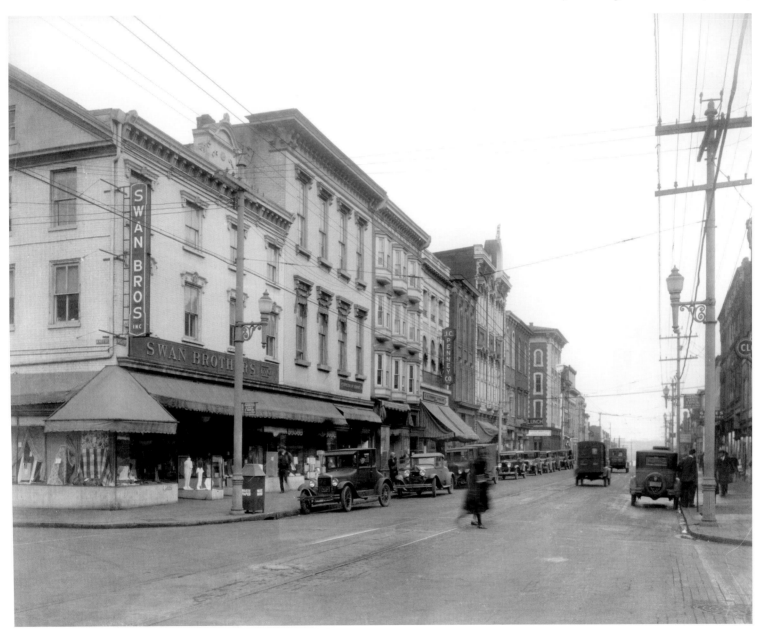

Prince Street Wharf. Cars are lined up waiting to board the ferry. (1929)

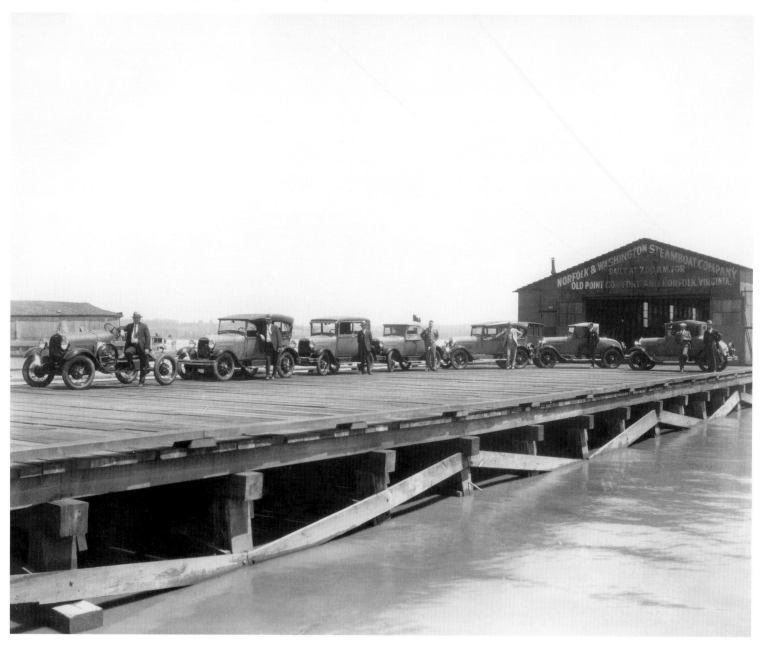

The Potomac Company Canal. George Washington founded the Potomac Company in the 1770s and proposed establishing a canal along the Potomac to allow boats to skirt the most dangerous sections of the river. When Maryland, which had jurisdiction over the river, agreed to support the canal in 1784, Washington oversaw its initial construction. It was completed in 1802, after his death. In the 1820s, the Chesapeake and Ohio Canal company took control of the canal and operated it until 1899. Later, the Baltimore and Ohio Railroad owned it. Competition from the railroads eventually made the canal unprofitable and it ceased operations in 1924.

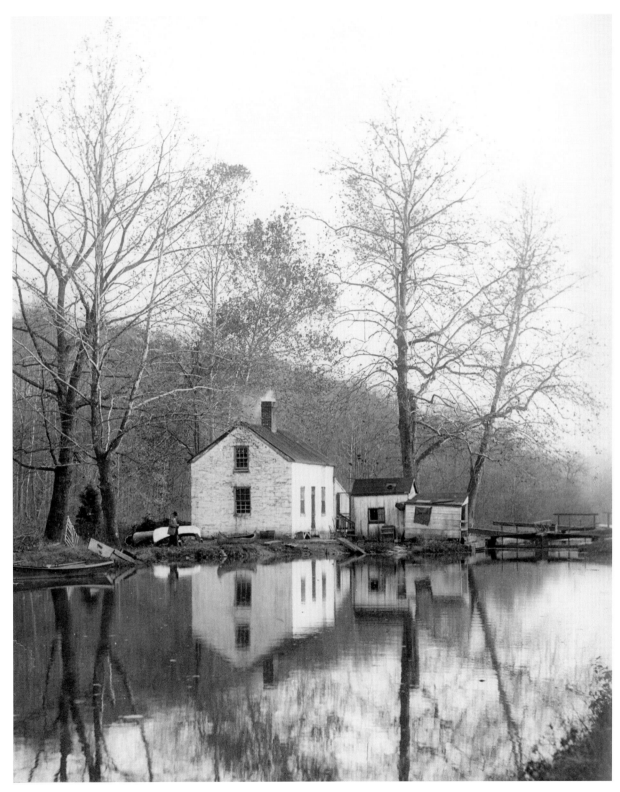

Alexandria City Hall and Market Place on Cameron and N. Royal streets. The original building was destroyed by fire in 1871. A new building was designed by Adolph Cluss and built by E. H. Delchay. The building housed a market house, courthouse, schoolhouse, two firehouses, and a jail, and today serves as City Hall. (ca. 1930)

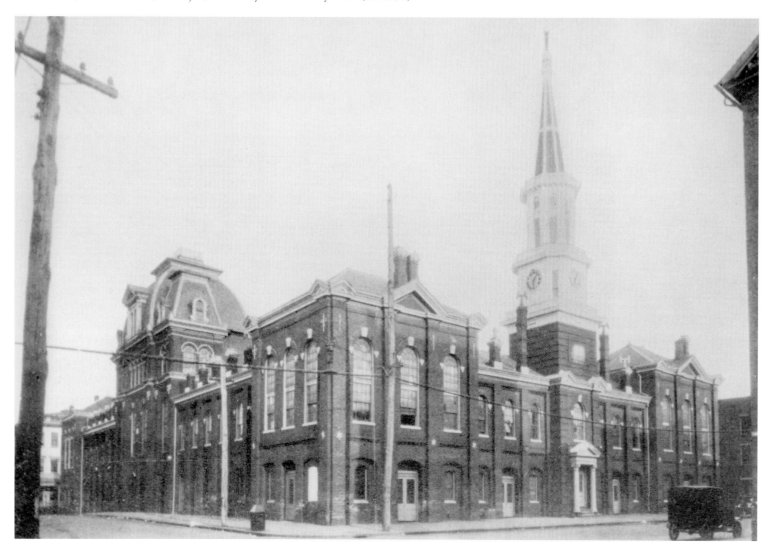

A parade in progress in 1930.

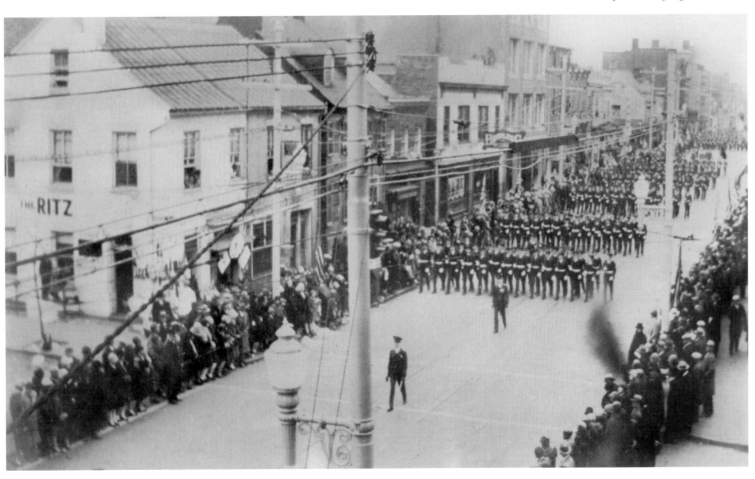

Wesley Snoots, one of the first officers to patrol by motorcycle for the Alexandria
Police Department. (ca. 1930s)

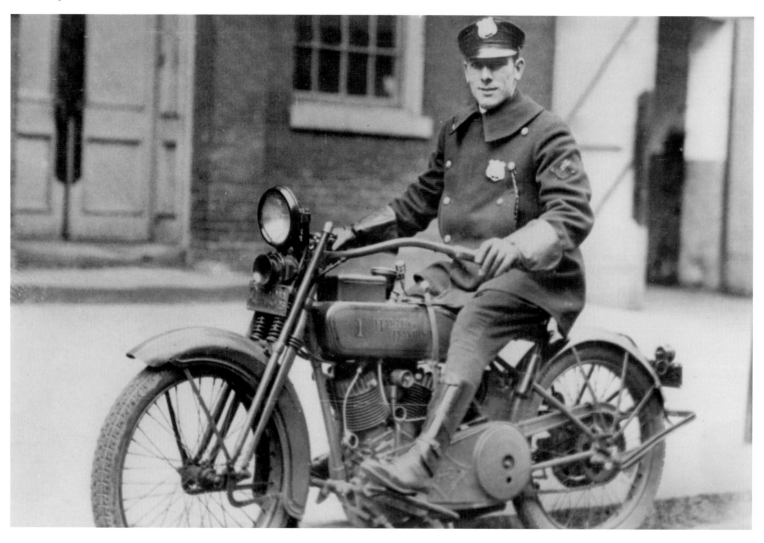

A rear view of the Carlyle House. The second-story porch and first-floor terrace were set atop the vaulted chambers used for storage. (ca. 1930)

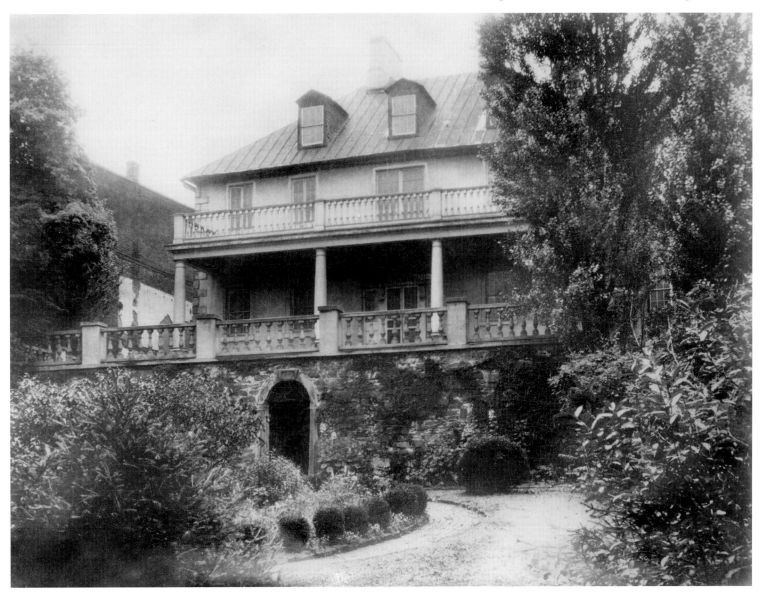

The men and vehicles of the Virginia Public Service Company on King Street. (ca. 1930)

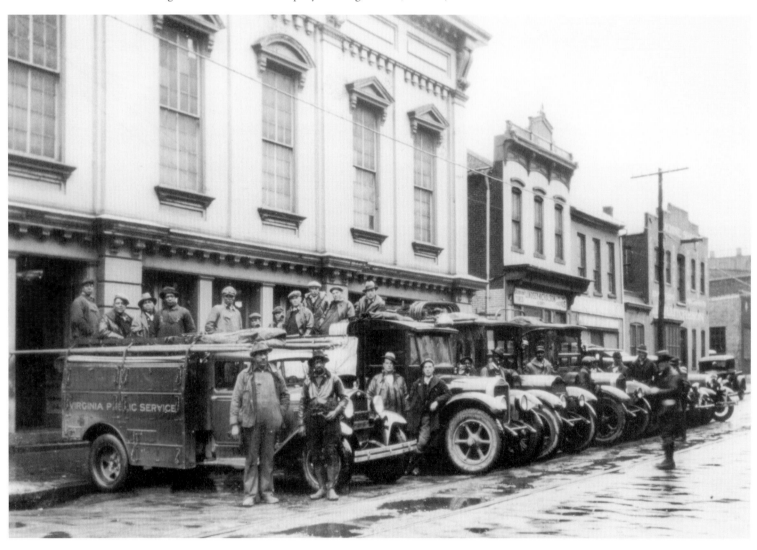

Construction of the George Washington Masonic National Memorial started in 1923. In this image, it nears completion. (ca. 1930)

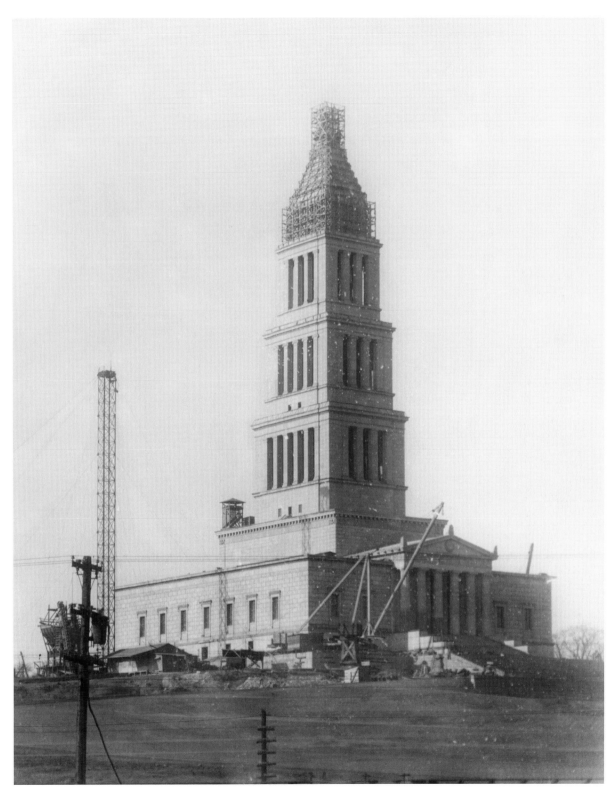

This statue of George Washington awaits installation inside the George Washington Masonic Memorial in 1950. The statue is 17 feet tall and weighs 7 tons.

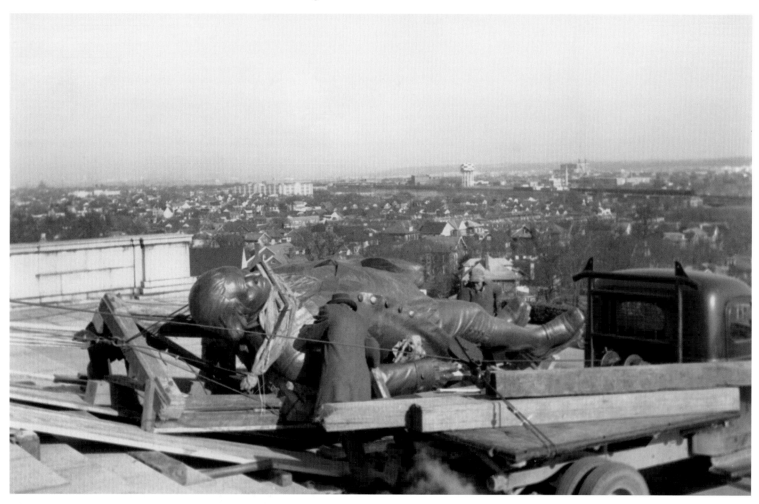

Workers inside the Express Spark Plug Factory at 515 N. Washington Street. (1930)

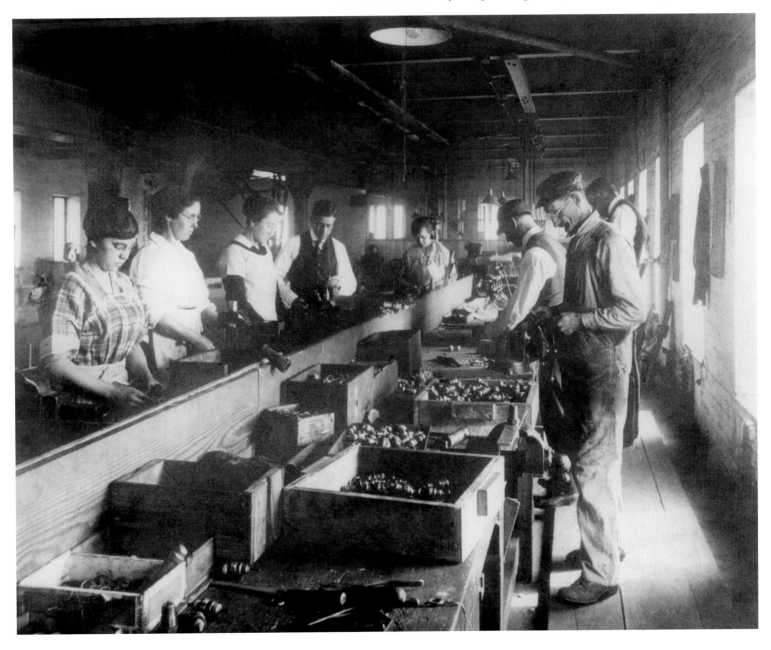

Gadsby's Tavern at 138 N. Royal Street. (ca. 1930)

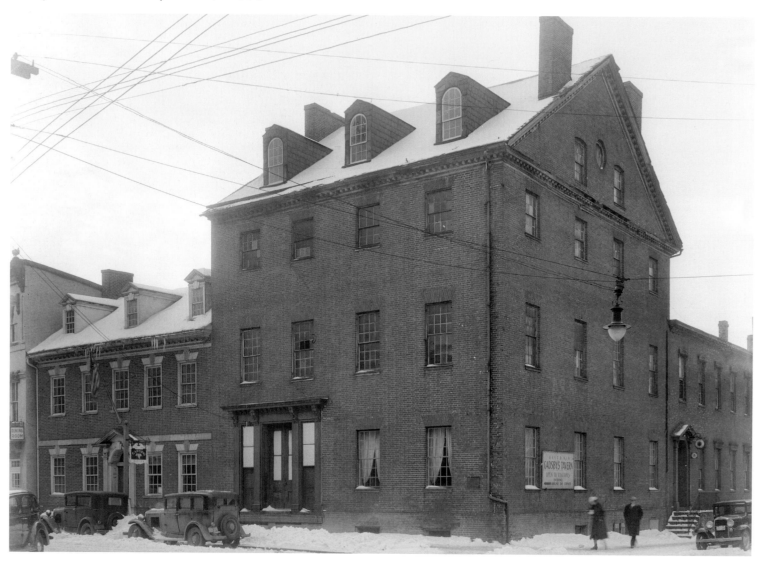

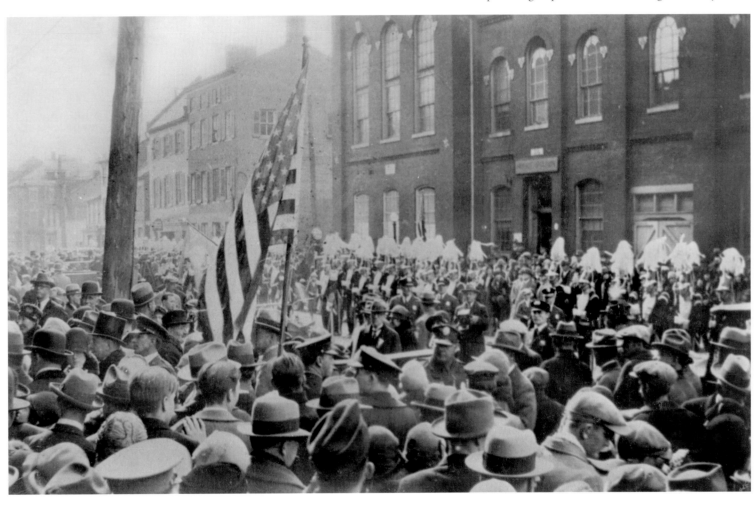

A George Washington birthday celebration in February 1930 along King Street. The white-plumed group is the Richmond Light Infantry Blues.

The Alexandria Light Infantry on Royal Street. (1930)

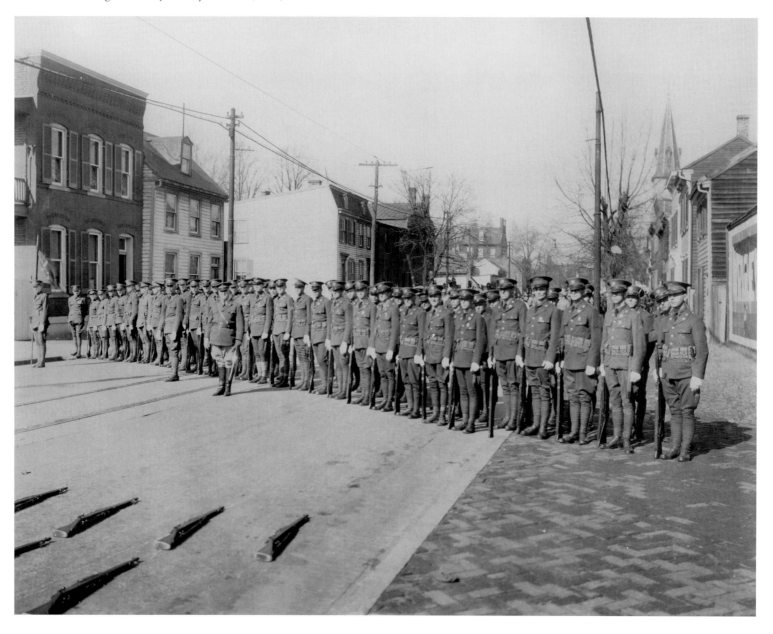

Memorial service for Confederate veterans. Colonel Edgar Warfield (center, in uniform) was the last surviving veteran. (May 1932)

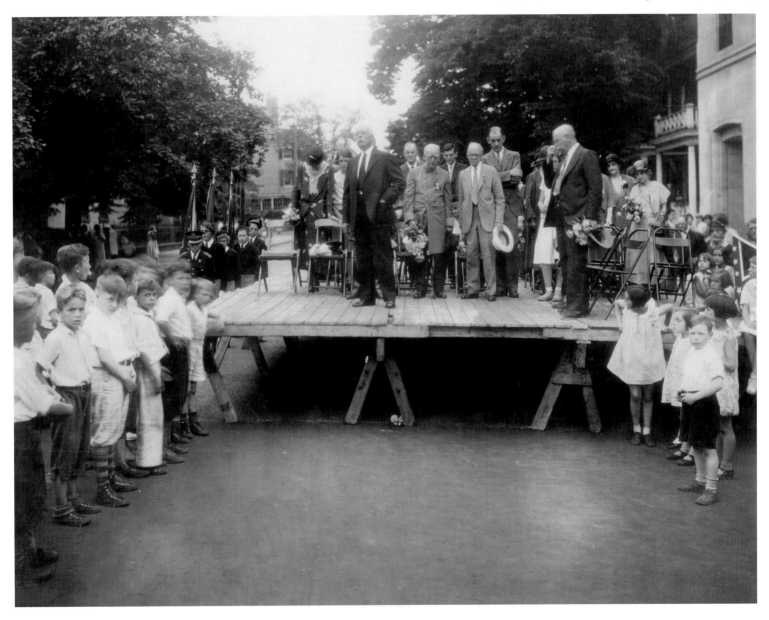

The Alexandria Light Infantry, Company I, in front of tents during
summer camp at Virginia Beach. (1932)

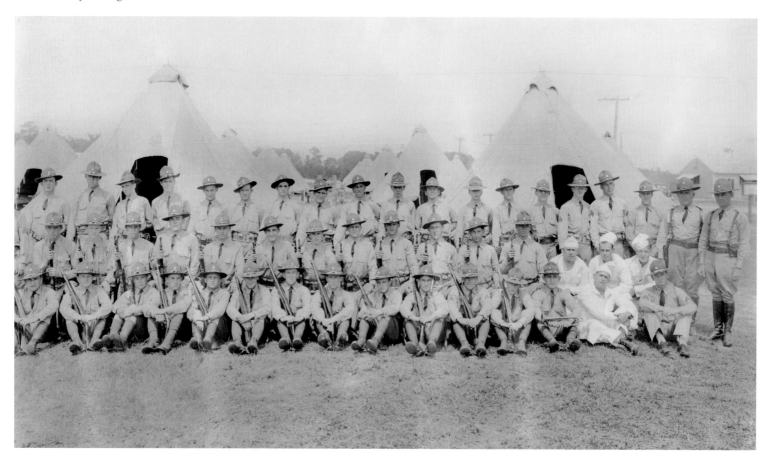

Members of the First Infantry during military exercises at the Armory. Left to right are Captain W. Cameron Roberts, Lieutenant W. Milton Glascow, Lieutenant John Arnold. (ca. 1935)

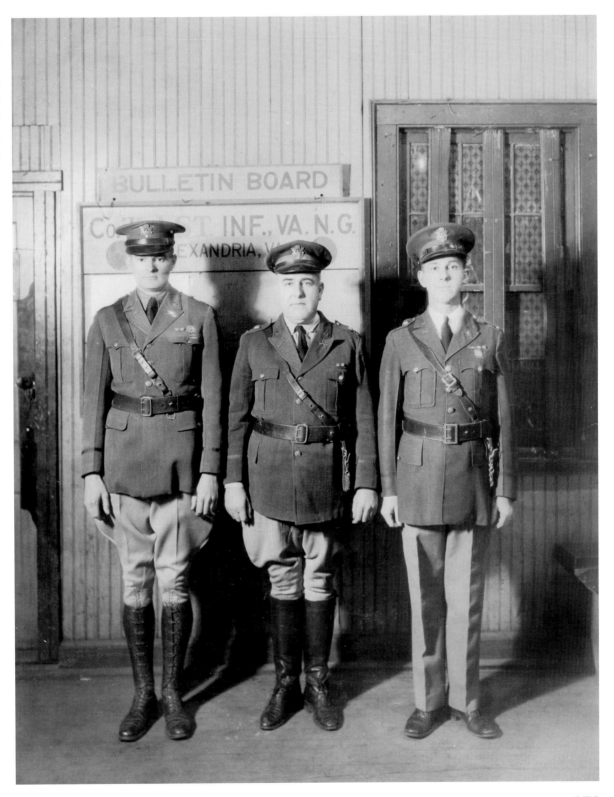

Alexandria, Barcroft & Washington Transit Company (AB & W) buses
provided transportation to the Hoover Airport. (ca. 1935)

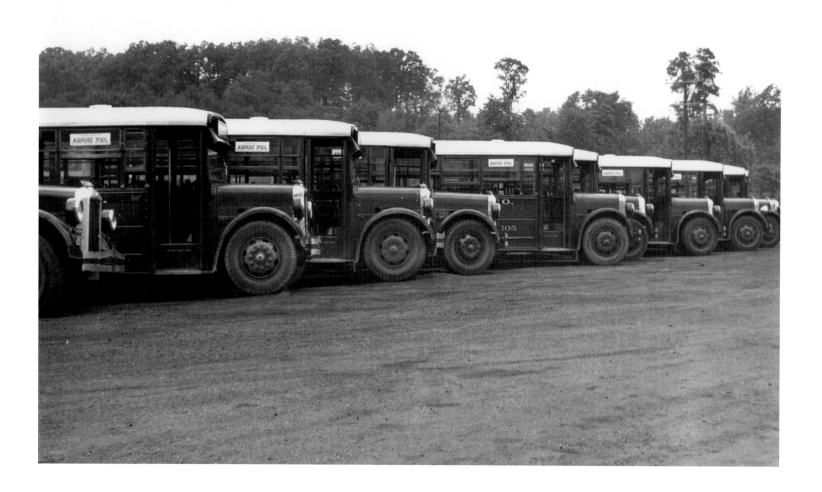

With bottles lining the shelves, these two gentlemen are ready to fill prescriptions at the Stabler-Leadbeater Apothecary Shop. (ca. 1930)

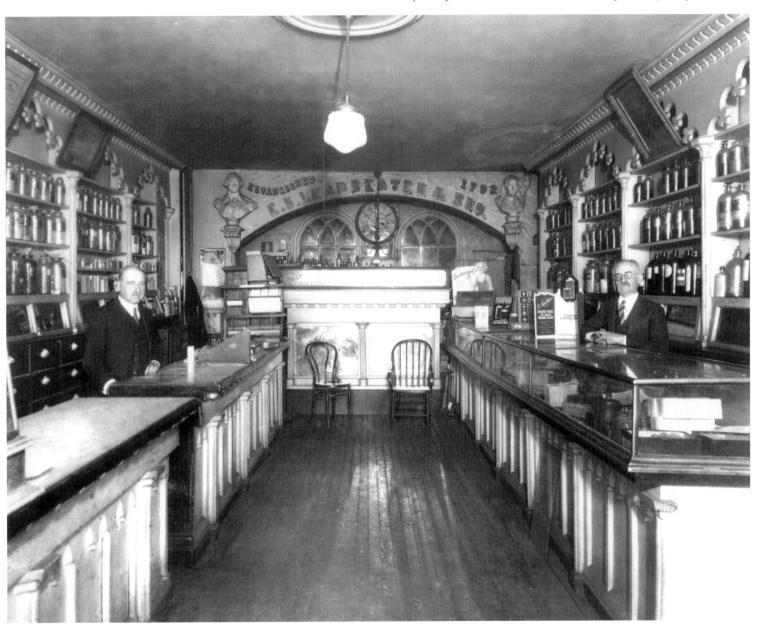

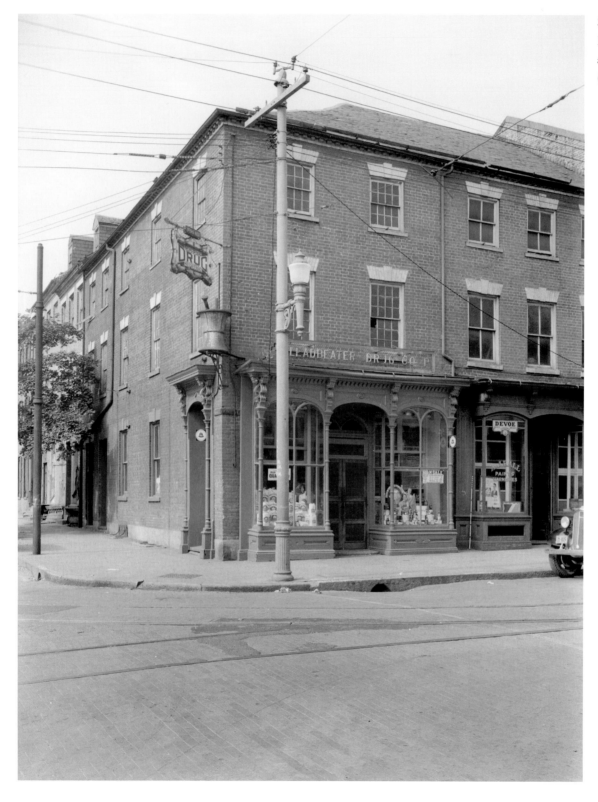

Stabler-Leadbeater
Drug Corp. at King
and S. Fairfax streets.
(ca. 1935)

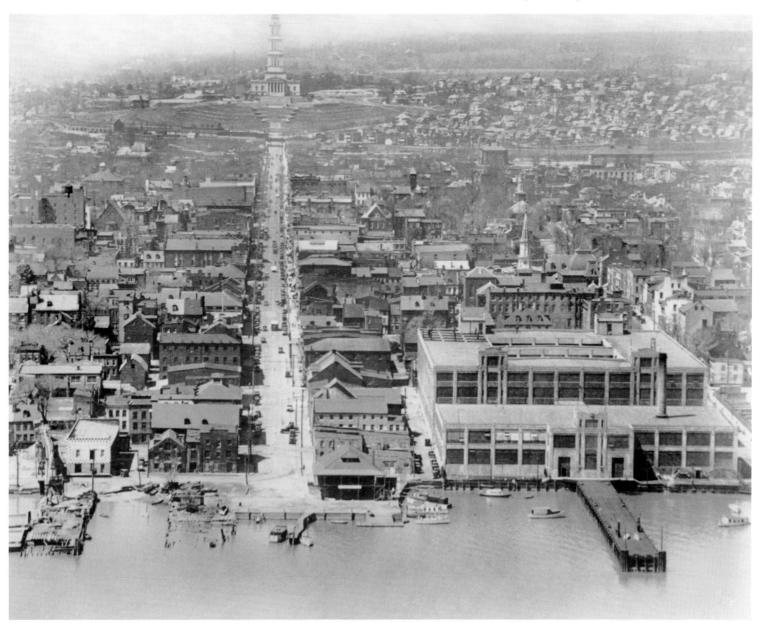

An aerial view of King Street, facing west from the waterfront to the George Washington Masonic Memorial. (ca. 1935)

A view of the George Washington Masonic Memorial across Hunting Creek. (ca. 1935)

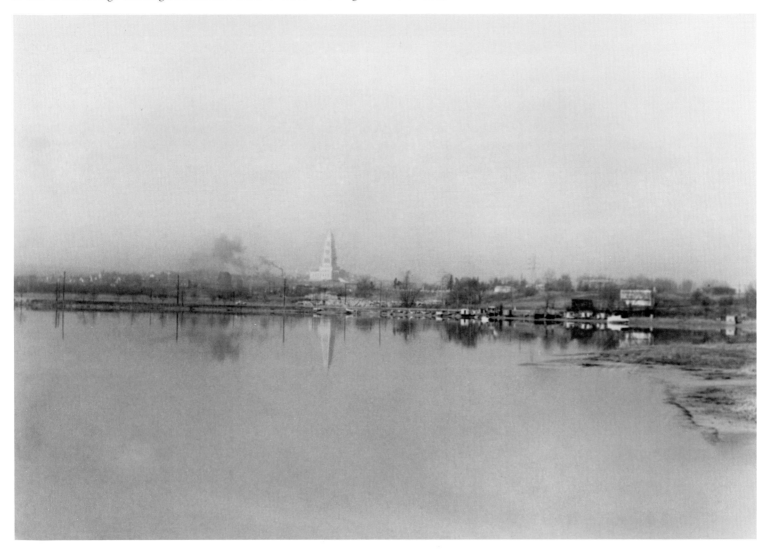

Members of the local Masons attend the laying of the cornerstone for the Alexandria Library on Queen Street. (1937)

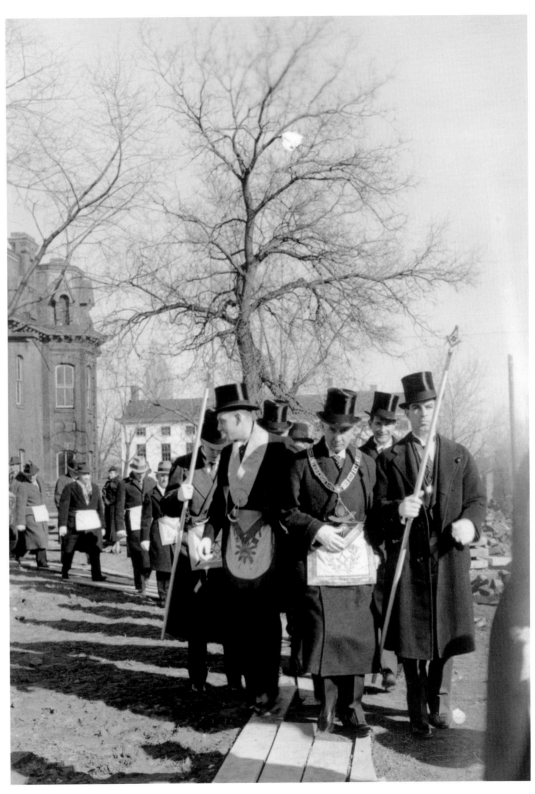

Corner of Prince and Washington streets. The Confederate Monument faces south. Behind the monument rises the U.S. Custom House and Post Office. (1937)

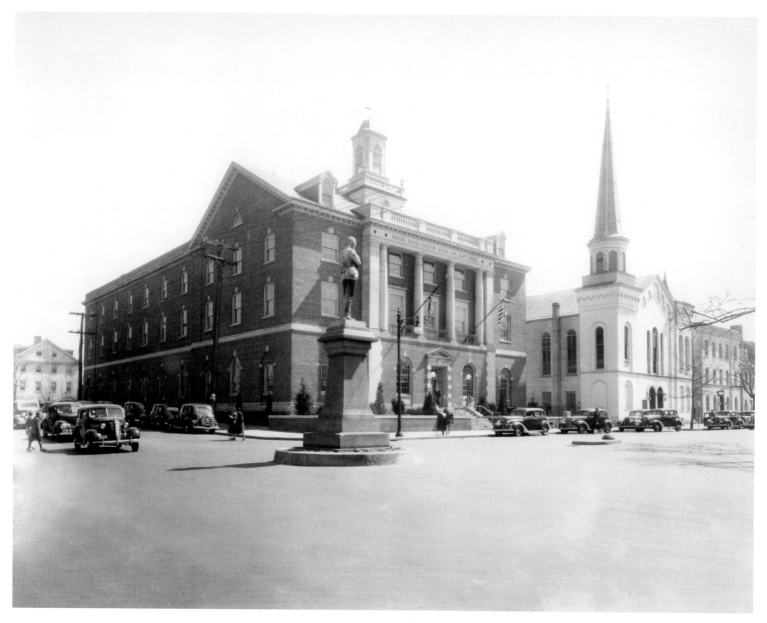

THE WAR YEARS AND POSTWAR PROSPERITY

(1940–1970s)

The start of World War II and associated growth in the federal government benefited Alexandria tremendously. Since Reconstruction, the city had struggled economically. The explosive growth of the federal government during and after World War II helped propel Alexandria out of its status as a struggling bedroom community of Washington, D.C., to a destination city in its own right. The expanded government needed thousands of workers, and Alexandrians helped fill the ranks. New federal employees also chose Alexandria as an affordable alternative to living in Washington. The preservation movement began in earnest during this time as the city came to realize the importance of preserving historic buildings.

The Torpedo Factory played a prominent role, locally and nationally, during and after World War II. As a munitions factory, it employed thousands and ran twenty-four hours a day, seven days a week to produce torpedoes and other weapons. After the war, it was used by the federal government as a sorting and storage facility for thousands of records captured in Europe and Asia. The records were later transferred to the National Archives.

Battles over desegregation occurred in Alexandria, much like the rest of the South. A sit-in during 1939 prompted the city to provide a library for African Americans by the early 1940s. Most businesses and institutions were segregated into the 1960s. In 1971, the recently integrated T. C. Williams football team won the state championship. The team and events surrounding the years shortly after school integration were the inspiration for the movie *Remember the Titans*.

The Woodrow Wilson Bridge, built at the edge of the Alexandria waterfront and designed as a route into Maryland and Washington, D.C., was completed in 1961. It became a main thoroughfare between the Virginia suburbs of Washington and communities across the river. The bridge and associated highway running at the boundary of Alexandria are now part of I-95, the main north-south highway on the East Coast.

Alexandrians are justly proud of their city. A colorful history and well-preserved downtown make it a charming place in which to live, work, and visit. Over more than 250 years, Alexandria grew from a small southern port town to a nationally known, cosmopolitan city. With its history always in mind, Alexandria looks forward to a prosperous future.

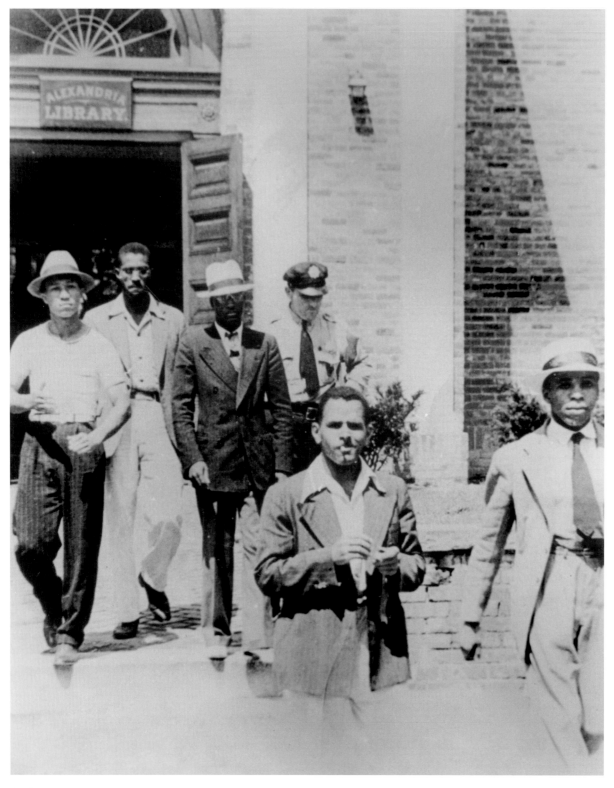

Five young men were arrested after a sit-in at the Alexandria Library to protest denial of access. By the early 1940s, Alexandria had provided a library for use by the African American community.

162

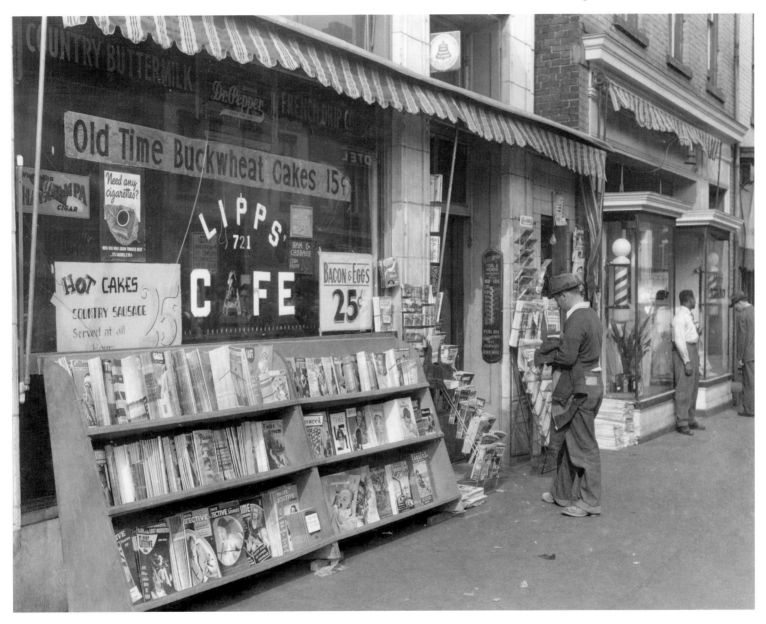

Lipps' Cafe at 721 King Street in the 1940s. This was a popular place to get a meal, buy a magazine, or have coffee with friends.

Tubby Sisson's Fish Wagon. (ca. 1940)

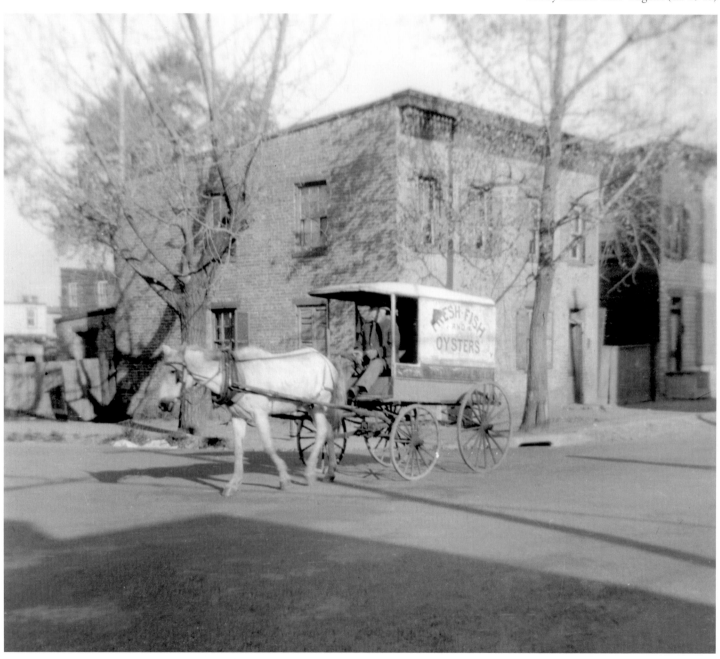

The George Washington
Masonic National Memorial.
(ca. 1940s)

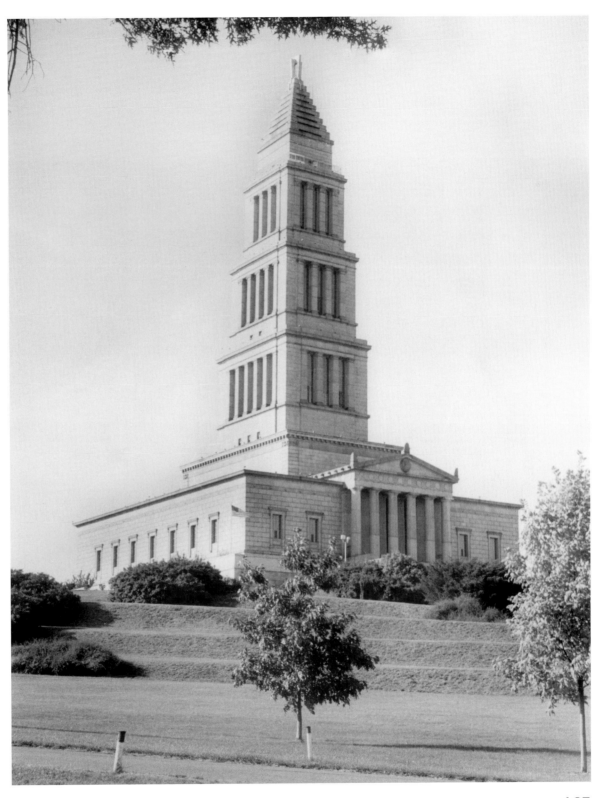

A faithful friend waits in the garden of this Alexandria locale.

Northwest corner of King and Washington streets. (ca. 1940)

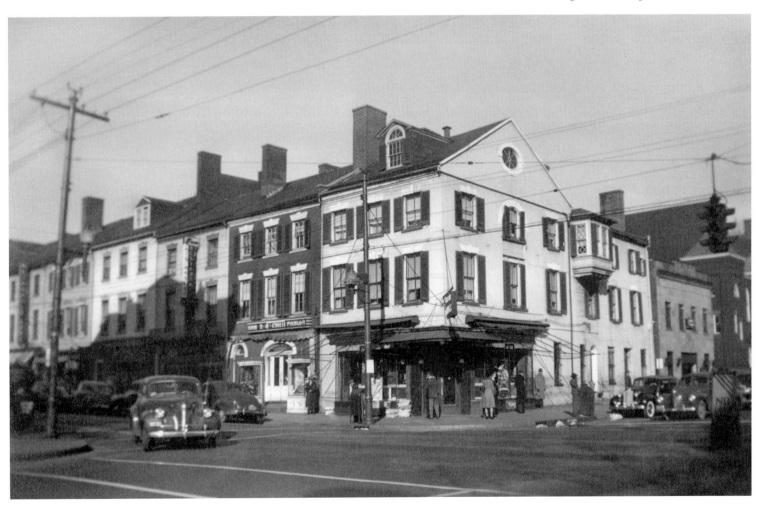

An eighteenth-century re-enactment takes place in front of the Stabler-Leadbeater
Apothecary Shop on S. Fairfax Street. (ca. 1940)

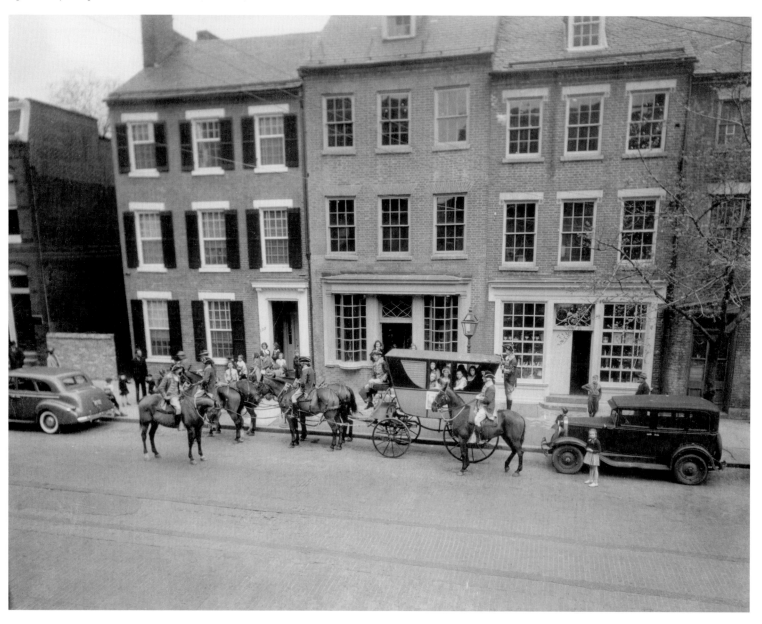

The 1944 George Washington High School football team.

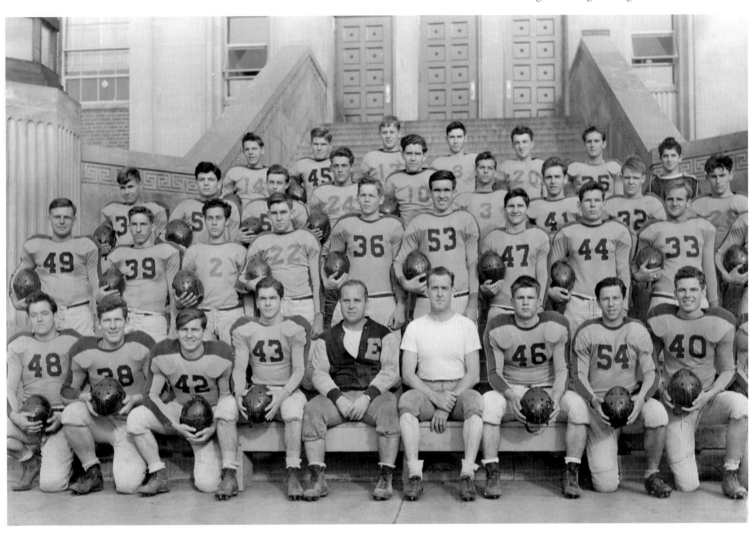

A wartime King Street in 1942.

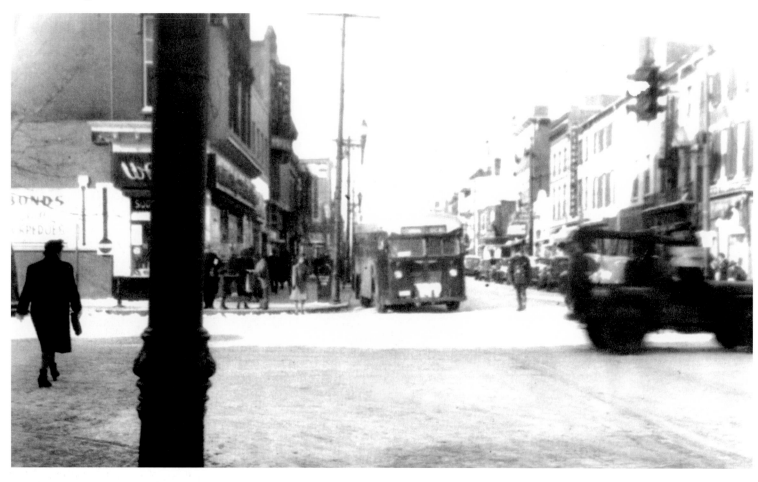

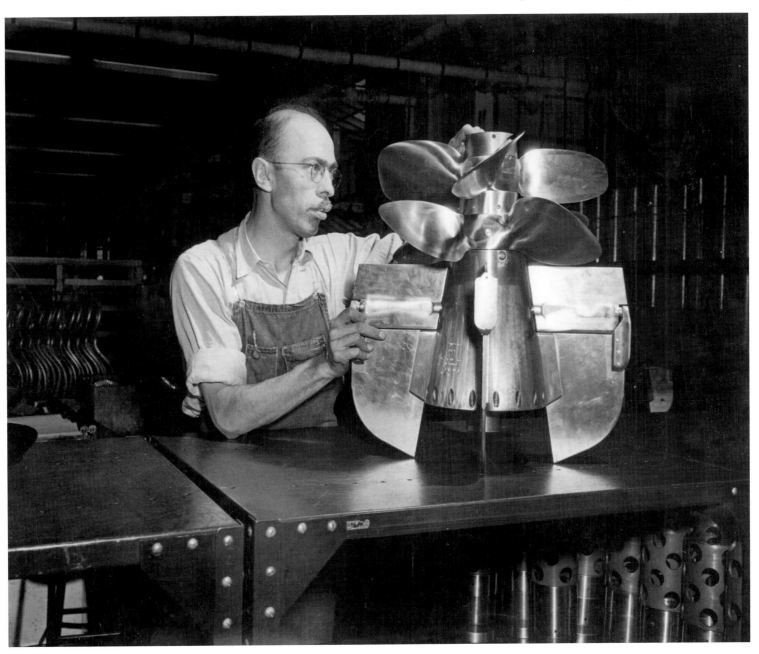

Torpedo Factory personnel during World War II. During the war, the factory
ran twenty-four hours a day and produced torpedoes for both aircraft and
submarines. (ca. 1943)

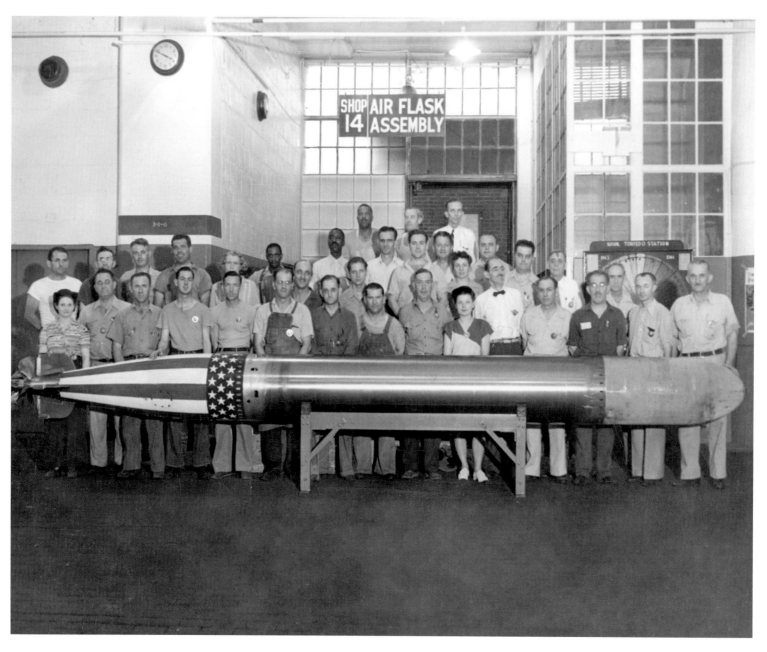

As World War II draftees, Alexandrians leave from the Union train station. (May 12, 1943)

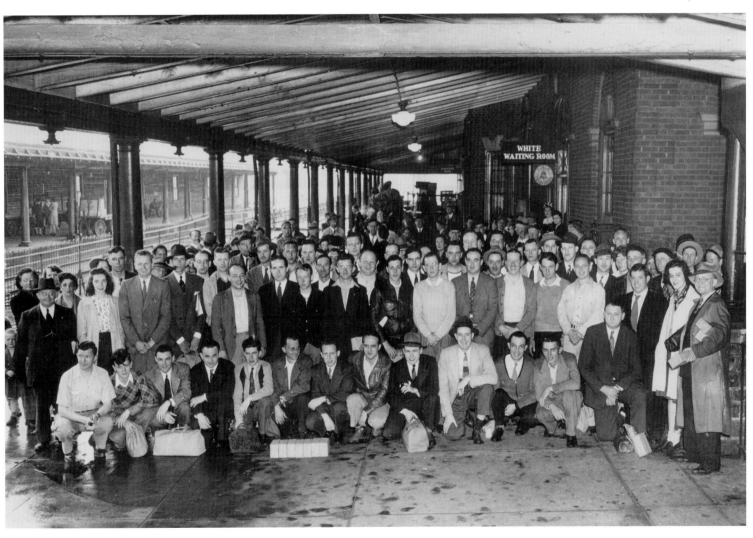

Mrs. Susie Glascow promotes the sale of Christmas trees by the Optimist Club to benefit the local Boys Club. (ca. 1945)

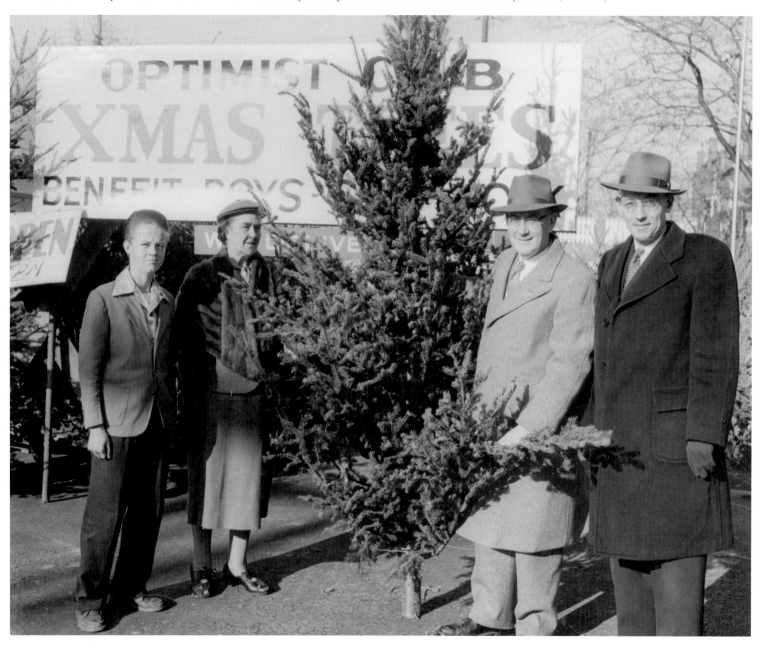

World War II draftees wait to board the bus. (June 1, 1945)

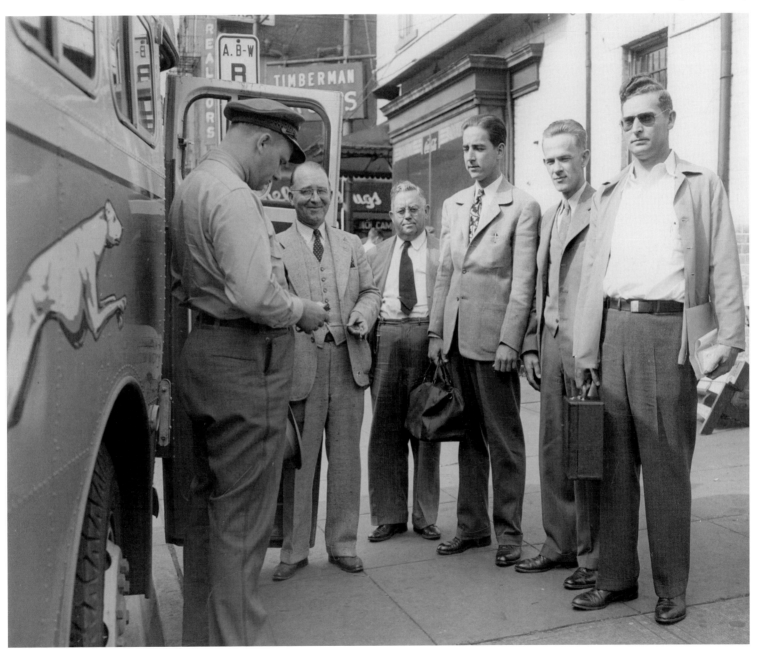

A view east from the George Washington Masonic Memorial toward downtown and
the Potomac River. (ca. 1945)

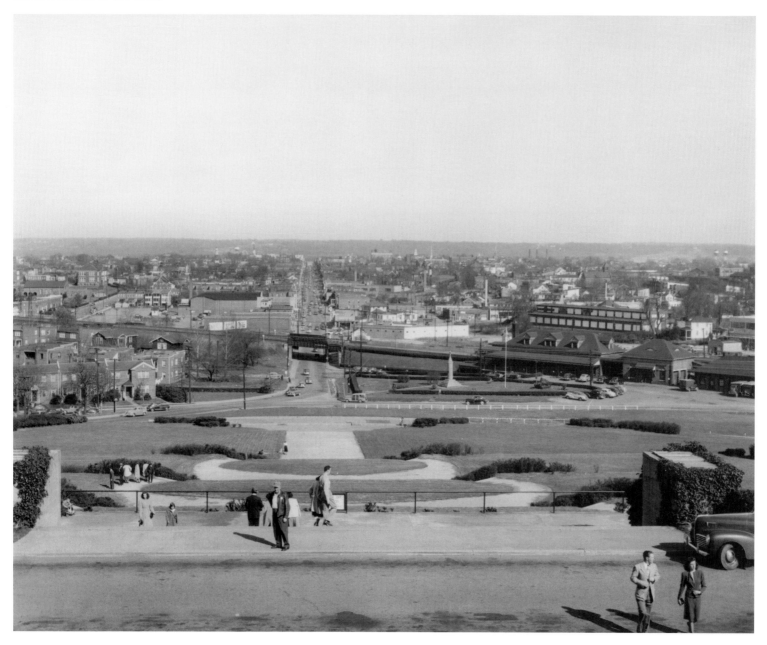

Jack Morton's Music provided the entertainment at the Christmas party hosted by the Potomac District Northern Division American Legion. (1946)

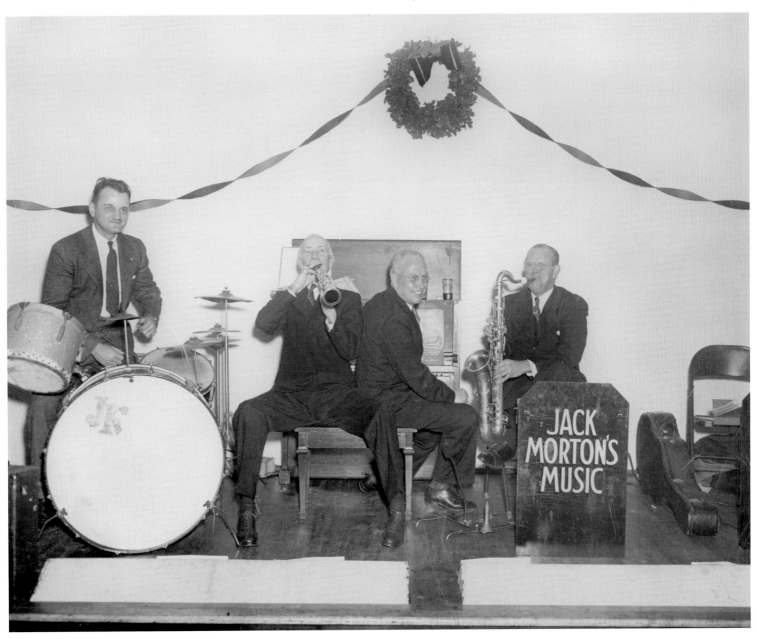

Banners and flags at King and Washington streets welcome VFW members to Alexandria. The city was hosting the state convention of Virginia Veterans of Foreign Wars. (February 26, 1946)

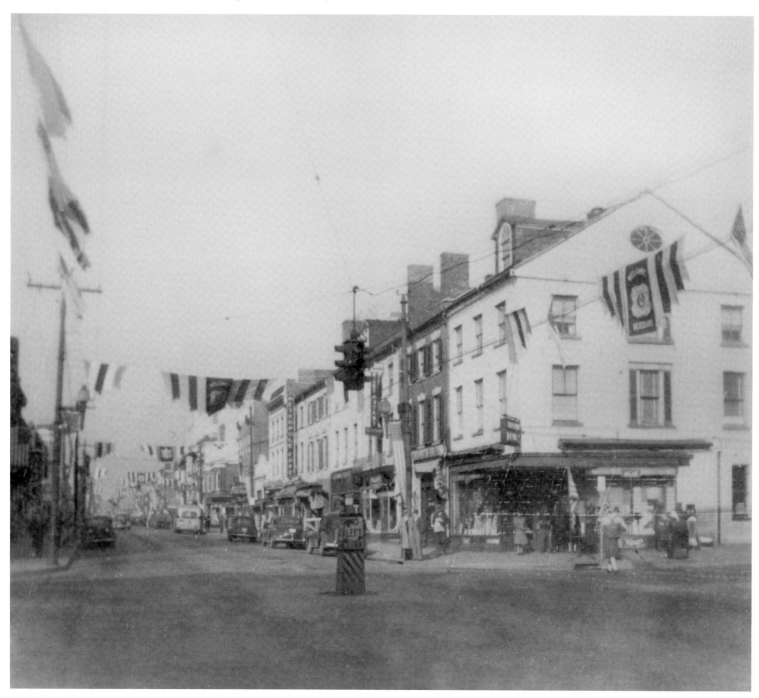

The Virginia Grill at King and Washington streets. The restaurant was one of the most popular places to eat in Alexandria. (1947)

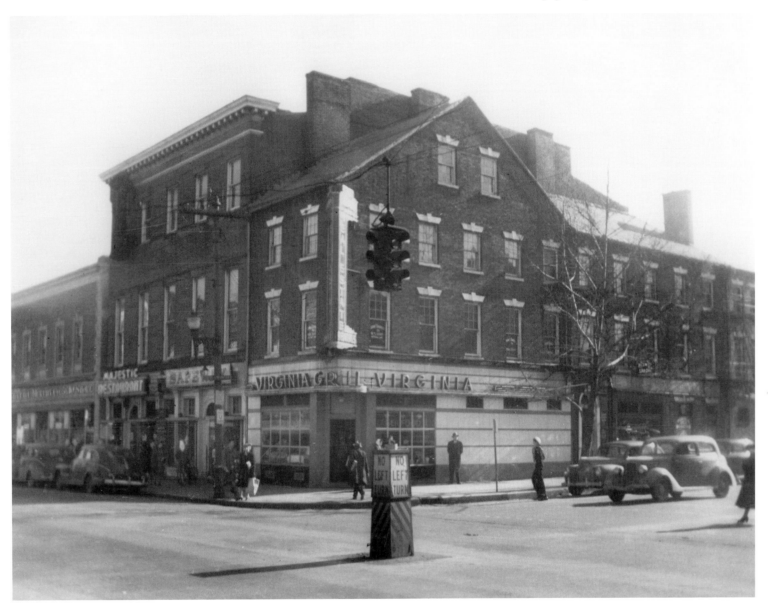

A view of the waterfront at the Old Dominion Boat Club dock during the Middle State Regatta. (September 5, 1948)

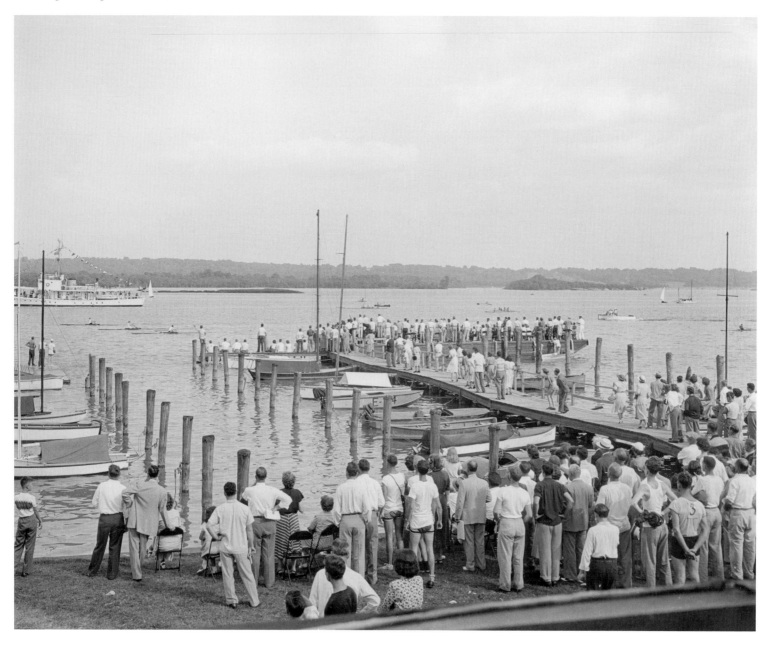

Members of the League of Women Voters remind citizens of Alexandria to register to vote. (1949)

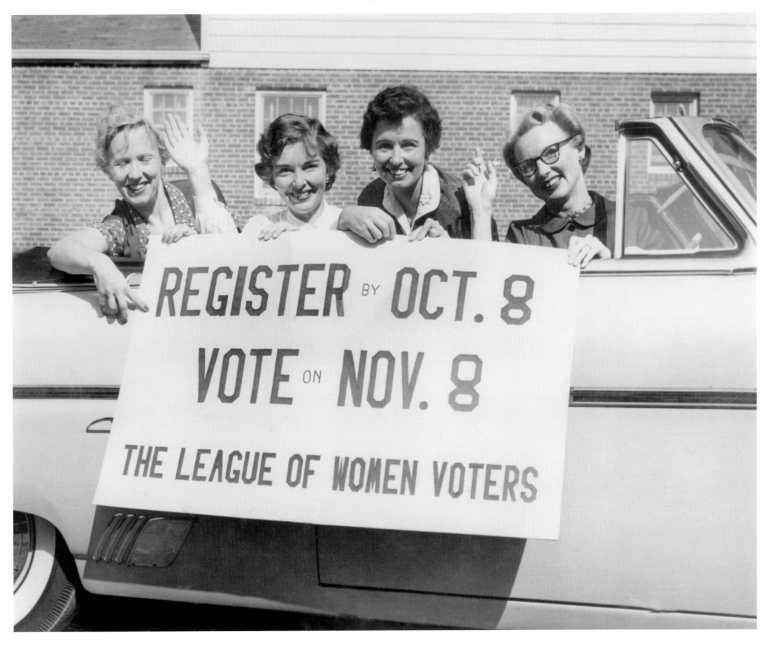

The Beachcombers Restaurant at the foot of Prince Street. It was built about 1948 by
Alexandria businessmen and was in business for approximately five years. (1949)

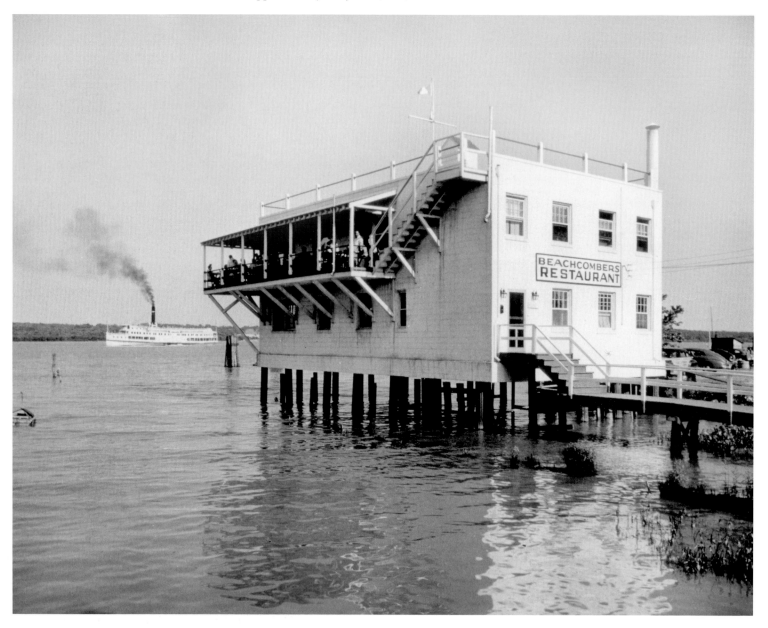

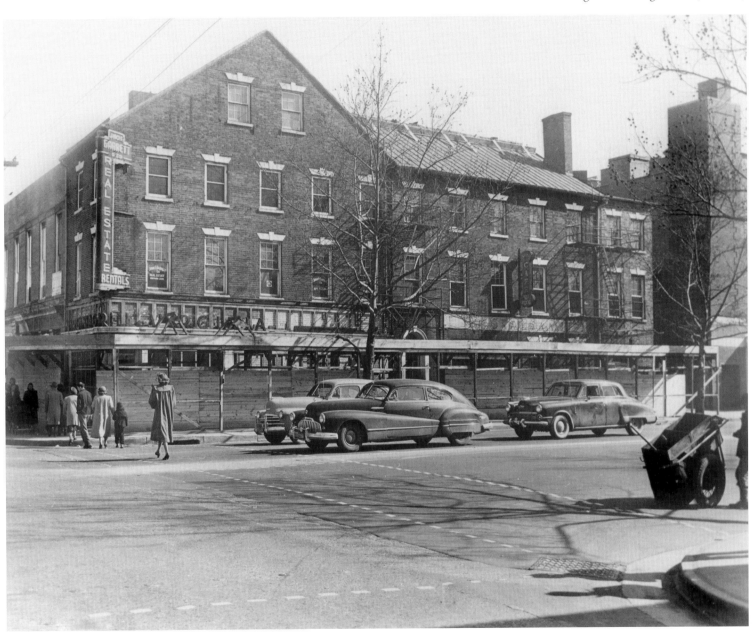

Washington and King streets. (ca. 1950)

183

King and Royal streets around 1950.

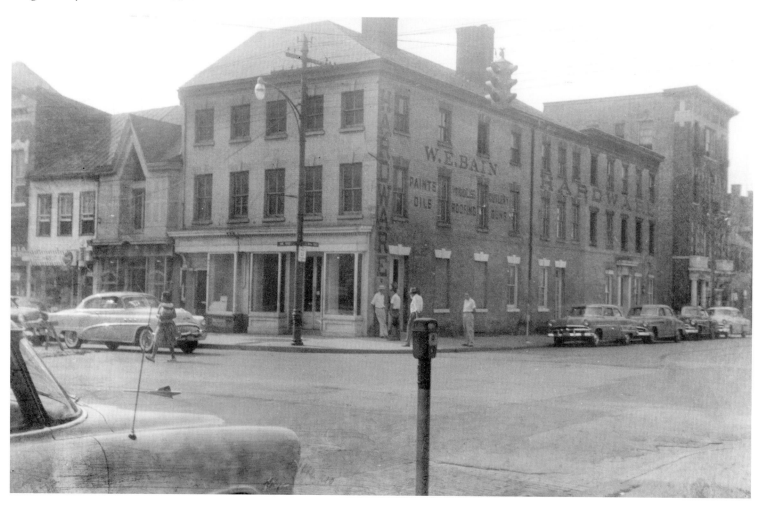

Remember the Rams? The Alexandria Rams, shown here in 1951, were a semi-pro football team that integrated well before the famous T. C. Williams High School Varsity Titans. In 1964, they became the first integrated team ever to play in Charleston, South Carolina.

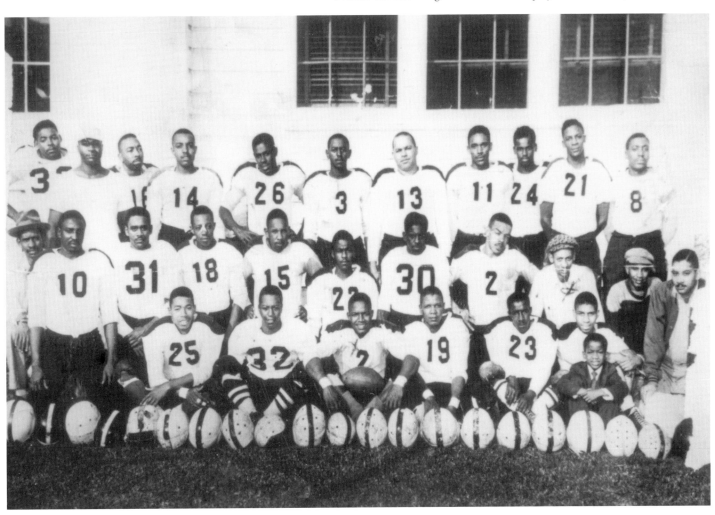

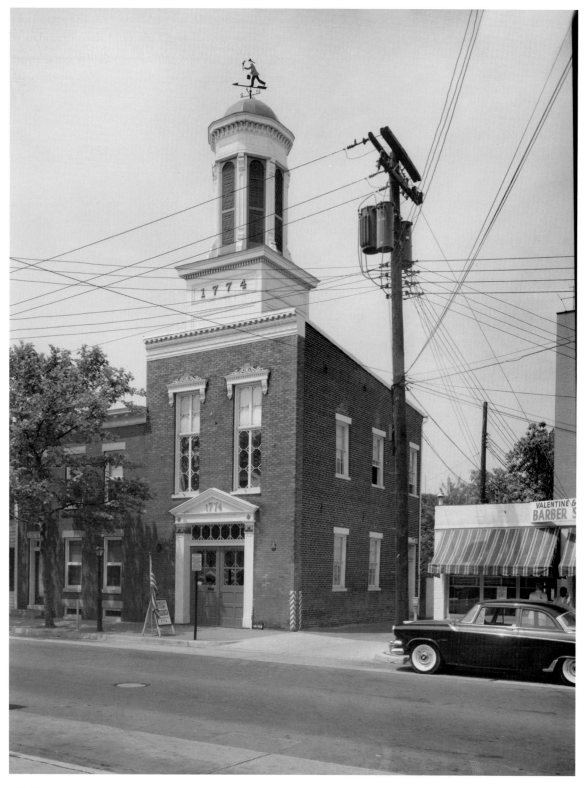

Friendship Fire Company, at 107 S. Alfred Street. The company was established in 1774 and moved to this firehouse about 1855. The building was renovated in 1992 and is now a museum. (ca. 1955)

A sign of days gone by: a railroad
crossing for the Washington & Old
Dominion Railroad. (ca. 1955)

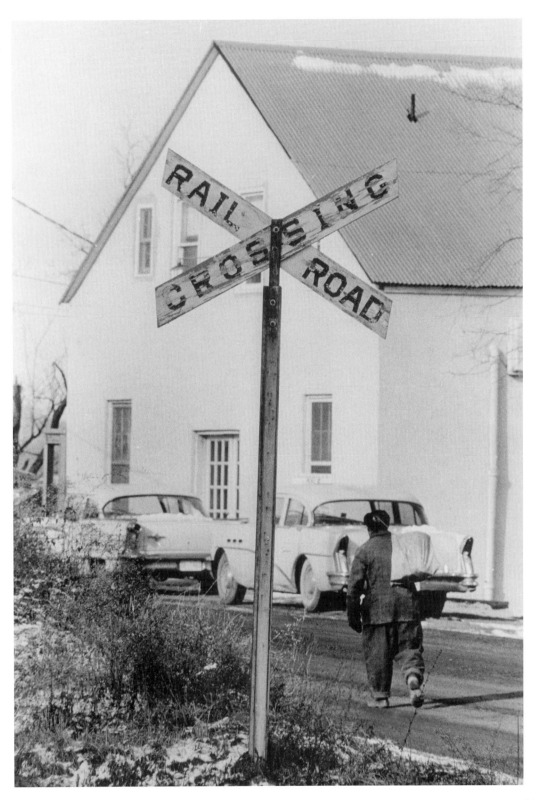

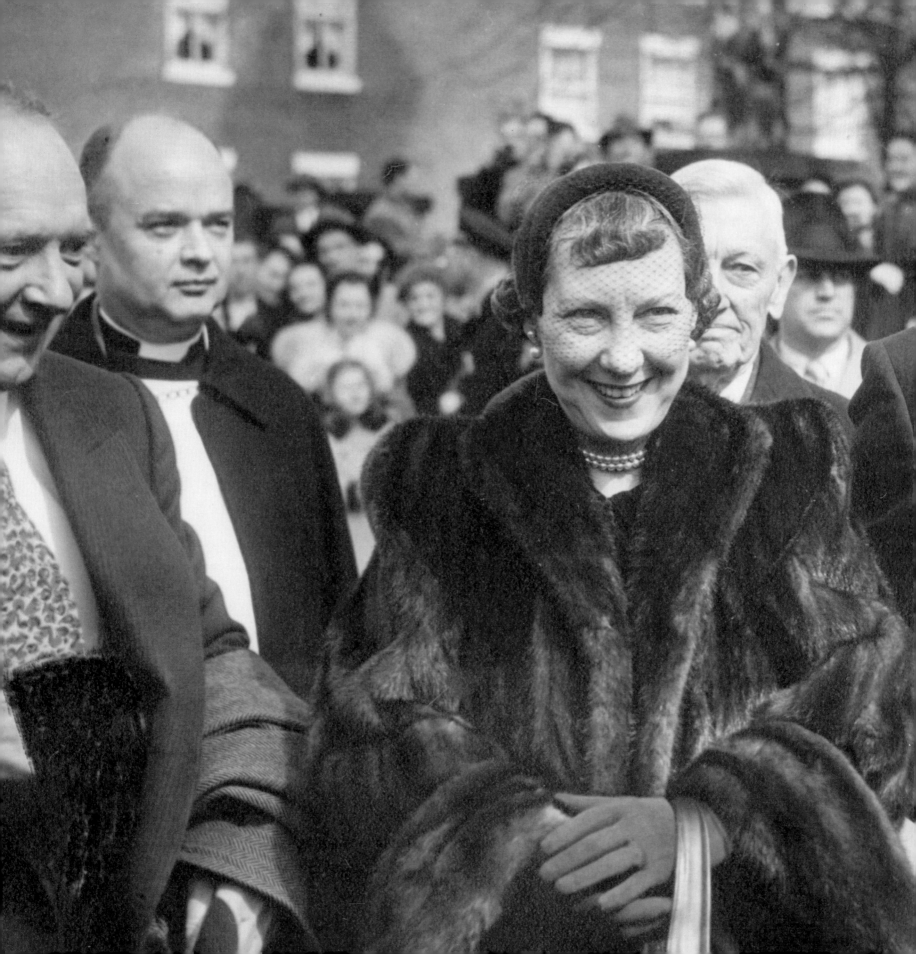

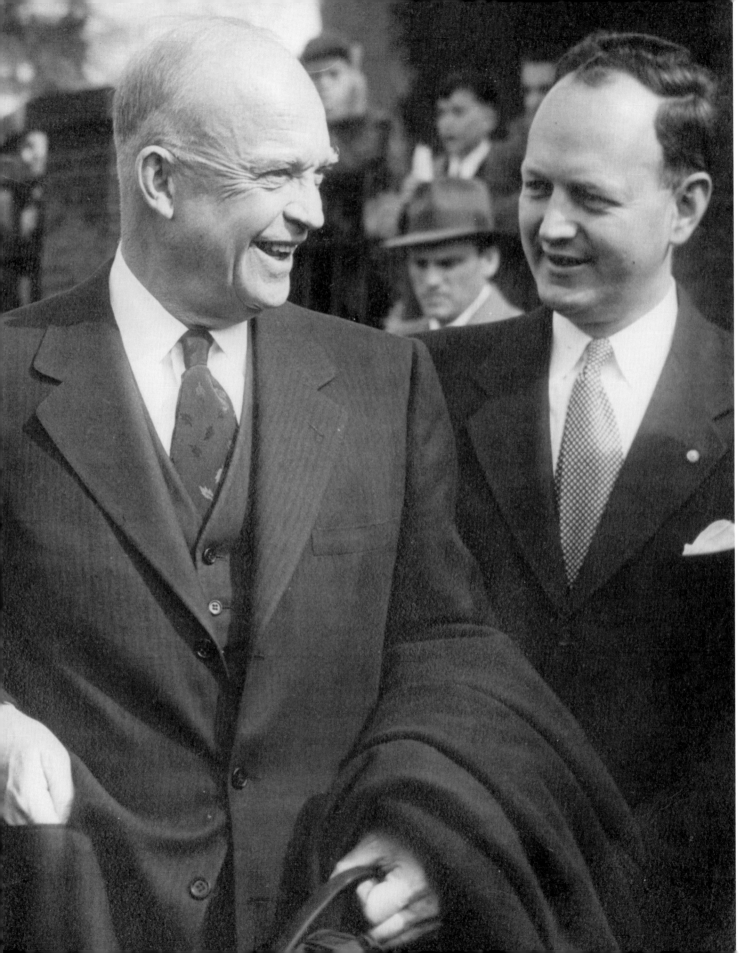

President Dwight D. Eisenhower and First Lady Mamie when they visited Christ Episcopal Church in February 1953.

A familiar landmark in Alexandria is the Washington Street United Methodist Church at 115 S. Washington Street. The cornerstone was laid in 1850. The church underwent extensive renovations in 1875 and 1899. (ca. 1955)

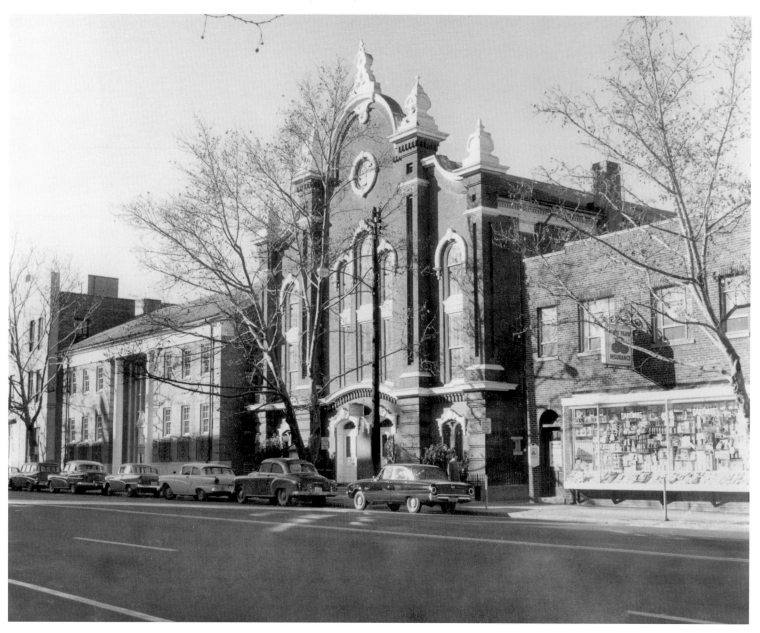

A popular stop for tourists is the smallest house in Alexandria, found at 523 Queen Street. Built in the 1830s, it has two stories and is a mere seven feet wide and 36 feet long. (1959)

Aerial view of Alexandria about 1960.

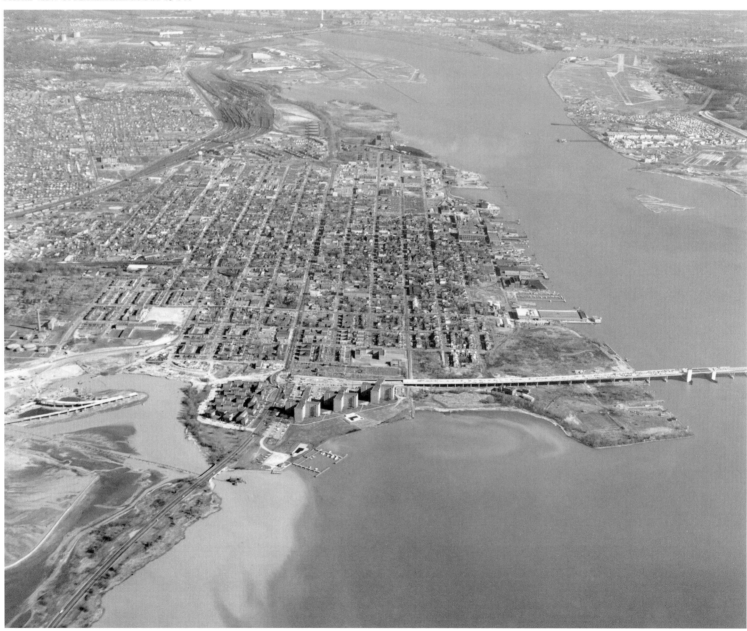

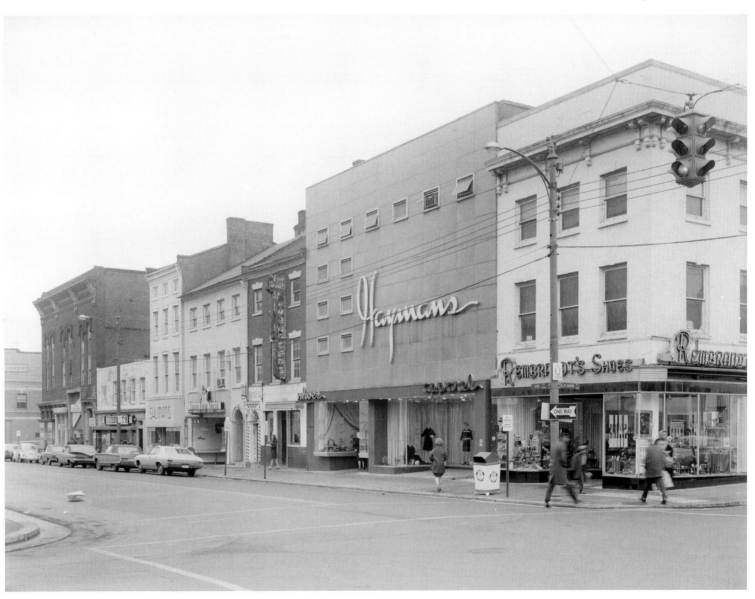

The 500 block of King Street in the 1960s.

Alfred Street Baptist Church, at 301 S. Alfred Street. Founded in 1803, it is the oldest African American congregation in Alexandria. The newer building was completed in the 1990s and added to the original church, built in the 1850s.

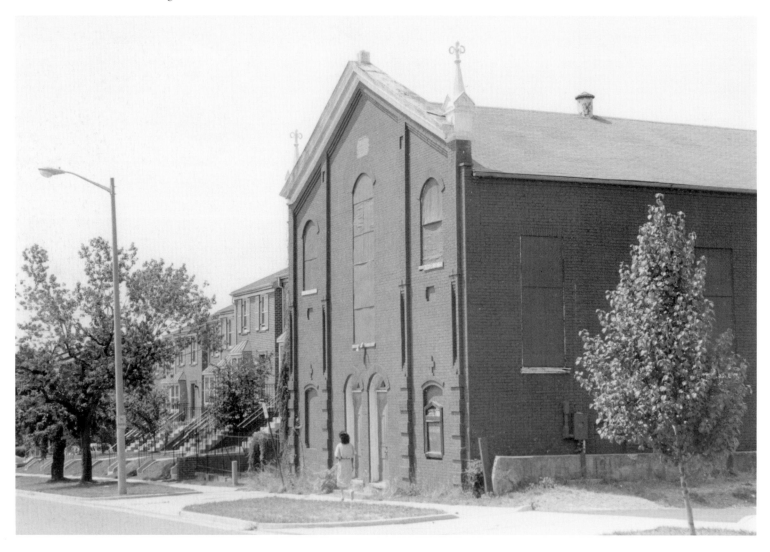

An engine waits at the Potomac Yards interchange. Standing on the engine are H. E. Cunningham (left), conductor, and Douglas Lee, engineer. Standing below them are Randolph Shutts (left) and Arthur Cole, both of them brakemen. (May 25, 1963)

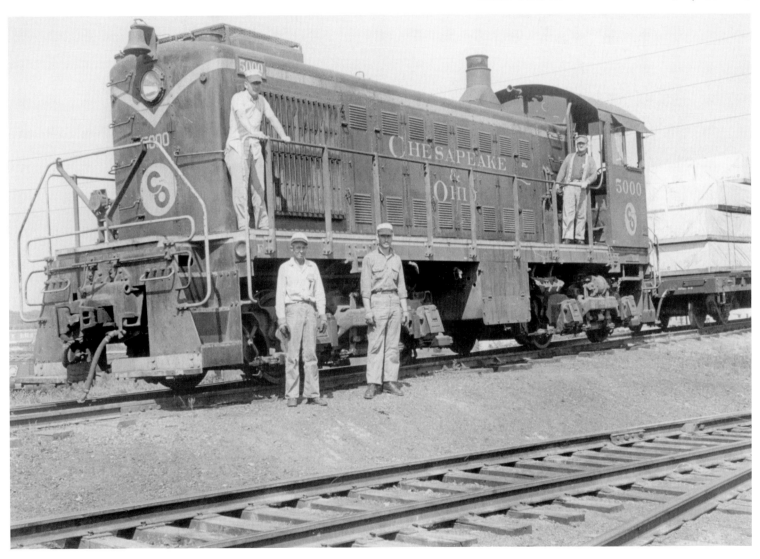

Lannon's Opera House at 500 King Street. The building was erected in 1870 and demolished 1969. (ca. 1965)

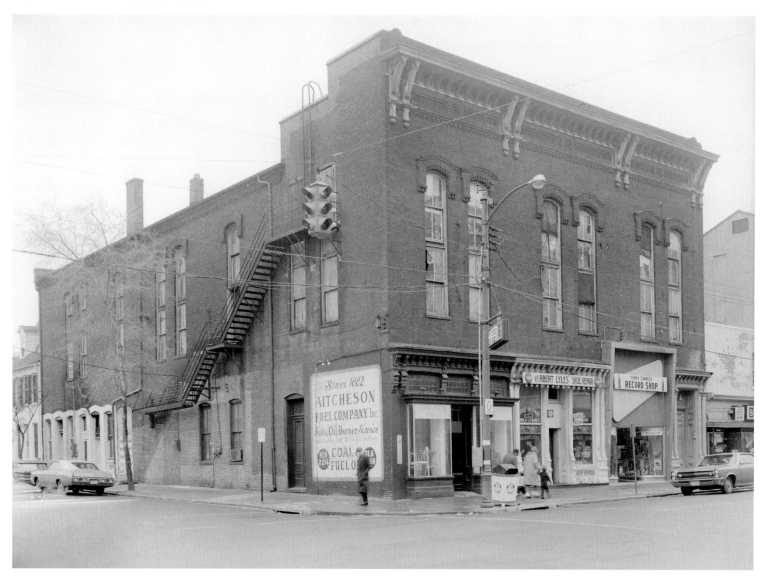

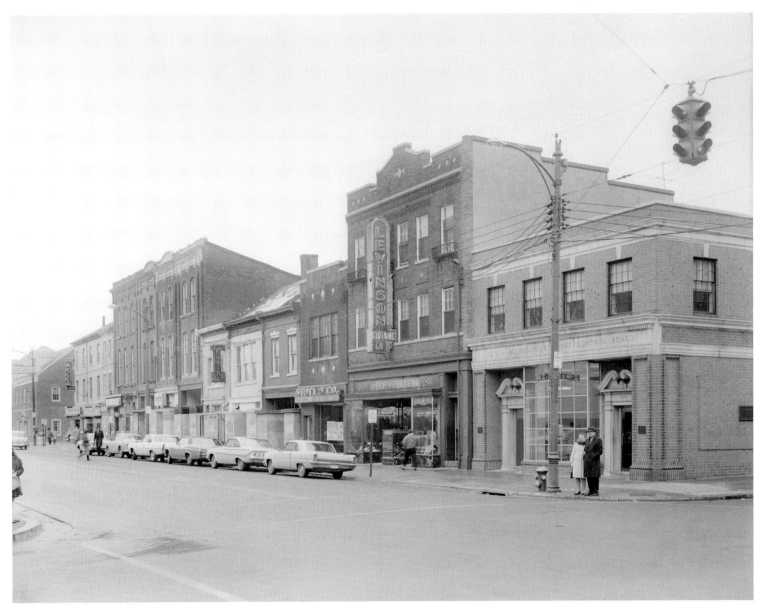

The 400 block of King Street, in view here around 1970.

Road construction on the beltway—a common sight in the Alexandria–
Washington, D.C., area. (1975)

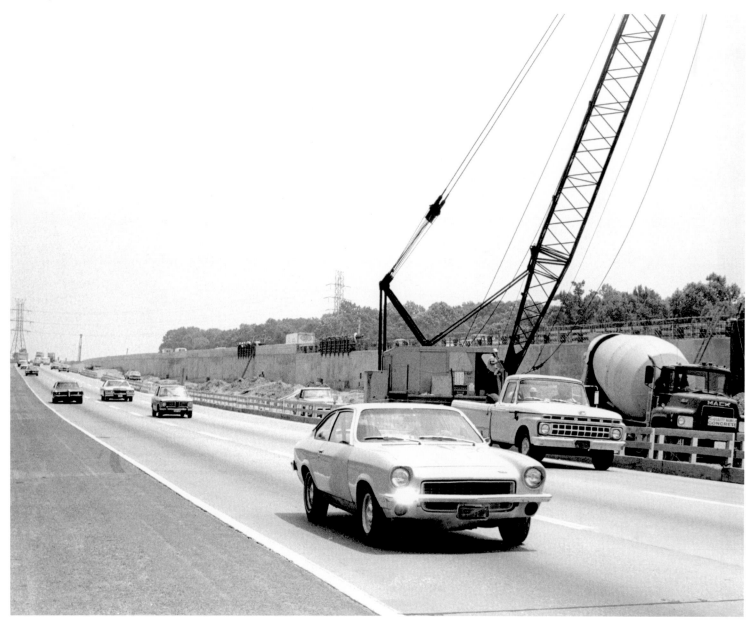

The Wilkes Street tunnel was built for the Orange & Alexandria Railroad in 1856 and is the only remaining structure of this early line. The tracks are now gone and it is used as a pedestrian walkway. (1970)

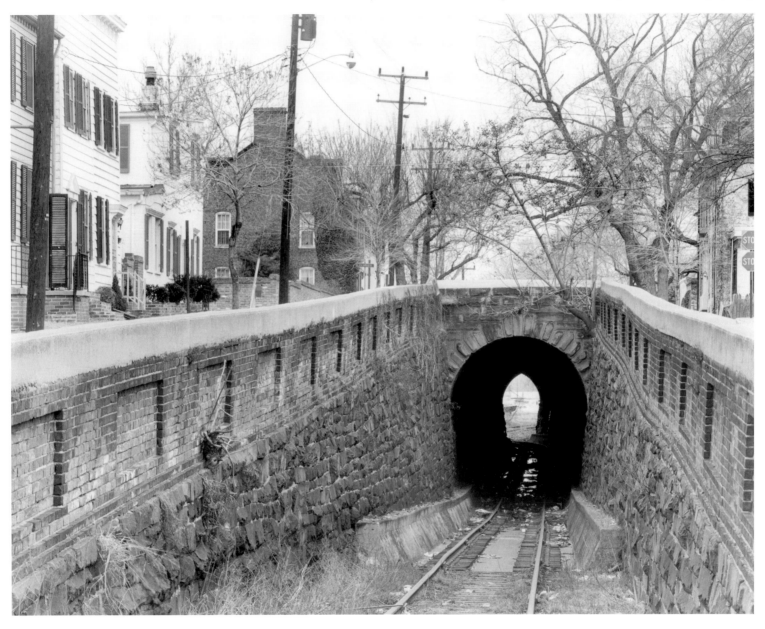

Notes on the Photographs

These notes, listed by page number, attempt to include all aspects known of the photographs. Each of the photographs is identified by the page number, photograph's title or description, photographer and collection, archive, and call or box number when applicable. Although every attempt was made to collect all available data, in some cases complete data was unavailable due to the age and condition of some of the photographs and records.

II **COAL WHARF**
Library of Congress
LOC 11486-B, no. 4

VI **VARSITY FOOTBALL TEAM**
Alexandria Library, Special
Collections, Vertical File
Collection 1201A

X **STAR FIRE COMPANY**
Alexandria Library, Special
Collections, William Smith
Collection 719

2 **MURDER AT MARSHALL**
Library of Congress
LOC LC-B811-4034

3 **STOCKADES**
Alexandria Library, Special
Collections, William Smith
Collection 136

4 **PENSACOLA**
Library of Congress
LOC LC-B811-103

6 **UNION SOLDIERS**
Library of Congress
LOC LC-B811-2296

7 **SLAVE PEN**
Library of Congress
LOC LC-B811-2300

8 **DUKE STREET SLAVE PEN**
Library of Congress
LOC LC-B811-2298

9 **RAIL CONSTRUCTION**
Library of Congress
LOC LOT 9209, no. 9

10 **RAIL CARPENTER**
Library of Congress
LOC LOT 9209, no. 41

11 **BRIDGE TRUSSES**
Library of Congress
LOC LOT 9209, no. 42

12 **INSPECTING TRUSSES**
Alexandria Library, Special
Collections, William Smith
Collection 635

13 **CITY HOTEL**
Library of Congress
LOC LOT 4336, no. 55

14 **ST. PAUL'S**
Alexandria Library, Special
Collections, William Smith
Collection 92

15 **SHUTER'S HILL**
Alexandria Library, Special
Collections, William Smith
Collection 119

16 **SEMINARY SCHOOL**
Library of Congress
LOC LOT 4161-H

17 **ASPINWALL HALL**
Alexandria Library, Special
Collections, William Smith
Collection 759

18 **TIDE LOCK**
Alexandria Library, Special
Collections, William Smith
Collection 1499

19 **HEADQUARTERS**
Library of Congress
LOC LOT 11486-B, no. 5

20 **CHRIST EPISCOPAL**
Library of Congress
LOC LC_B811-2301

21 **MECHANICS BANK**
Alexandria Library, Special
Collections, William Smith
Collection 382

22 **CITY HOTEL**
Alexandria Library, Special
Collections, William Smith
Collection 681

23 **ASPINWALL HALL**
Alexandria Library, Special
Collections, William Smith
Collection 756

24 **BOXCARS**
Library of Congress
LOC LOT 4336, no. 57

25 **FIRE HOUSE**
Library of Congress
LOC LOT 4336, no. 56

26 **SANITARY MISSION LODGE**
Library of Congress
LOC LC-B811-1204

27 **HOME NEAR FORT LYON**
Library of Congress
LOC LC-B811-2305

113 KING STREET
Alexandria Library, Special
Collections, William Smith
Collection 774

114 SNOWSTORM
Alexandria Library, Special
Collections, William Smith
Collection 831

115 LIGHT INFANTRY BAND
Alexandria Library, Special
Collections, McKenney
Collection 8

116 STREET CLEARING
Alexandria Library, Special
Collections, Loeb Collection
16

117 KING STREET
Alexandria Library, Special
Collections, Loeb Collection
17

118 TIN LIZZIES
Alexandria Library, Special
Collections, Creegan
Collection 239

119 PARKER-GRAY SCHOOL
Alexandria Library, Special
Collections, Vertical File
Collection 1178A

**120 ALEXANDRIA AUTO
SUPPLY**
Alexandria Library, Special
Collections, William Smith
Collection 840

121 PRESIDENT COOLIDGE
Library of Congress
LOC LOT 12283, v. 1

122 KING STREET
Alexandria Library, Special
Collections, Loeb Collection 15

123 CAPTAINS ROW
Alexandria Library, Special
Collections, William Smith
Collection 567

124 515 N. WASHINGTON
Alexandria Library, Special
Collections, William Smith
Collection 830

125 ROLLERSKATERS
Alexandria Library, Special
Collections, William Smith
Collection 224

126 WARFIELD DRUG STORE
Alexandria Library, Special
Collections, Sampson
Collection 85

127 SPARK PLUG FACTORY
Alexandria Library, Special
Collections, William Smith
Collection 826

128 ROYAL STREET
Alexandria Library, Special
Collections, William Smith
Collection 85

129 WOMEN'S AUXILIARY
Alexandria Library, Special
Collections, Sampson
Collection 48

130 KING STREET
Alexandria Library, Special
Collections, William Smith
Collection 1013

131 ROYAL STREET
Alexandria Library, Special
Collections, William Smith
Collection 370

132 COHEN'S CLOTHING
Alexandria Library, Special
Collections, Cohen Collection 2

134 KING STREET
Alexandria Library, Special
Collections, William Smith
Collection 972

135 KING STREET
Alexandria Library, Special
Collections, William Smith
Collection 385

136 RAMSAY HOUSE
Alexandria Library, Special
Collections, Loeb Collection
320

137 400 BLOCK
Alexandria Library, Special
Collections, Loeb Collection
68

138 PRINCE STREET WHARF
Alexandria Library, Special
Collections, Loeb Collection 41

**139 POTOMAC COMPANY
CANAL**
Alexandria Library, Special
Collections, Ira Smith
Collection 38

140 CITY HALL
Alexandria Library, Special
Collections, Somerville
Collection 326

141 1930 PARADE
Alexandria Library, Special
Collections, Sampson
Scrapbook Collection 139

142 WESLEY SNOOTS
Alexandria Library, Special
Collections, Sampson
Scrapbook Collection 4

143 CARLYLE HOUSE
Alexandria Library, Special
Collections, Loeb Collection
107B

144 PUBLIC SERVICE COMPANY
Alexandria Library, Special
Collections, William Smith
Collection 768D

145 MONUMENT
Alexandria Library, Special
Collections, William Smith
Collection 420

146 WASHINGTON STATUE
Alexandria Library, Special
Collections, William Smith
Collection 421

147 SPARK PLUG FACTORY
Alexandria Library, Special
Collections, McKenney
Collection 15

148 GADSBY'S TAVERN
Library of Congress
LOC HABS VA, 7 ALEX, 19

149 WASHINGTON'S BIRTHDAY
Alexandria Library, Special
Collections, Sampson
Scrapbook Collection 142

150 LIGHT INFANTRY
Alexandria Library, Special
Collections, Glascow Collection
44A

151 MEMORIAL SERVICE
Alexandria Library, Special
Collections, Gallagher
Collection Box 3, Folder 2, #5

152 INFANTRY
Alexandria Library, Special
Collections, Glascow Collection
101

153 FIRST INFANTRY
Alexandria Library, Special
Collections, Glascow Collection
56

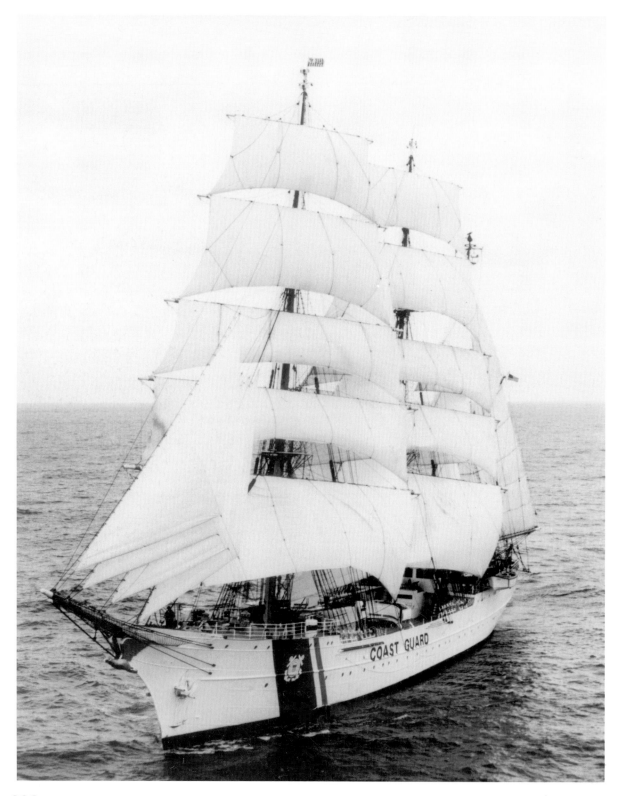

The U.S. Coast Guard's *Eagle* calls on Alexandria during the annual waterfront festival. (1977)